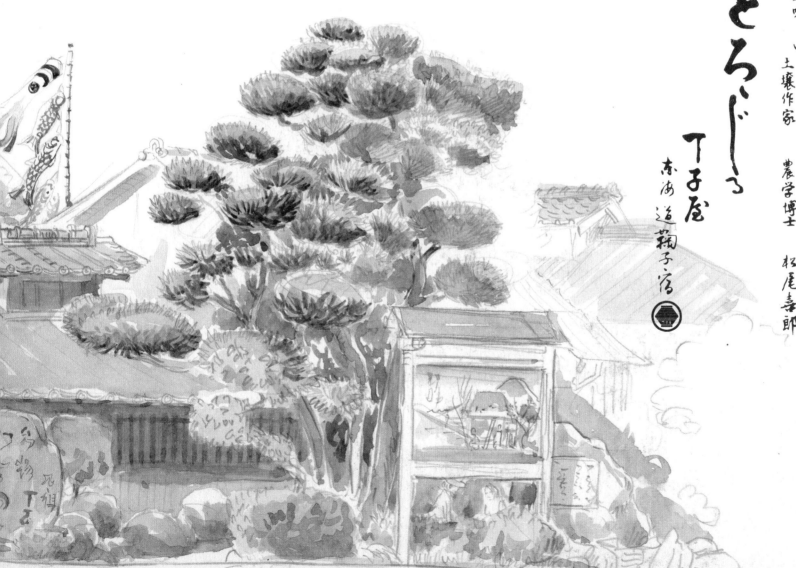

とろろ（自然薯）一口ばなし
お米や麦の殿粉はベータ型。だから生ではまずく
て食べられない。しかし、炊くとアルファ型になり、
生でアルファ型のとろろ汁にピッタリ合って
美味しい！
土壌作家　農学博士　松尾嘉郎

とろゝじる

丁子屋

東海道鞠子宿

HIROSHIGE'S JAPAN

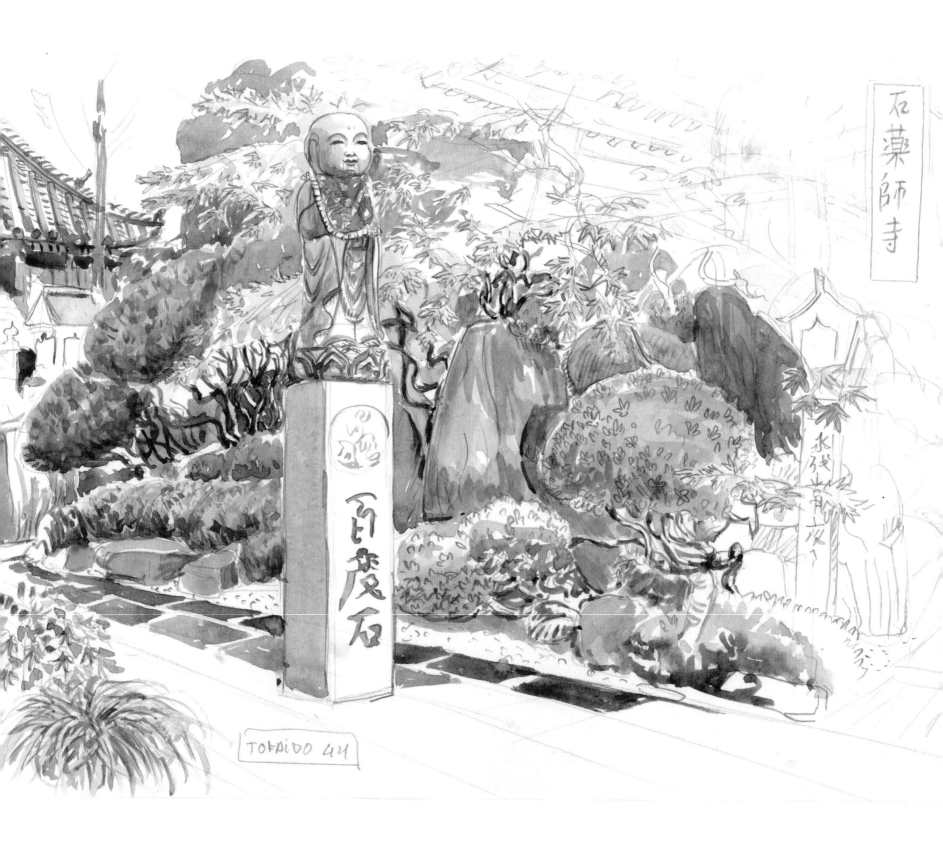

石薬師寺

水残草前次子

石薬石

TOKAIDO 44

HIROSHIGE'S JAPAN

On the Trail of the Great Woodblock Print Master

PHILIPPE DELORD

TUTTLE Publishing

Tokyo | Rutland, Vermont | Singapore

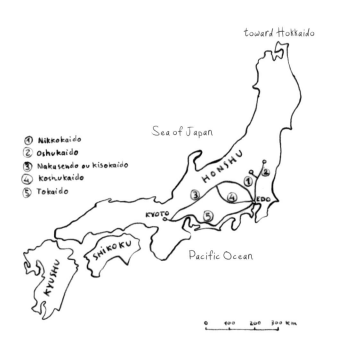

toward Hokkaido

Sea of Japan

① Nikkokaido
② Oshukaido
③ Nakasendo ou kisokaido
④ Koshukaido
⑤ Tokaido

HONSHU

KYOTO

EDO

KYUSHU

SHIKOKU

Pacific Ocean

0 100 200 300 Km

IN THE FOOTSTEPS OF HIROSHIGE

This book showcases drawings made between 2014 and 2016 during trips I made along the historic Tokaido road, atop a 125 cc scooter. This road, stretching for three hundred miles (five hundred kilometers), dates back to the eleventh century, connecting Tokyo (formerly Edo) to Kyoto.

My goal was to follow the path of the ancient road to see if I could find the locations depicted in the series of prints *The Fifty-Three Stations of the Tokaido*, the best-known work of renowned artist Utagawa Hiroshige (1797–1858), first published from 1832–33. As I tried to capture the modern-day versions of these scenes in my own sketches and watercolors, I found myself in a world floating between past and present, where fabulous images from the Edo period and contemporary Japan blended together. This book is a record of that journey.

The Fifty-Three Stations of the Tokaido Road

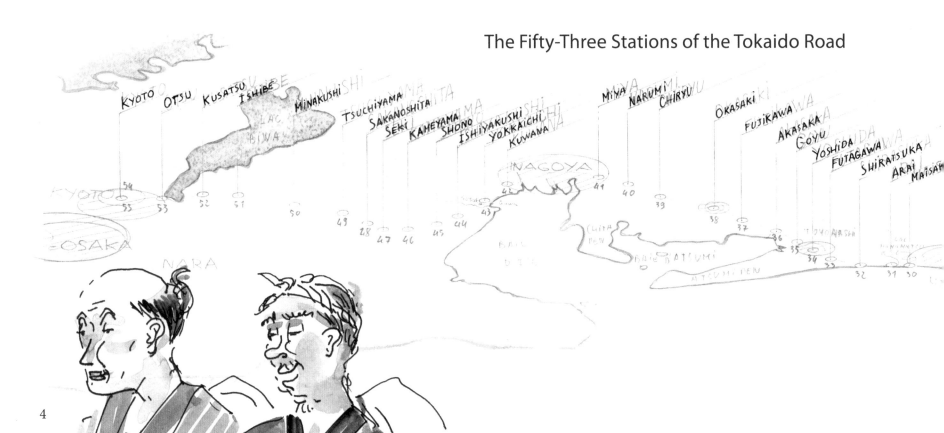

A Brief History of the Tokaido Road

During the Edo period (1603–1868), five main roads crisscrossed Japan's main island of Honshu. These five roads were collectively called the Gokaido (lit., "five roads"). They all started from the newly established capital, Edo, today's Tokyo. Two roads went north: the Nikkokaido and the Oshukaido. Three roads went south to connect to Kyoto: the Nakasendo and the Koshukaido went through the inland mountains whereas the Tokaido, the "Eastern Sea Road" more or less followed the Pacific coast.

THE FIFTY-THREE STATIONS OF THE TOKAIDO

The Tokaido was at its busiest during the Edo period. In 1603, Tokugawa Ieyasu, the first shogun, had gained control of the whole of Japan. Edo became the new capital of the country, seat of his military government, the *bafuku*. The former capital, Kyoto, was still regarded as the imperial capital. The Tokaido became the main thoroughfare for traffic between these two administrative cities for feudal lords and their retinues, as well as for pilgrims visiting religious sites at Ise, near Kyoto.

The word Tokaido is made up of three characters:
 TO = east
 KAI = sea
 DO = road
So "Tokaido" means the Eastern Sea Road, in other words, the Pacific Ocean Road.

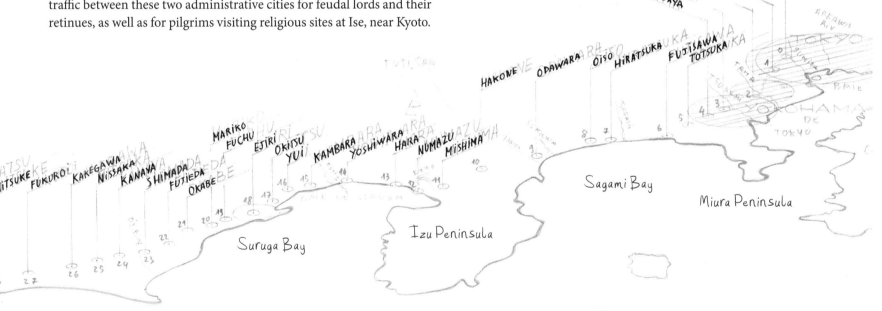

Pacific Ocean

62 MILES (100 KM)

Shank's Mare by Jippensha Ikku, English edition, 2001, Tuttle Publishing.

Tokaidochu Hizakurige, Japanese edition of Shank's Mare, 2013, published by Iwanami Shoten.

Hiroshige designed at least eleven woodblock print series on the subject of the Tokaido. Three versions of 41st station: Miya, are shown here: right, published by Hoeido; below right published by Sanoki; below, published by Koeido.

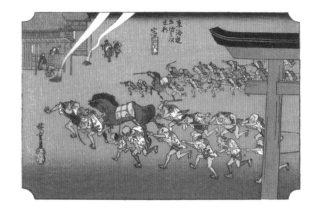

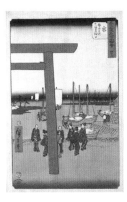

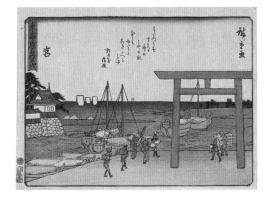

Laborers would also use the road to commute between large cities and provincial towns. Its path was well marked and controlled by guards who monitored safety along the road. At regular intervals were "stations": places where travelers could find inns and restaurants. Many "guides to famous places" (*meisho-ki* and *meisho-ku*) were published at the time. These travel books would indicate distances between stations, local specialties, as well as the prices of lodgings, and the locations of porters and toll booths.

At the beginning of the Edo period, the first Tokugawa shogun, Ieyasu, fixed the number of stations along the Tokaido at fifty-three. Along the roughly three hundred miles (five hundred kilometers) separating Edo from Kyoto there would be a station every five miles (eight kilometers) on average.

TWO ICONIC BOOKS ABOUT THE TOKAIDO

During my own trip along the vestiges of the old Tokaido road, I carried two books in my luggage. One was *Shank's Mare*, by Jippensha Ikku, first published in serial form between 1802 and 1822. This comedy, largely inspired by meisho-ku guidebooks of the time, relates the picaresque adventures and misadventures of two pals who travel the Tokaido on foot. The characters are Yajirobei and Kitahachi, better known in Japan by the nicknames Yaji-san and Kita-san, or the contraction "Yajikita" to refer to both of them.

The other book I brought with me was the actual starting point for this project; it contains the famous series of woodblock prints *The Fifty-Three Stations of the Tokaido* by Utagawa Hiroshige. The best-known version of this collection of prints was published from 1832–33 by the Japanese publisher Hoeido. The prints depict the fifty-three stations of the road season after season, and linger with humor and empathy on the numerous characters making their way along the thoroughfare. From 1832 until 1857, Hiroshige would design at least eleven different versions of this set of prints.

THE TOKAIDO ROAD TODAY

The Edo period ended in 1868, and the old Tokaido road, illustrated by master printmakers such as Hiroshige, has almost vanished in today's modern landscape. Still, the Tokaido exists in a contemporary shape. Even though the stretch of coast between Tokyo and Kyoto is heavily built up, traces of the old road can still be found, meandering past commercial and industrial zones, rice fields, tract houses, elevated freeways and waterfront docks.

In contemporary Japan, both National Route 1 and the Tokaido *shinkansen* bullet train line follow the route of the old Tokaido road. Today's travelers may take these urbanized routes without giving a thought to the original thoroughfare. But during my first trip along this route, I would unexpectedly stumble upon reminders of the past, in the form of a memorial plaque, a historical sign, or a section of the old route preserved for the pleasure of tourists.

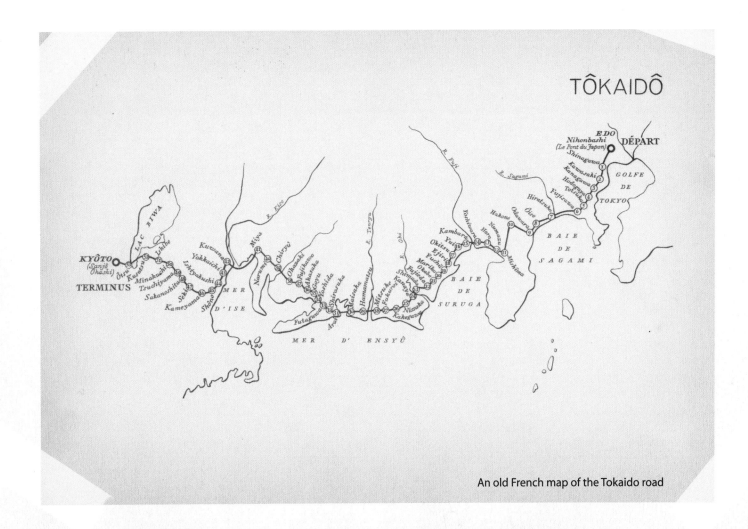

An old French map of the Tokaido road

Traveling the Tokaido by Shinkansen

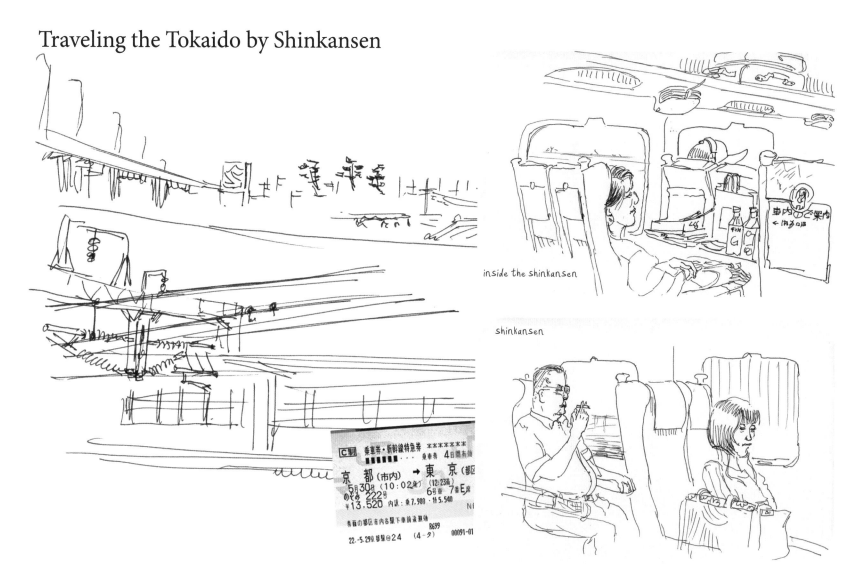

inside the shinkansen

shinkansen

I am on the high-speed *shinkansen* bullet train, which takes me from Tokyo to Kyoto. The Tokaido railway line more or less follows the path of the "East Sea Road" from which it took its name.

The ticket price is astronomical. Seats are occupied by business men in custom-made suits, by women laden with delicate parcels, by English-speaking foreigners with goatee beards. The conductor is obsequious. He thanks passengers in a well-rehearsed speech and his bowing upon leaving the train car is deferential.

Through windows shaped like a plane's portholes, a disjointed landscape goes by. A series of visual events stretches from one high-voltage pylon to another above tract-house suburbs: rice fields border factories; expressways, tortuous and elevated, fly above strip malls. Over there, on top of a hill, a temple and its glossy roof tiles emerge from dense vegetation. A trickle of water flows lazily into a too-large river bed, walled in by high concrete dikes.

Suddenly the eye catches a spark of light in the distance . . . It's the sea, a myriad of scintillations behind a barrier of chimneys, bridges and docks. Everything is in a topsy-turvy rush. How to recognize the thread

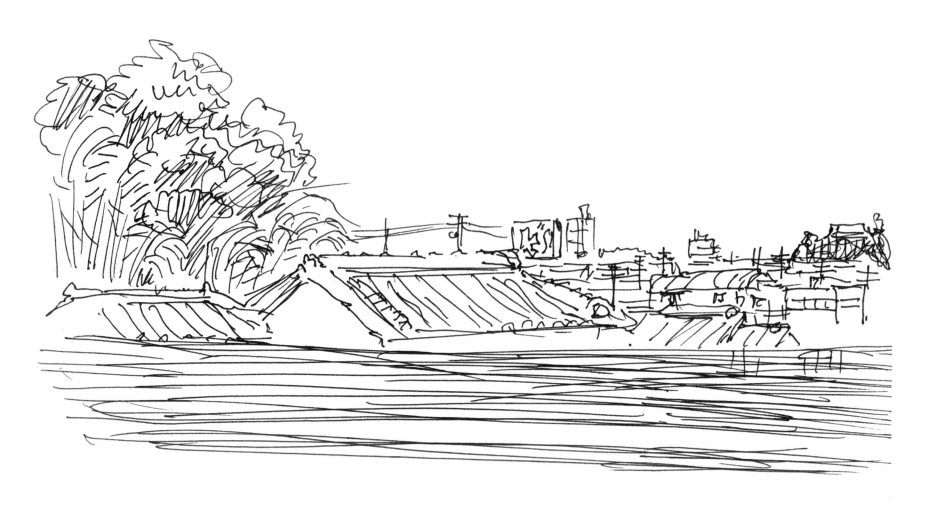

of the Tokaido within this urban maze? Could there still be traces of it intact within this tangled landscape?

I go back to the two books on the table at my seat.

The first book is *Shank's Mare* by Jippensha Ikku. Both comic novel and travel guide, it tells of the picaresque trials and tribulations of two friends, Yajirobei and Kitahachi, who set off along the Tokaido road in order to escape creditors from the eastern capital, Edo.

The second is a book of prints by Utagawa Hiroshige, one of Japan's greatest printmaking masters. First published from 1832–33, *The Fifty-Three Stations of the Tokaido* depicts all the stations of the Tokaido road as they were in the Edo period.

As I look at these accounts of times past I think of the shouts of the tea-hawkers, the songs of the grooms, the equine whinnies—sounds that have the died out beneath the racket of pachinko parlors, karaoke music and loudspeakers blaring advertisements. What about the teahouses that used to line the route? Where to find them?

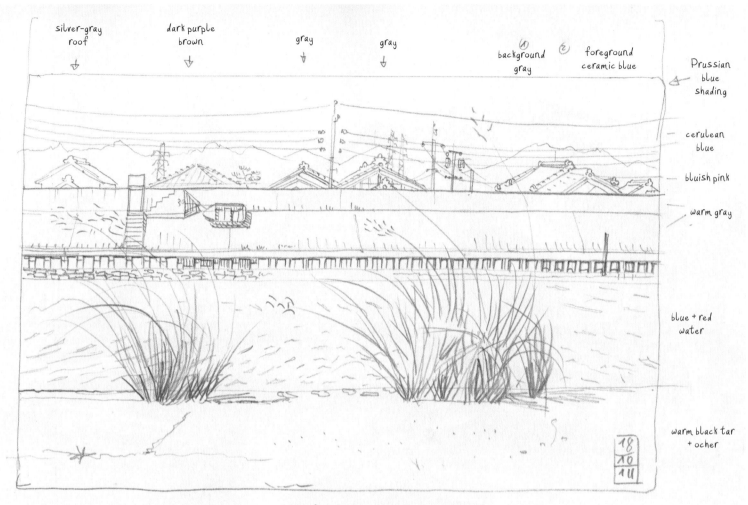

silver-gray roof

dark purple brown

gray

gray

background gray

foreground ceramic blue

Prussian blue shading

cerulean blue

bluish pink

warm gray

blue + red water

warm black tar + ocher

the floating world

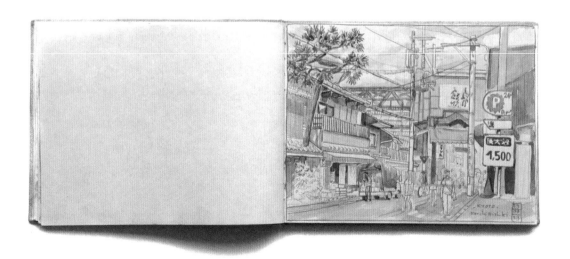

10

Traveling the Tokaido on a Scooter in a Light Breeze

My first Tokaido sketchbooks.

NARA, OCTOBER 2014

My friend Yoshi said he would do it and he did! He bought me a secondhand scooter to ride along the Tokaido. "You'll be free like the wind," he said. After an inspection and lots of paperwork, I'm finally ready to set off, as my friends shout "Ki o tsukete!" (Take care!) And here I am, on the road, moving along smoothly, sharp eyed, scanning my left for any curiosity worth drawing, scanning my right for vehicles that might want to pass me. I'm getting used to doing everything in reverse because they drive on the left in Japan. Ah, but I'm as light as the wind . . . On this beautiful gleaming blue steed, I feel as though the asphalt is melting beneath me as I fly through the breeze toward the eastern capital, Tokyo, the starting point for my journey along the old Tokaido road.

Nihonbashi, Tokyo
The Trip Begins

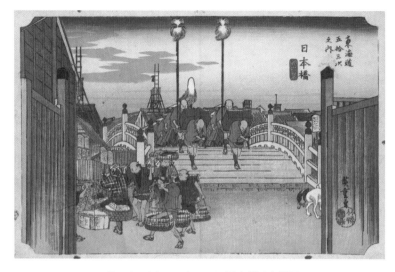

Nihonbashi, Leaving Edo 日本橋 / 広重画

Footsteps from a procession echo on Nihonbashi, the old bridge, breaking dawn's quiet. Behind the open gates of the city checkpoint emerges a daimyo's retinue heading back to the provinces. Two porters lead the way, their backs bent under the weight of their burdens. Two halberds stand majestically upright against a pink sky. A group of fishermen returning from the market wisely move out of the way. Two oblivious mutts sniff around, completely unperturbed by the goings-on.

Crowded with buildings, traffic, and freeways, today's urban landscape has little relation to Hiroshige's original image. But the human comings and goings shown in the Edo-period print is still here in this Tokyo neighborhood, close to Ginza. Department stores, banks and office towers neighbor traditional stores and small restaurants, making up Nihonbashi's modern-day panorama.

From time to time a tourist boat will slalom between the pillars of the bridge. It glides silently on the canal's dark waters before vanishing into shadows.

blue red reddish gray

Leaving Edo

Nihonbashi literally means "Japan Bridge." A bronze plaque marks the starting point of the five Gokaido roads that lead out of old Edo.

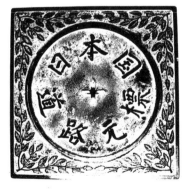

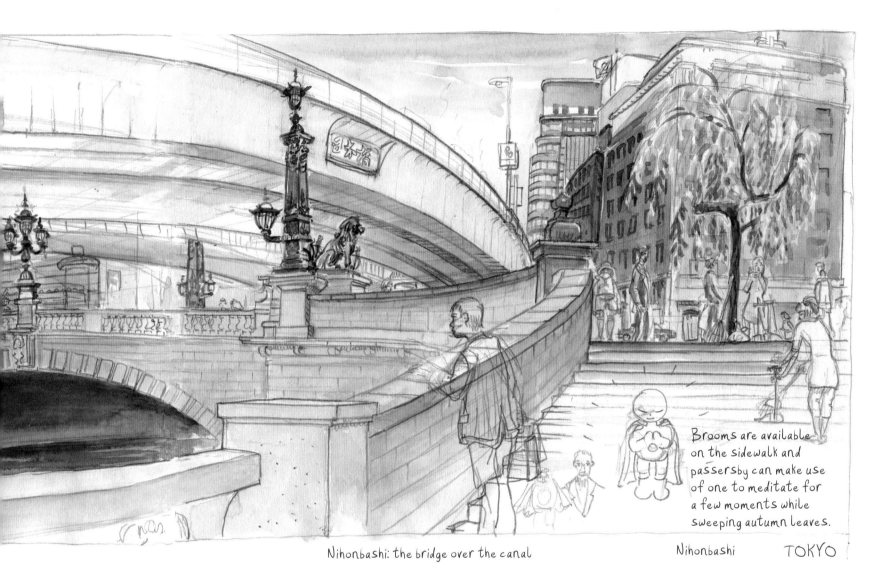

Brooms are available on the sidewalk and passersby can make use of one to meditate for a few moments while sweeping autumn leaves.

Nihonbashi: the bridge over the canal Nihonbashi TOKYO

In 1911, the former wooden bridge made way for this stone bridge, in line with Western standards adopted by the Meiji government. Cast-iron lions hold rudders between their legs; hybrid and mustachioed dragons proudly stand guard at the bases of lampposts. In readiness for the 1964 Olympic Games, an expressway was built above the bridge as Tokyo developed a road network befitting a modern capital, to satisfy the International Olympic Committee. Pragmatic developers gave a nod to the olden days by erecting an information board close to the bridge, giving a short history of old Nihonbashi.

It's been three days since I've started coming to Nihonbashi to draw. I've made a place for myself at the bottom of a small flight of steps, slightly out of the way of the steady flow of vehicles and pedestrians crossing the bridge. A few passersby linger long enough to make a phone call or smoke a discreet cigarette without attracting attention—smoking in the street is forbidden here. Tourist boats glide at regular intervals along the canal's black water before disappearing around one of the massive concrete pillars that hold up the expressway.

NIHON
JAPAN

BASHI
BRIDGE

Yesterday I noticed a very beautiful young woman gliding slowly down a flight of steps, wearing a deep-blue floaty dress. A cameraman was shooting her, overseen by a woman with severe bangs and a man in jeans and plaid shirt with rolled-up sleeves. There she is again today, wearing a gray overcoat and high heels. When she reaches the bottom of the steps, she takes off her coat.

The woman with the bangs folds the coat carefully before sliding it under her arm. Beneath the coat the woman is wearing a pink suit with a miniskirt and laced corset. She strikes a sexy pose while reclining against a gray wall. Her neck, shoulders and legs are bare despite a fresh wind that is making a few leaves dance between sky and earth. The cameraman has gotten closer and is focusing on the young woman's hand in a close-up. She unlaces with infinite slowness the strings at the bottom of her corset. This action is repeated several times. It's only clear to me now that she's a model being watched over by her entourage.

Cast of Characters morning

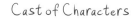

white helmet
+ blue bands

dark
blue
gusset

fluorescent
stripe

dark
blue
stripe

fluorescent
green

light
blue

dark
blue

workers'
trash bags

salaryman

black

white

bag
or shoulder bag
or backpack

black

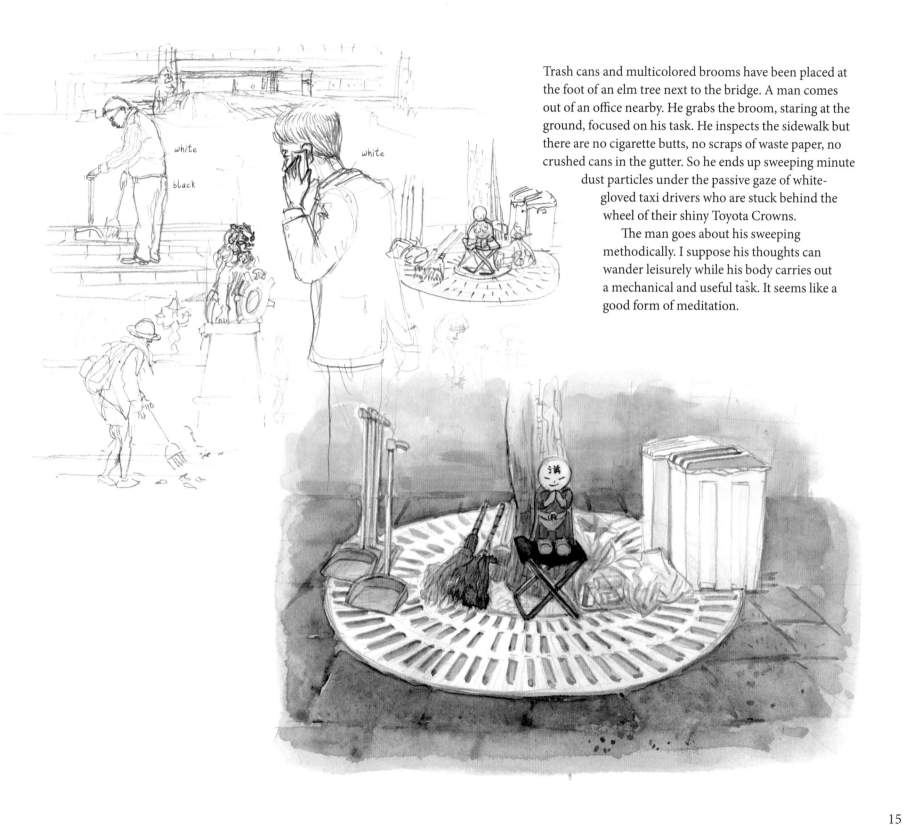

Trash cans and multicolored brooms have been placed at the foot of an elm tree next to the bridge. A man comes out of an office nearby. He grabs the broom, staring at the ground, focused on his task. He inspects the sidewalk but there are no cigarette butts, no scraps of waste paper, no crushed cans in the gutter. So he ends up sweeping minute dust particles under the passive gaze of white-gloved taxi drivers who are stuck behind the wheel of their shiny Toyota Crowns.

The man goes about his sweeping methodically. I suppose his thoughts can wander leisurely while his body carries out a mechanical and useful task. It seems like a good form of meditation.

white

black

white

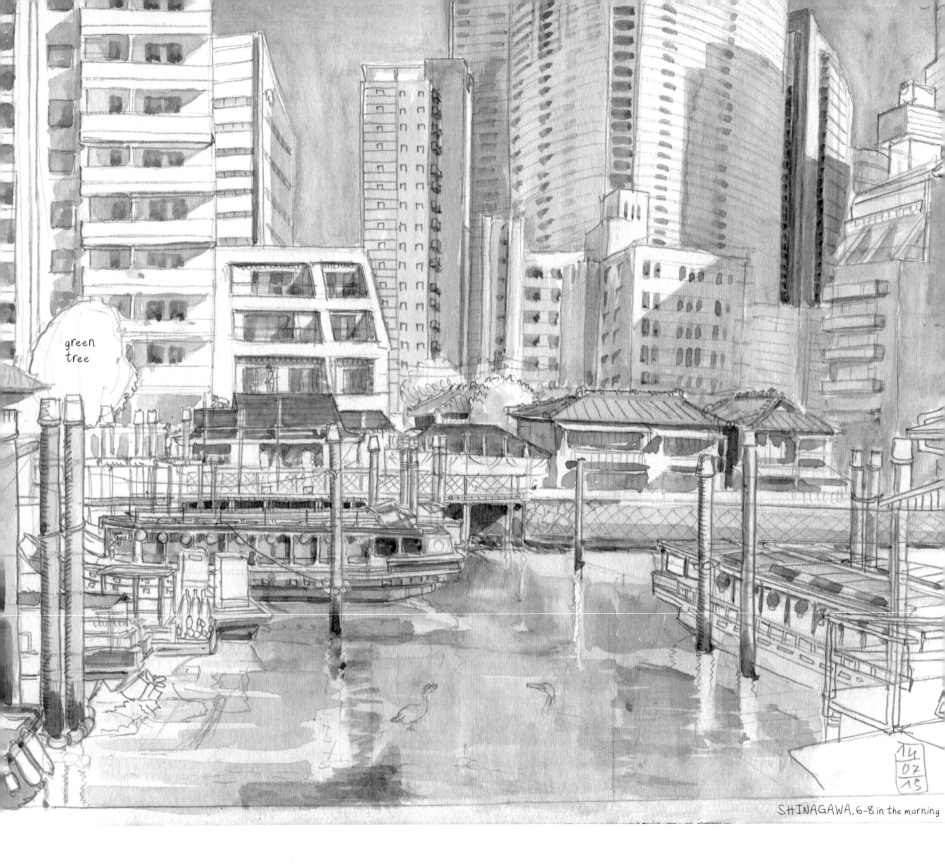

green
tree

14
07
15

SHINAGAWA, 6-8 in the morning

Shinagawa

The Past Has Passed

On November 3, 1954, a nuclear giant appeared on Japanese movie screens. *Gojira* rises from the ocean and appears in Shinagawa where he unleashes terror and destruction on Tokyo. Soon his fame will cross the Pacific and in America he is named Godzilla, king of the monsters!

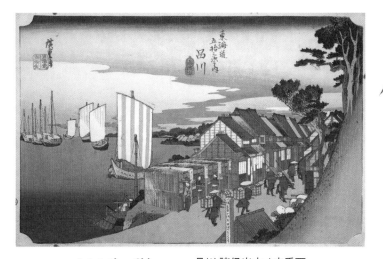

1st station: Shinagawa 品川 諸侯出立 / 広重画

Shogunal troops go through the village. Less than five miles (eight kilometers) separate Nihonbashi from the Tokaido's first station, Shinagawa. The daimyo and his retinue advance between the homesteads. Travelers, huddled on one side of the street, patiently await the end of the parade and even teahouse waitresses momentarily give up on hawking their wares to potential customers.

VIEW OF THE SHINAGAWA WATERFRONT

Shinagawa was incorporated into Tokyo in 1947. In Hiroshige's time, the district was on a waterfront lined with houses. Since then, land reclamation means that the original shoreline has now vanished beneath new construction. Today only a few low houses have resisted real estate pressure, and are listed on the city's historic register.

When night falls, myriad lights glide on deep and dark waters. Gradually, one can make out boats decorated with romantic lanterns. These are traditional *yakatabune* cruise boats, where a seafood meal will be served paired with plenty of sake as the boat drifts across Tokyo Bay illuminated by city lights.

Kawasaki

A Phallic Celebration

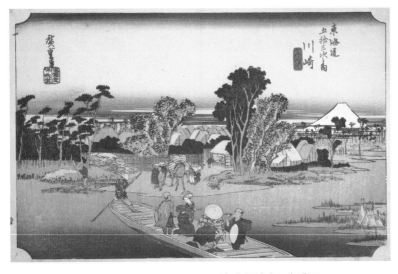

2nd station: Kawasaki 川崎 六郷渡舟 / 広重画

On a clear morning, Fuji's snowy peak dominates the plain. Travelers aboard the Tamagawa River ferry enjoy the quiet of the ride. A man smokes his pipe while looking at the scenery, another checks the rope and buckles on his luggage, while a third, sitting next to him seems to be asking, "Are you sure those will hold?" A mother makes heavy-handed recommendations while waving her closed fan. It's all so calm and clear that you can almost hear the gentle whinny of a horse on the other bank as it whips the air with its tail.

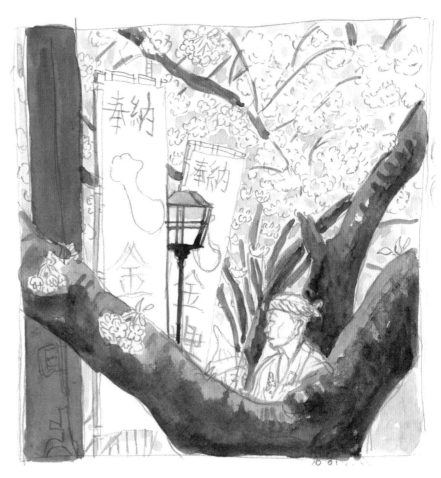

THE KANAMARA FESTIVAL

On this April Sunday in Kawasaki, cherry-tree buds are exploding in bouquets of pure white flowers in the spring rain. Sap invigorates tree trunks like a virile life force. Here I am at the heart of the Kanamara Festival, or Kanamara *matsuri*, a day celebrating the phallus. *Mikoshi* portable shrines are being carried on the shoulders of a compact crowd of people, heaving up and down in rhythm. Each shrine houses a large statue of a penis, either pink, black or plain wood, and is paraded festively around the streets.

Close by, in an annex of Kanayama Shrine, a Shinto priest burns last year's votive tablets. In front of the main shrine building, pilgrims have formed a long line in order to worship at the altar.

Along wooden passageways, there is a sculpture workshop for

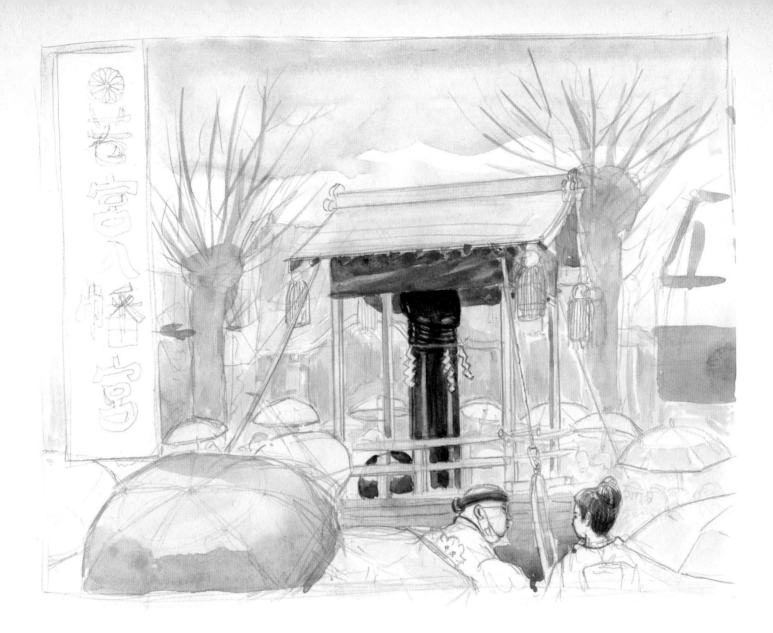

participants to shape their dream phallus from large white daikon radishes, an artistic exercise that people engage in willingly. While waiting for the next portable shrine to arrive, people drink beer, eat *okonomiyaki* savory pancakes or lick penis-shaped lollipops, in a wholesome atmosphere.

This festival stems from a legend about a syphilitic demon who fell in love with a young woman. He took up residence in her vagina, and would bite off the penis of any of her suitors. A clever blacksmith forged an iron penis so that the demon would break his teeth on it. And thus the woman was freed from her curse.

During the Edo period, *meshimori onna* "meal-serving ladies" from local inns used to visit Kanayama Shrine to ask the gods to favor their trade and to chase away shameful diseases.

Today, both men and women take part in the festival for the chance to be fertile and free from sexual diseases.

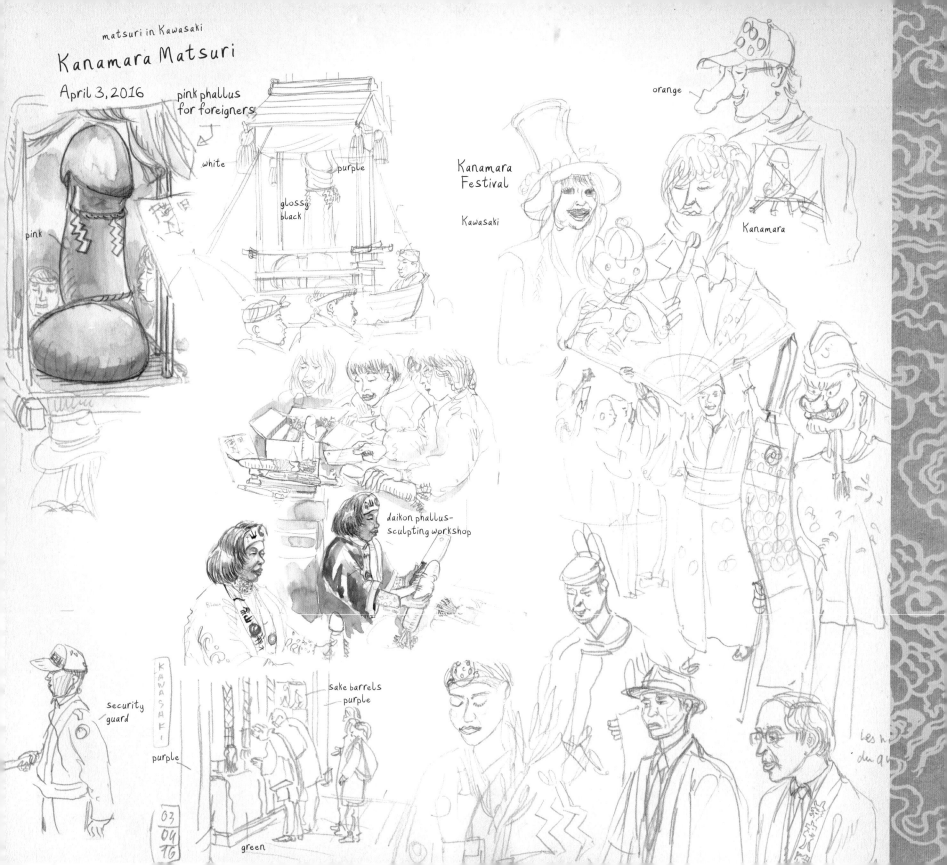

matsuri in Kawasaki

Kanamara Matsuri

April 3, 2016

pink phallus
for foreigners

white

purple

glossy
black

pink

Kanamara
Festival

Kawasaki

orange

Kanamara

daikon phallus-
sculpting workshop

security
guard

KAWASAKI

purple

sake barrels
purple

green

03
04
16

Kanagawa

A Distant Shore

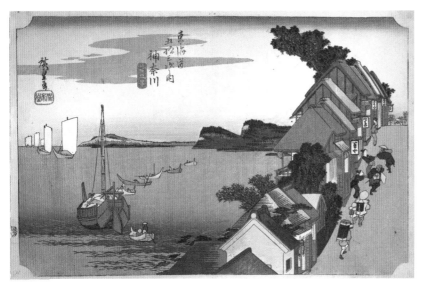

3rd station: Kanagawa 神奈川 台之景 / 広重画

white

black lacquer

"Our macaroni is the biggest!" You won't hear anymore of bowing down when a lord and his escort are going by. Popular Japan reigns here and "tea callers" try to attract customers heavy-handedly. In 1802, author of *Shank's Mare*, Jippensha Ikku, describes Kanagawa just as Kitahachi and Yajirobei are entering the village: "At Kanagawa the teahouses are all two-storied, with balustrades and flying galleries, giving a view over the sea. The teahouse girls were standing at the gates calling, 'Come in and rest. Try our cold dishes heated up again. Cold broiled fish. Try our thick vermicelli. Our macaroni is the biggest. Come in and rest.'"

01
04
16

visit to Ryotei Tanakaya
Kanagawa

21

"WE'RE WALKING ON THE OLD TOKAIDO ROAD!"

This is what I am told by Lee, the manager of the inn where I'm staying, about the street we are walking along.

It's true: the street climbs a hill, just like in Hiroshige's print.

Below us are modern buildings, in place of the sea and shore that were there in Hiroshige's time. That was way before the building of Yokohama and the 1859 opening of the port, when this place was just a village called Kanagawa. Lee knows the neighborhood well. His inn is just down the street.

We come across an old-looking house, surrounded by blocks of modern buildings. It's the Ryotei Tanakaya, a very chic Japanese restaurant outside which, at night, uniformed chauffeurs wait in large black cars. Lee has scheduled an appointment to visit the place. A young woman welcomes us. She talks in an ethereal voice reminiscent of a children's anime character. We go up a wooden staircase. On the walls are old photographs of the glory days of this establishment.

It seems that the Ryotei Tanakaya is the only place to have withstood the test of time among the 1,300 buildings, inns and teahouses that made up Kanagawa back in Hiroshige's day.

YOKOHAMA
KANAGAWA

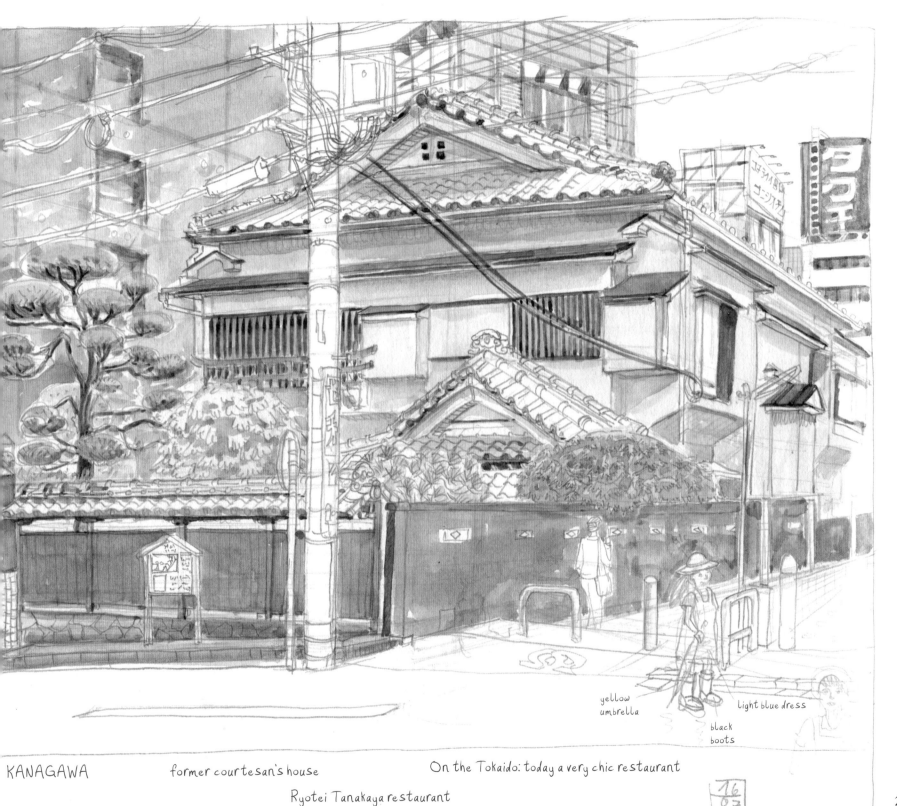

yellow
umbrella

black
boots

light blue dress

KANAGAWA former courtesan's house On the Tokaido: today a very chic restaurant

Ryotei Tanakaya restaurant

16
07
15

23

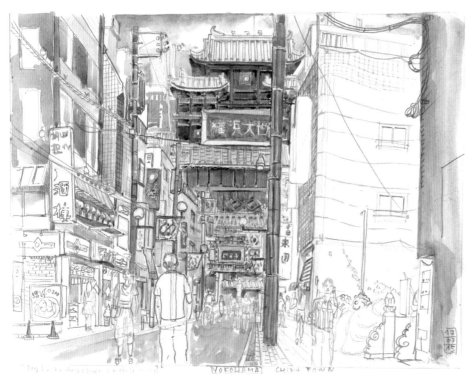

Yokohama is home to Asia's largest ethnic Chinatown, founded in 1863.

In 1853, an American Navy fleet commanded by Commodore Matthew Perry appeared in Edo Bay. Perry threatened to attack if the shogun denied him permission to land. His fleet was eventually allowed to dock, the first step in ending Japan's hundreds of years of isolation, and opening the country up to foreigners. Yokohama became the gateway to Japan, and many people moved there, making it a flourishing city. This was the period when the Westernization of Japan began. In 1872 the first railroad was built, connecting Tokyo to Yokohama.

Hikawa Maru 氷 川 丸

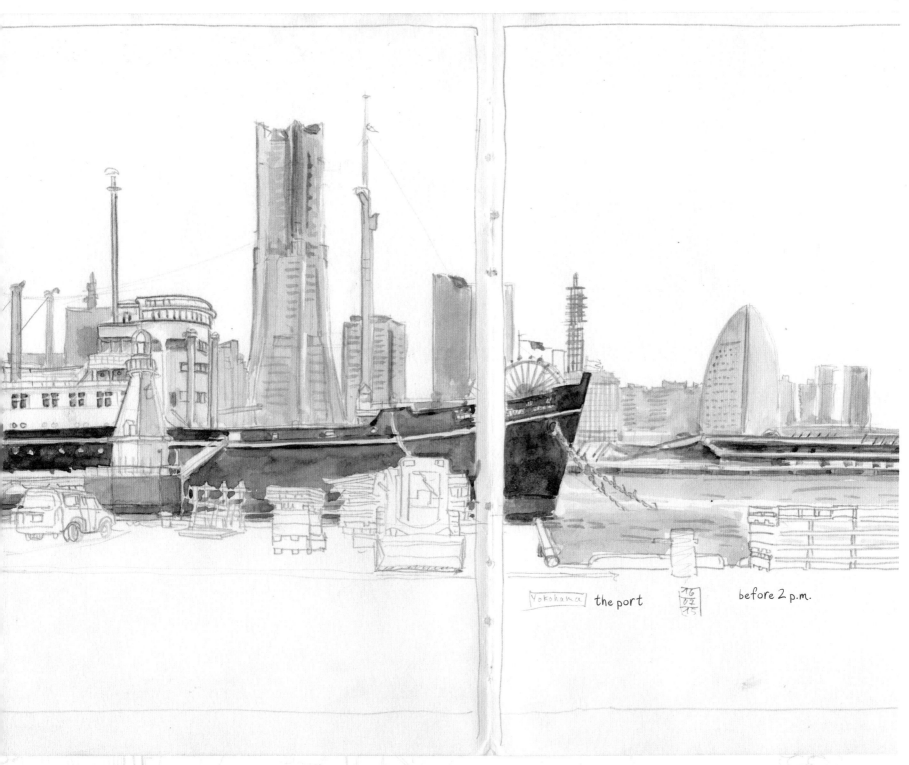

Yokohama the port before 2 p.m.

Hodogaya
Where We Talk about Soba Noodles

4th station: Hodogaya 保土ヶ谷 新町橋 / 広重画

"Look!" Lee is pointing to Hiroshige's print. I can make out a small sign decorated with kanji characters against a house entrance.

"It says *Soba, two-eight*."

"Two-eight, what on earth are you talking about?"

"Well, it means that this house, right after the bridge, where the palanquin is heading, is a soba restaurant."

"I know soba means buckwheat noodles, but two-eight . . ."

"Two-eight is twenty and eighty. It means 20 percent wheat flour and 80 percent buckwheat flour."

"I don't get it . . ."

"It's easier to make buckwheat noodles if you mix in a bit of wheat flour because buckwheat flour is very sticky. For the proportion two-eight, you say *ni-hachi* in Japanese. If you only use buckwheat flour, you call the soba *ju-wari*. If the proportions are somewhere between the two it's called *sotoni-hachi*. Buckwheat flour is either *sarashina* when it's finely ground, or *inaka*, which is darker and contains some whole grains. You add about 40 percent water to make the dough, but you have to take into account air humidity, so proportions vary. You need at least ten years to become a master soba-noodle maker and follow the way of soba: *soba-do*. When soba is served cold it's called *mori-soba*; served warm with a broth, it's called *kake-soba*."

"Well, I don't know if I'll follow the way of soba, but tomorrow I'll see if I can find some soba restaurants in Hodogaya."

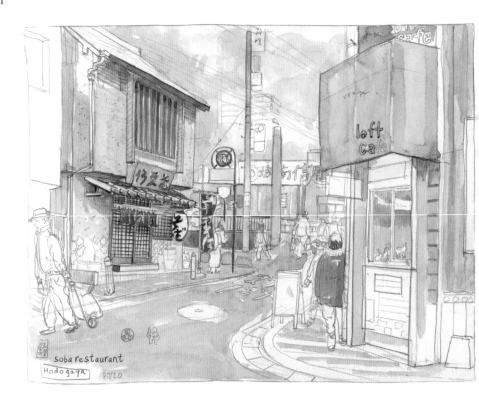

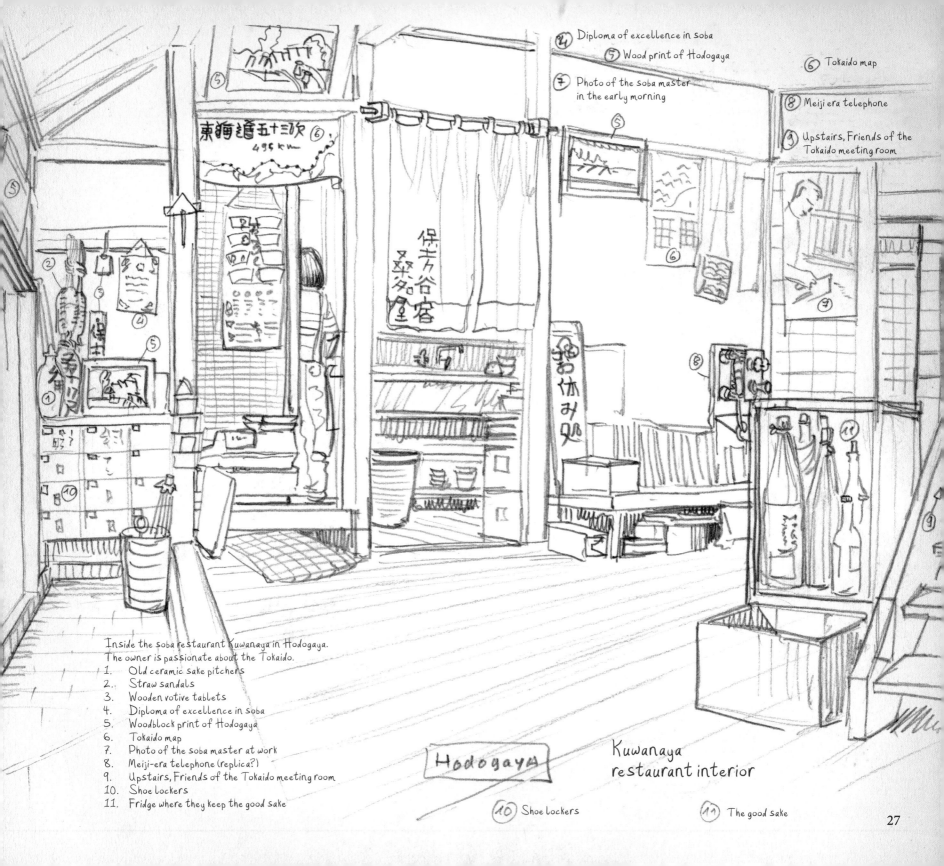

④ Diploma of excellence in soba

⑤ Wood print of Hodogaya

⑥ Tokaido map

⑦ Photo of the soba master in the early morning

⑧ Meiji era telephone

⑨ Upstairs, Friends of the Tokaido meeting room

東海道五十三次
495 km

保土ヶ谷宿
桑名屋

お休み処

Inside the soba restaurant Kuwanaya in Hodogaya.
The owner is passionate about the Tokaido.
1. Old ceramic sake pitchers
2. Straw sandals
3. Wooden votive tablets
4. Diploma of excellence in soba
5. Woodblock print of Hodogaya
6. Tokaido map
7. Photo of the soba master at work
8. Meiji-era telephone (replica?)
9. Upstairs, Friends of the Tokaido meeting room
10. Shoe lockers
11. Fridge where they keep the good sake

Hodogaya

Kuwanaya
restaurant interior

⑩ Shoe lockers

⑪ The good sake

27

Totsuka

Ephemeral Beauty and Eternal Wrinkles

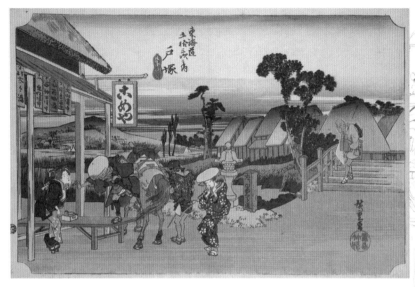

5th station: Totsuka 戸塚 元町別道 / 広重画

Ten leagues on foot will wear down your shoes! After a trip of ten leagues (about twenty-five miles or forty kilometers), Yajirobei and Kitahachi, our two walking companions on this trip along the Tokaido, are about to spend the night at the 5th station, Totsuka. One can imagine the number of worn-out straw sandals they'll have to leave by the wayside before reaching Kyoto three hundred miles (five hundred kilometers) from their starting point.

Notice that even the horses are fit with straw sandals. On the Tokaido, everything that moves on two or four legs wears them.

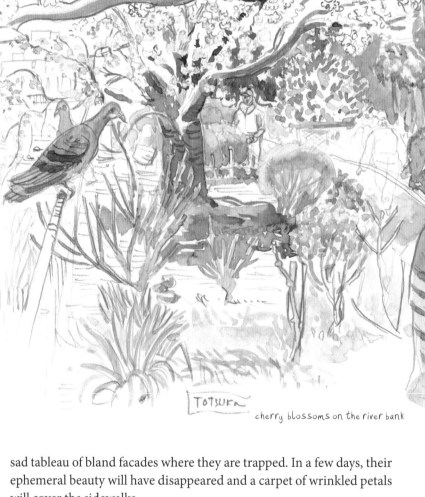

TOTSUKA

cherry blossoms on the river bank

I wander around for a long time in Totsuka without finding anything remarkable, despite the cherry blossoms in full bloom. On the riverbanks, boughs are heavy with the weight of the flowers but the backdrop of buildings spoils the vista. The clouds of blooms give the impression that they want to free themselves from their branches, like prisoners ready to rip off their chains, so that they can escape from the sad tableau of bland facades where they are trapped. In a few days, their ephemeral beauty will have disappeared and a carpet of wrinkled petals will cover the sidewalks.

My wanderings take me to a wooded hill where there's a crumbling temple, ravaged by woodworms and humidity. Next to a tree stump, there is a green rock carefully protected by a tin lid and placed between

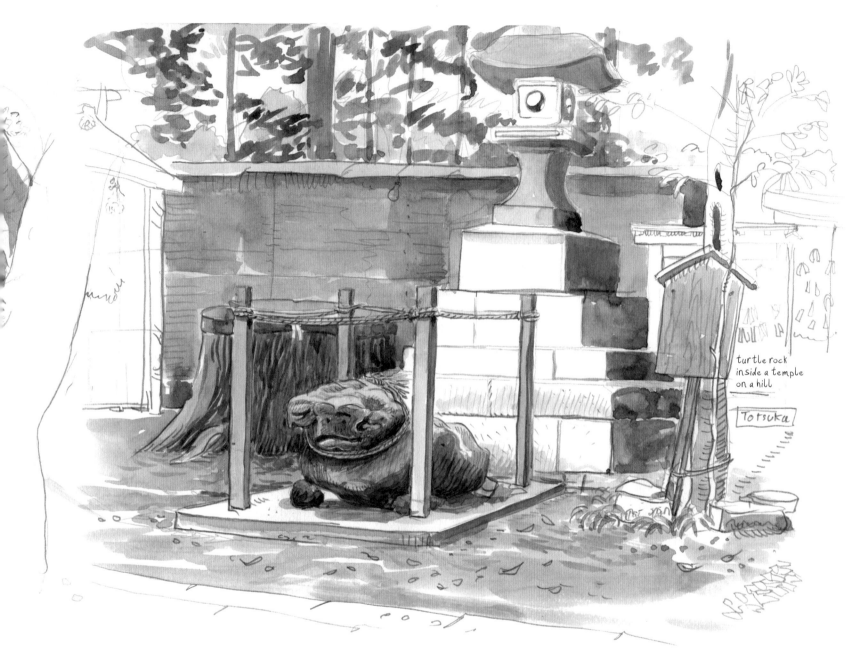

turtle rock
inside a temple
on a hill

Totsuka

four posts. Is it really a rock? No, wait . . . it's a very wrinkled turtle. Her eyes are half closed and she's wearing a scarf of sacred rice straw around her neck to protect from the cold of winter. The turtle is waiting patiently—she has all the time in the world, it seems.

Fujisawa

Tourism on Benten Goddess Island

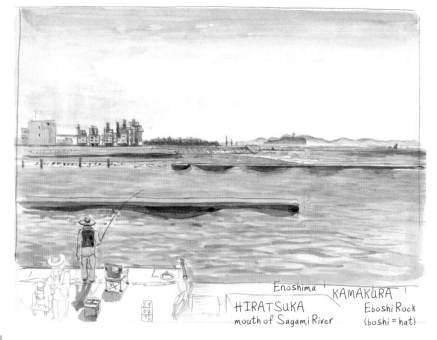

It's the period known as Golden Week, when four public holidays fall in quick succession. Down at the beach, tanned surfers skillfully ride the waves that rise from the depths of Sagami Bay. Bikers in black sunglasses and Hawaiian shirts rev up their engines on machines customized with blue lights and chrome accessories. The bridge connecting Enoshima Island to the coast is jammed with tourists. They wander along eating ice creams, arms laden with souvenirs from the shops along the steps leading to the temples. Everyone is enjoying these summer pleasures, their spirits light from having worshipped the Buddhist goddess Benten and trekked through caves that were long ago inhabited by mystic hermits.

In the west, the sun setting behind Mount Fuji offers quickly unsheathed smartphones a gorgeous tableau.

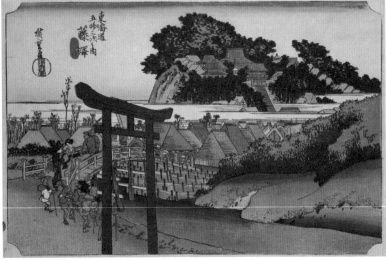

6th station: Fujisawa 藤沢 / 広重画

The sacred grounds of Enoshima Island. Three blind men go through the *torii* gates marking the entrance to the island. Between the trees, you can get a glimpse of the roof of Yugyoji Temple. On the bridge, a man seems to be carrying a *koto*, a Japanese zither. He is undoubtedly back from the temple dedicated to Benten, the goddess of eloquence and music, a lone female figure among the seven Japanese deities of good fortune.

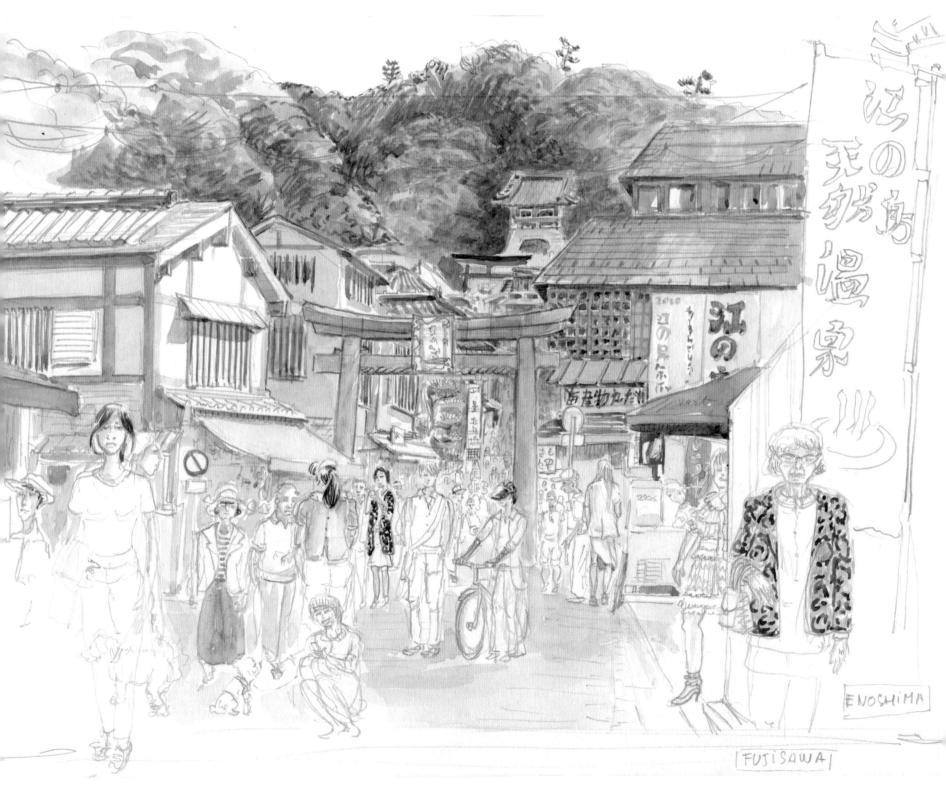

江の島　天然温泉　♨

ENOSHIMA

FUJISAWA

31

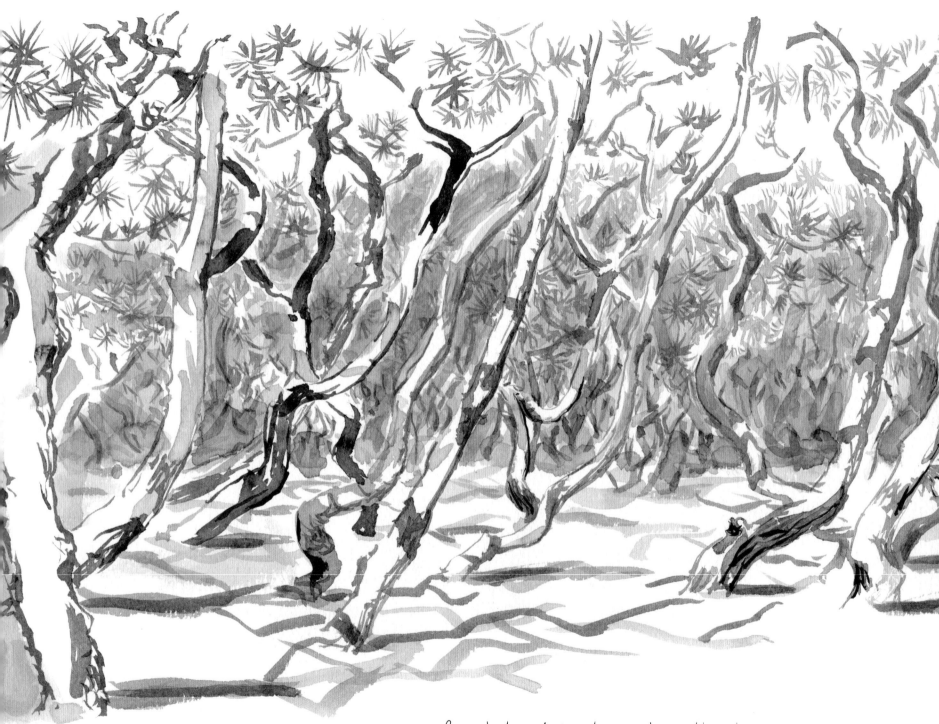

a grove of sculptured pine trees along the shore

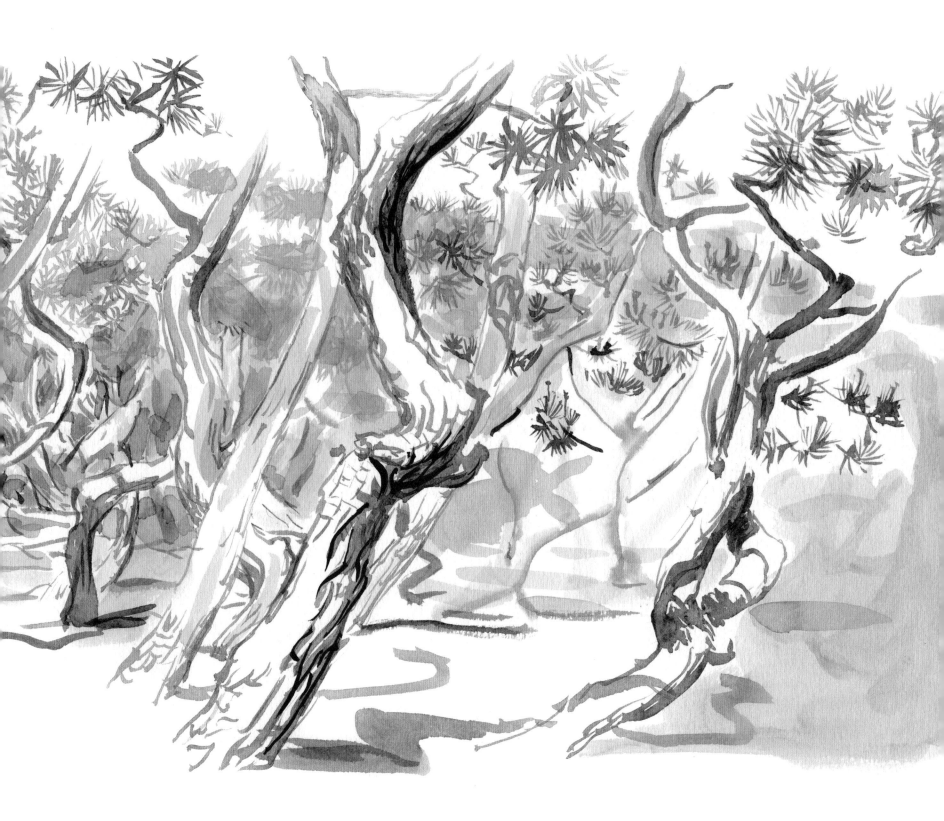

Hiratsuka

Camembert, Baguette and Côtes-du-Rhône

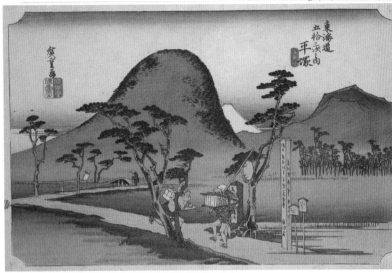

7th station: Hiratsuka 平塚 繩手道 / 広重画

A courier dashes merrily along a road that meanders between pine trees.
These couriers were known as *hikyaku*, meaning "flying legs," due to their fast
running speed as they formed a relay along the Tokaido. A dispatch from
Edo would on average take six days to reach Kyoto.

What a wonderful evening . . . I manage to unearth a bottle of
Côtes-du-Rhône, a Japanese Camembert and a baguette at the local
supermarket and I enjoy this frugal "Franco-Japanese"
meal in a fisherman's hut on Chigasaki beach. The
place is clean: the sand has been swept out. My
surroundings make the place's purpose clear: meticulously coiled
ropes hang from enormous nails hammered into the pillars, buckets
are stacked next to a set of brooms leaning against one of the four thick
beams. Even though it's open to the wind, the shack has been designed
for maximum space optimization.

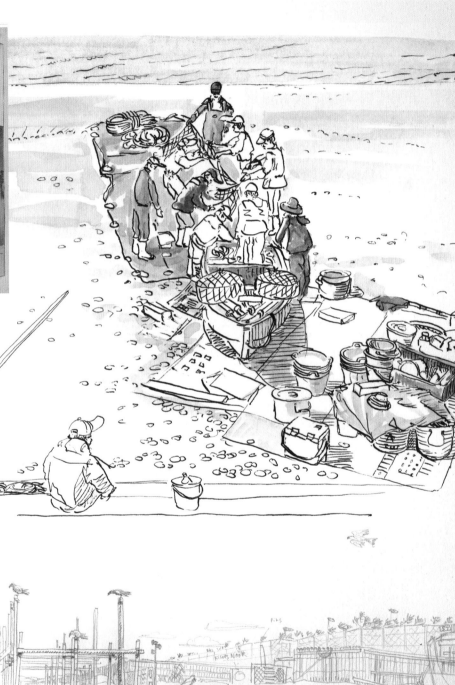

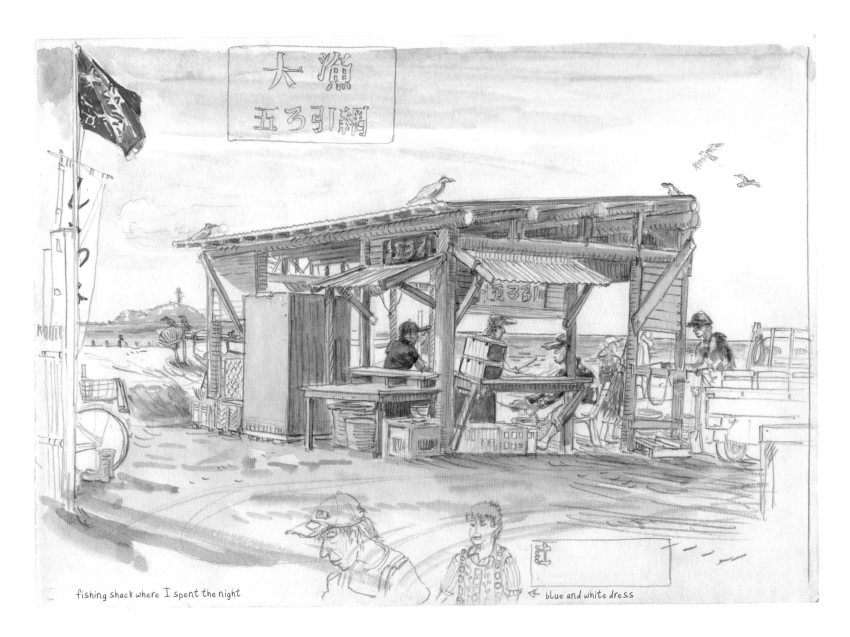

fishing shack where I spent the night

blue and white dress

As I work my way down the bottle, I reflect on this place so simple yet so meticulously organized—a physical manifestation of the Japanese way of thinking. Lost in nocturnal vastness, the contours of Enoshima Island vanish, swallowed by the night, drowned in my sleep.

I wake up with a start. The sudden apparition of a little man, pants tucked inside his boots, cap screwed on top of his head, quickly brings me back from the land of Morpheus and forces me to find some words of greeting.

The magic words *ohayo gozaimasu* (good morning) make no impression on him. He starts a winch motor and I get out of there, finding a spot nearby where I can observe the scene. A heavy skiff is being pushed into the water as the fishing day begins. Men cast their nets and the winch does the rest. I see hundreds of captive small fish thrashing in the nets.

The men immediately throw the minnows in iceboxes in the rear of pickup trucks, monitored closely by an excited murder of crows.

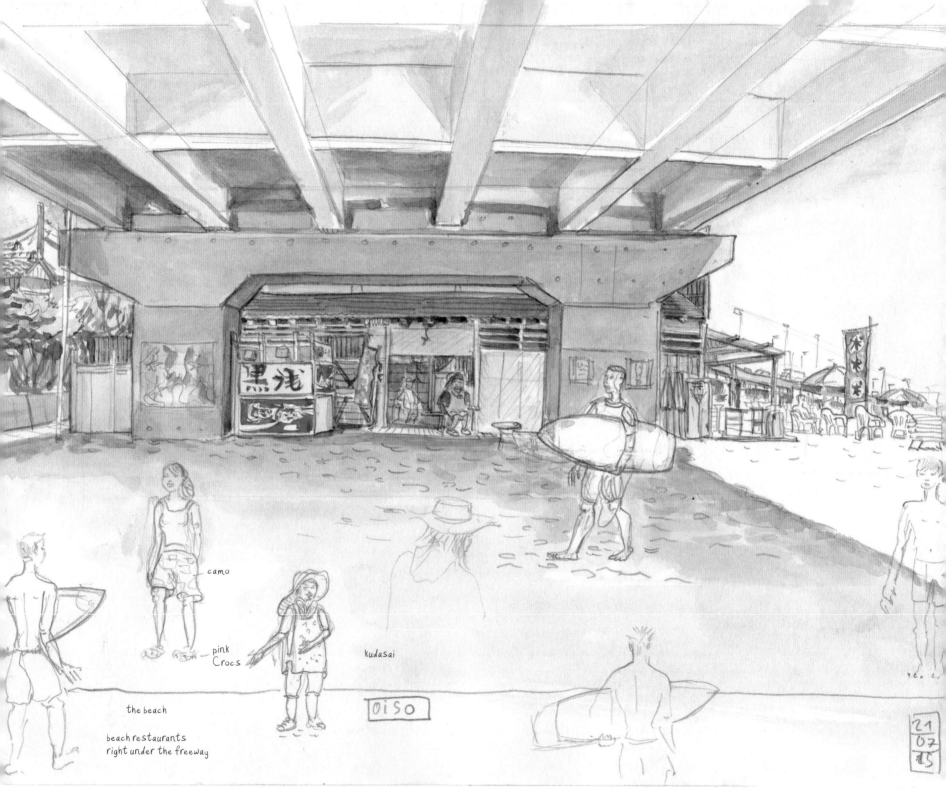

camo

pink Crocs

kudasai

the beach

beach restaurants
right under the freeway

OiSO

黑汽

21
07
15

Oiso

Sea, Surf and Sun

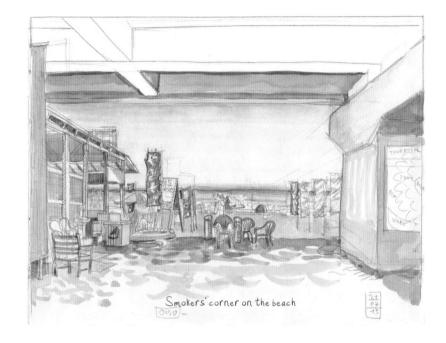

Smokers' corner on the beach
Oiso

8th station: Oiso 大磯 虎ケ雨 / 広重画

The sky has darkened and clouds bring heavy rainfall. Under their sedge capes, men hurry toward the village. The landscape has taken on yellowish and gray hues. On the horizon, a band of light sparkles on the sea. The full title of the print, *Oiso, tora ga ame*, refers to the legend *Tears of Tora*, a drama of vengeance and unhappy love that ends in tears.

National Route 1 juts out above Oiso beach. A row of tiny greasy-spoon cafés occupies the spaces between the bridge's concrete pillars, protected from the caprices of time.

"*Irasshaimaseeee! Come on in!*"

Right on the beach, in the busiest place, I am hooked by a café owner. Sitting down, on alert, she expects a quick return on investment, thanks to the strategic location of her business.

"How about a refreshing drink? We have delicious fruit juices! A bite to eat? No problem. I'll bring you a bowl of noodles . . . and you can have free refills of my famous broth! You're bound to like it. Come on in, please… *Dozo, ohairi kudasai.*"

Quick to stand up, to call out to passersby, she reminds me of the women of yesteryear who would reel customers into teahouses all along the Tokaido.

Odawara

An Accident on Poets' Avenue

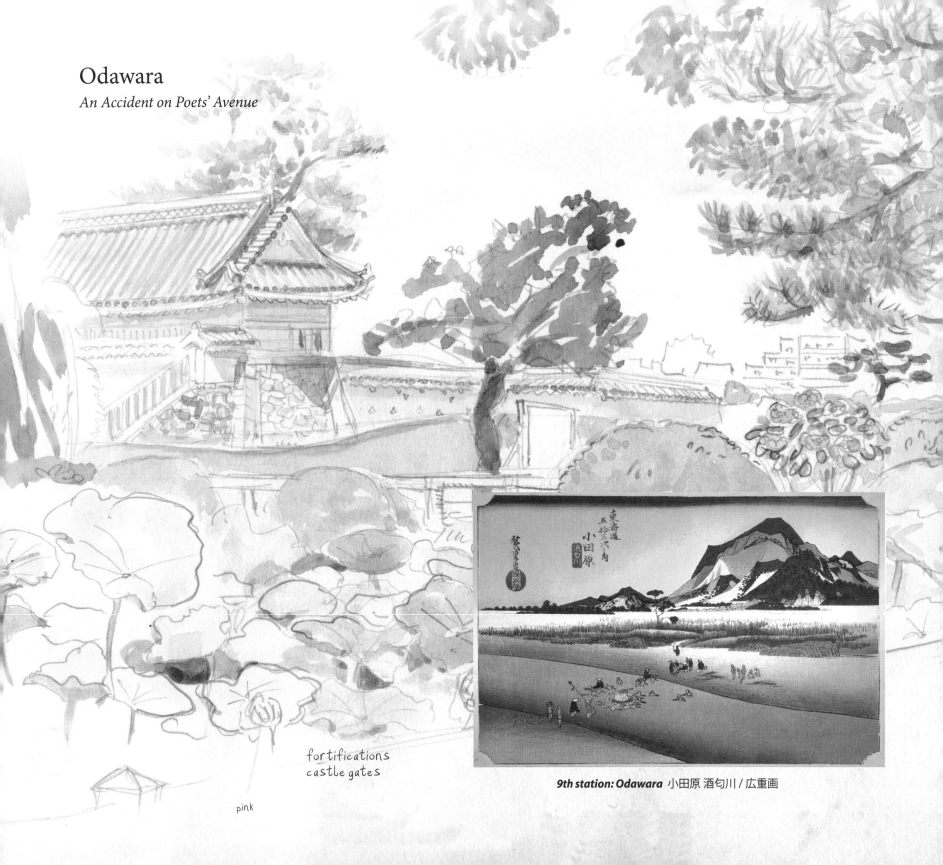

fortifications
castle gates

pink

9th station: Odawara 小田原 酒匂川 / 広重画

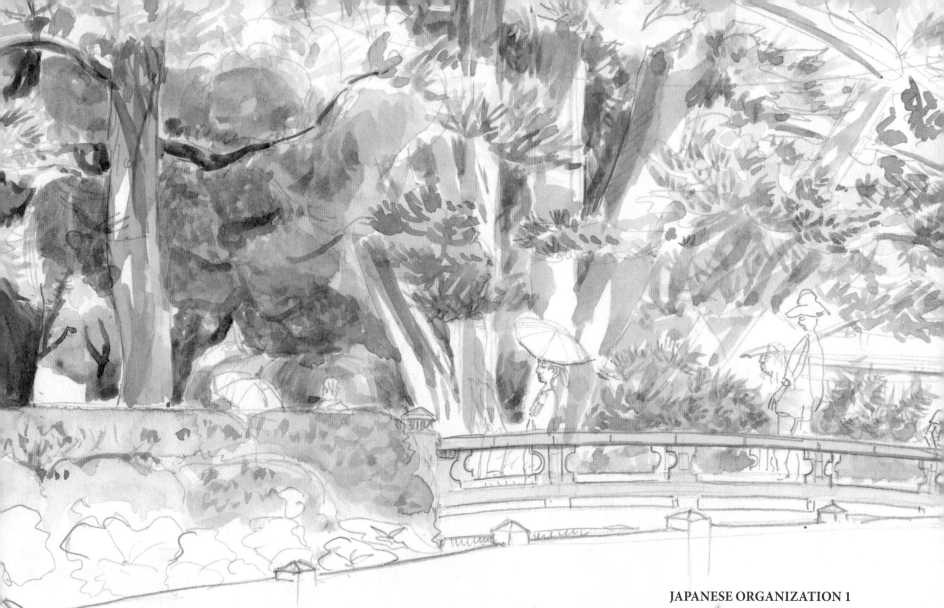

JAPANESE ORGANIZATION 1

Odawara marks the end of the long coastal strip of Sagami Bay. Between wavy lines in the foreground tiny people are busy crossing the blue ribbon of the Sakawa River like hardworking ants. Hiroshige seems to be having fun depicting with encyclopedic precision the ways of crossing a river. In the background we can make out Odawara Castle in the foothills of jagged mountains. The Tokaido is about to take a steep and difficult route up toward the resort town of Hakone.

The heat is stifling today and the air is clinging to my skin like a wet sheet. At Odawara Castle parking lot, I can at last take off my helmet and wipe my sweat-covered face. Out of nowhere appears a little lady with tight skin and a smile. Very kindly she has me park on a spot reserved for two wheels. "You have to pay the fee!" she says. I oblige, and in exchange get a few travel brochures. My backpack weighs heavily on my shoulders, could I perhaps leave it at the little office next to the vending machines? She refuses categorically even though she's still smiling. However, she invites me to follow her under the relentless sun. We go into the local tourist office. In the lobby are lockers with keys. Her face now exhibits a grave and solemn expression. "Free locker!" she repeats over and over while I stuff in my bag.

I bet that in her head she's probably complaining that it's hard to communicate with foreigners and that, no matter what you do, they fail to measure up to the Japanese way of organization, from which stems perfect social harmony.

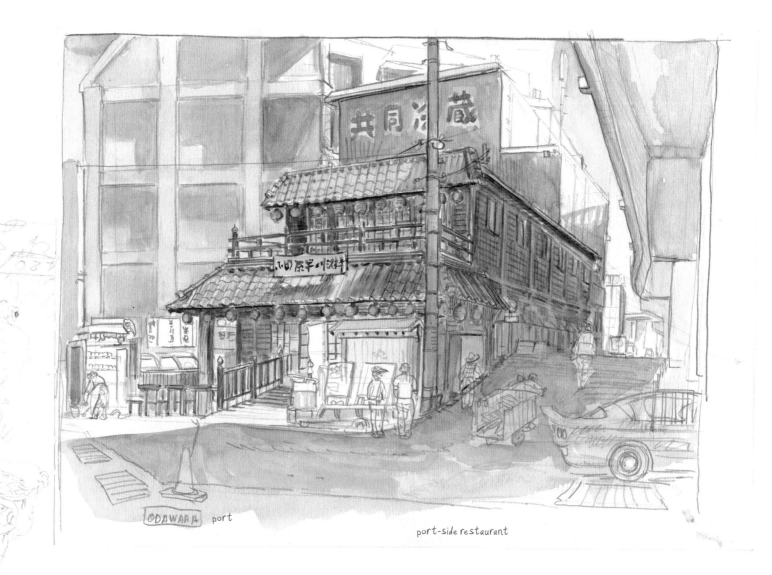

ODAWARA port

port-side restaurant

AN ACCIDENT ON POETS' AVENUE

The city map shows a small "Museum of Poetry." It is located on Poets' Avenue. Despite the rain, I decide to go on my scooter. The avenue is lined with cherry trees and the sidewalk is coated with gorgeous white pebbles. This is a marked contrast to the gray asphalt sidewalks of neighboring streets. But just when I'm about to brake at the stop sign, my scooter skids and ends up on its side in the middle of the road. Here I am, sliding down the road, weighed down on my back because of my bag, gesticulating with my limbs like a flipped turtle. It's not as bad as it seems and I get up, cursing the poets and their avenue. The scooter is dented and the right mirror has broken off. I'll have to get it fixed before I continue my journey.

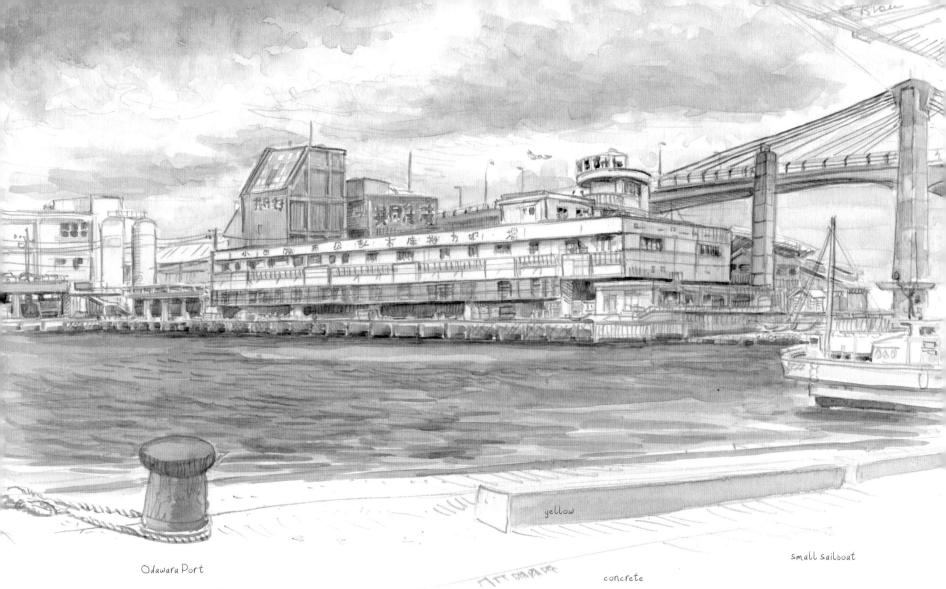

Odawara Port

yellow

concrete

small sailboat

JAPANESE ORGANIZATION 2

After fruitless hours of search, I finally spot a repair shop. Three men in greasy overalls are busy working on an old wreck in the twilight. I get out the broken mirror from my pocket and I explain why I'm here. One of the men gets it: he pulls out a tool and tries to unscrew the part of the broken mirror that remains on the bike. A bit of lubricant should do the trick. But no, the screw is rusty and won't budge. The man starts banging at the bike with a hammer and I can feel the color draining from my face. One of his colleagues comes up and scolds him: "You gotta fix it to a vise to get the screw out!" The guy obeys and finally manages to unscrew the remains of the mirror from the bike. He sticks his hand in a bucket full of junk and comes out with a mirror fixed with duct tape that he attaches to the handle.

As night falls, I am on the road again. The scooter purrs between my legs, the bike handle is responsive, and the replacement wing mirror rattles gently.

41

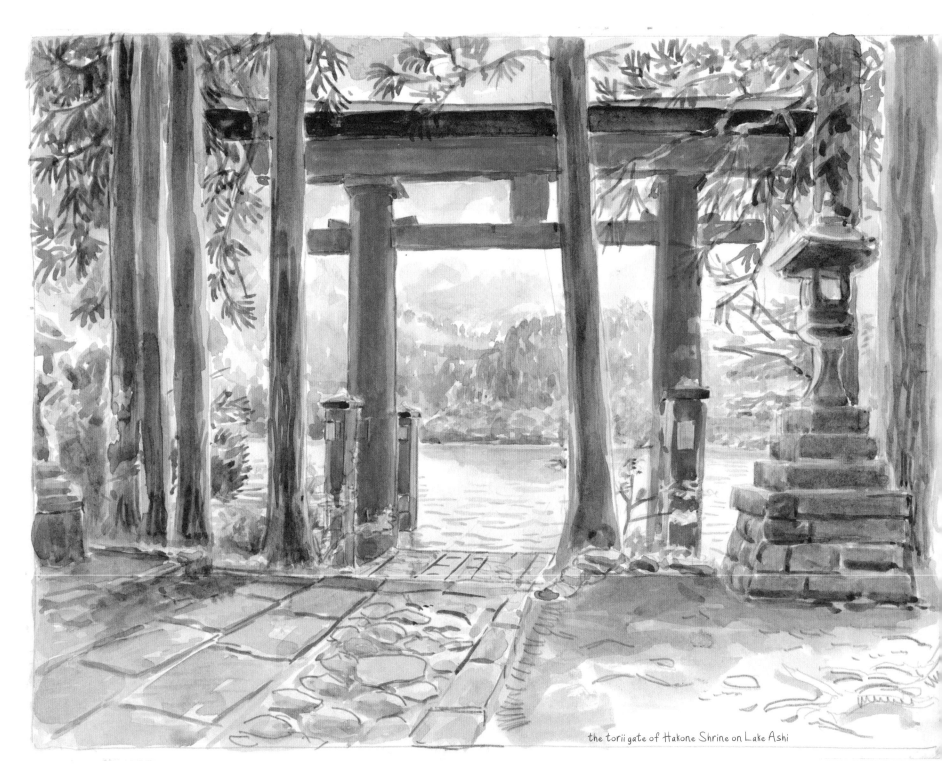

the torii gate of Hakone Shrine on Lake Ashi

Hakone
Where the Tokaido Touches the Clouds

The very bumpy old Tokaido crosses the road that slaloms all the way up to Hakone Pass. Higher up, the path of the old road follows the lake, beneath cedars more than three hundred years old. These huge trees would protect travelers from the heat of the sun or heavy snow.

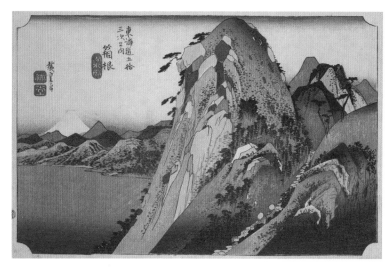

10th station: Hakone 箱根 湖水図 / 広重画

Hakone Pass was the biggest challenge of for travelers on the old Tokaido. A vertiginous mountain, abstract and unreal, juts above Lake Ashi and seems to want to escape from the frame. A procession of travelers, only hinted at by hats, files up the sloping path leading to the pass.

the old Tokaido crosses the road going up toward Hakone Pass

Hakone: the old Tokaido passes through the woods

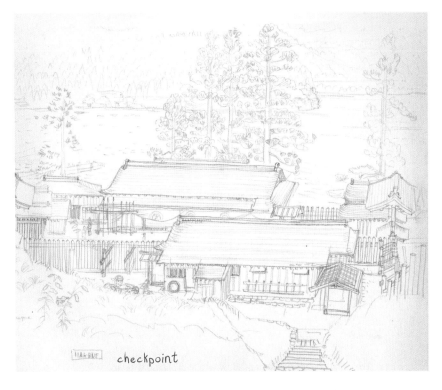

HAKONE checkpoint

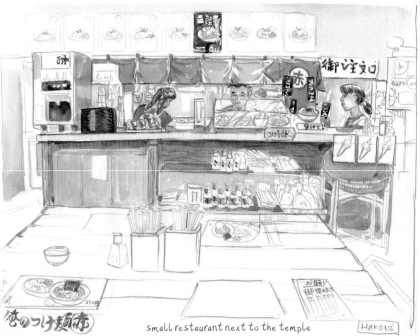

small restaurant next to the temple HAKONE

HAKONE, A RESTAURANT NEXT TO A TEMPLE

I spend the morning drawing in the rain. I go to the restaurant in the temple parking lot, behind rows of tourist buses, to warm up.

Their specialty? *Tsukemen*—a large bowl of noodles with a side of vegetable broth.

THE HAKONE CHECKPOINT

The building used for the Hakone checkpoint on the old Tokaido road has been rebuilt using traditional techniques from the Edo era: wooden construction without nails or screws; pieces fitting together with a clever mechanism of interlocking joints. Hakone was probably the most important of the checkpoints along the old Tokaido road. Placed strategically in the middle of the mountains, close to Edo, this checkpoint could control weapons being carried to the capital, as well as women on the run from forced marriages.

I climb the stairs to the observation tower at the top of a hill and I sketch the vista you can see at the top left of this page. From time to time, small patches of gaudy color appear between the cryptomeria branches. They are ridiculous boats that go back and forth between the banks of the lake. In my drawing, I purposefully omit these pompous replicas of pirate galleons escaped from an amusement park.

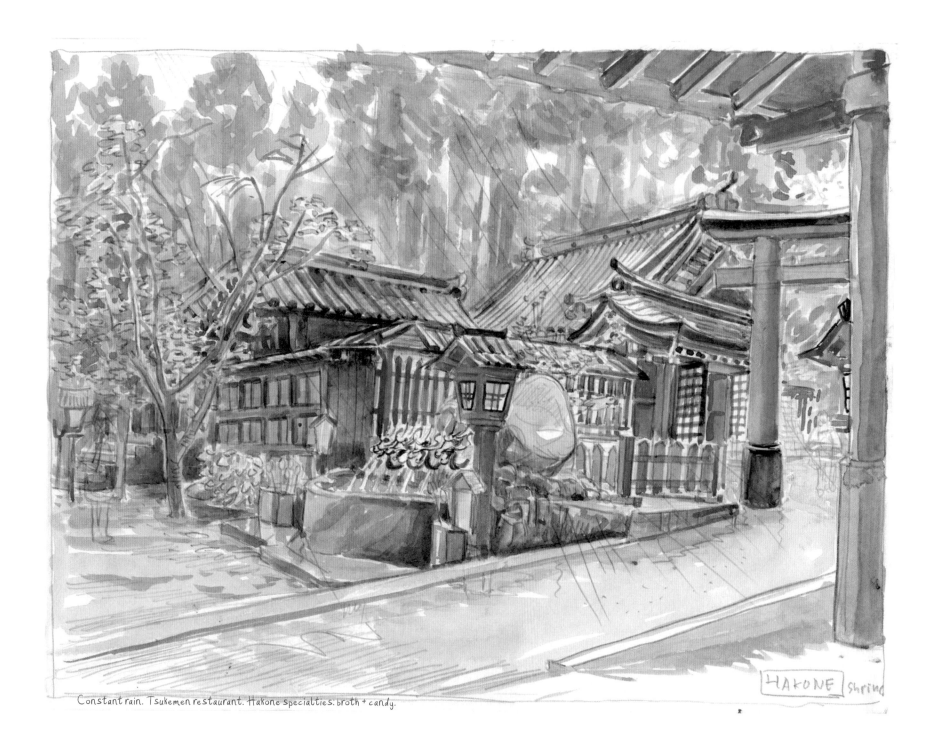

Constant rain. Tsukemen restaurant. Hakone specialties: broth + candy.

HAKONE shrine

Mishima

Broken Dishes in the River

The melancholy sound of a *koto* zither floats from a window and mingles with the pitter patter of raindrops. I have taken shelter under a large bronze bell, a symbol of the prosperity of this small city.

Mishima is crisscrossed by springs and streams coming down from Mount Fuji. In front of me, a man in boots and raincoat slowly wades through a river in the heavy rain, carrying tongs and a plastic bag. He is quick and precise, like a heron, pouncing on minute shards of broken crockery and picking them up them skillfully.

Later I would learn that a neighborhood association meticulously monitors the cleanliness of the Genbe River.

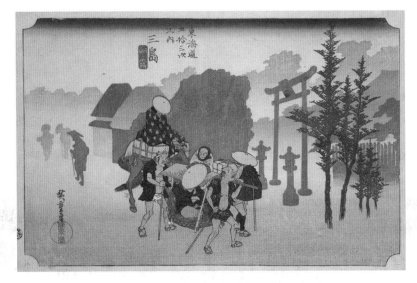

11th station: Mishima 三島 朝霧 / 広重画

Mountain fog has descended on the landscape. Among ghostly figures, an escort of vigorous porters carry their cold, sleeping passengers.

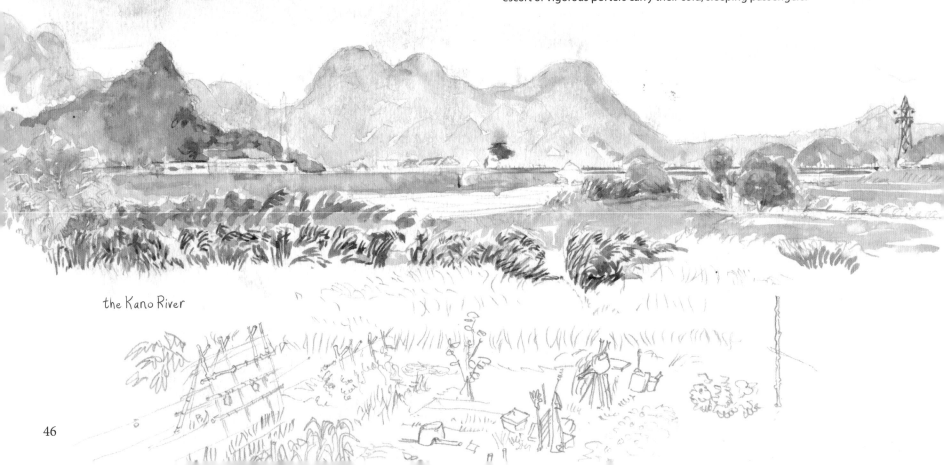

the Kano River

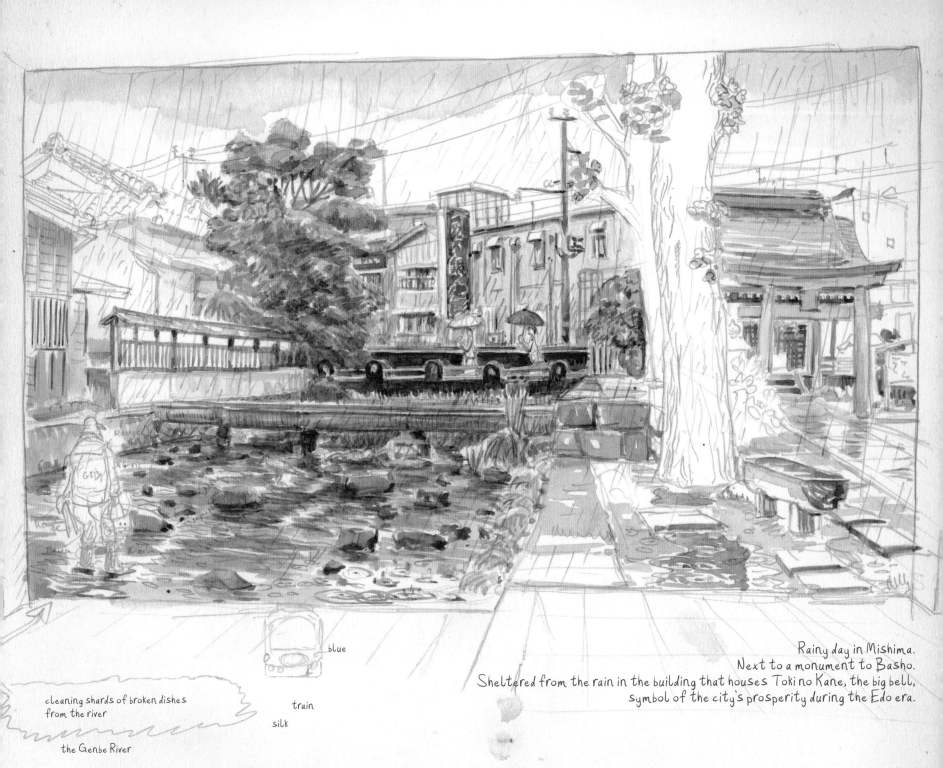

cleaning shards of broken dishes
from the river

blue

train

silk

the Genbe River

Rainy day in Mishima.
Next to a monument to Basho.
Sheltered from the rain in the building that houses Toki no Kane, the big bell,
symbol of the city's prosperity during the Edo era.

47

Numazu

More Fish!

NUMAZU FISH MARKET

Raw, dried, flaked, shaved, stringy, spiced, with soy sauce, with sesame seeds—you find all sorts of fish at Numazu fish market.

Fried, deep-fried or tempura-fried, you're bound to find something to your liking. I watch the passersby greedily eyeing the food stalls and I think of the thousands of nostrils and taste buds that have been drawn here by this culinary bounty.

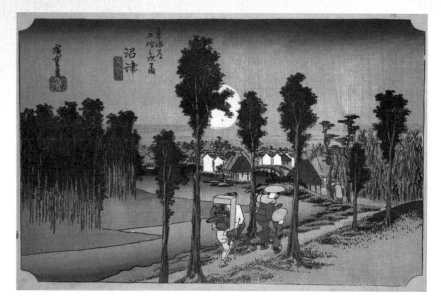

12th station: Numazu 沼津 黄昏図 / 広重画

It's twilight; shadows are slowly creeping across the land. Trees and thickets take on sinister inkblot shapes. Travelers hurry to reach the 12th station at Numazu, along a path lit by a rising full moon. A man carries a mask on this back that depicts a *tengu*, a cunning spirit that haunts forests.

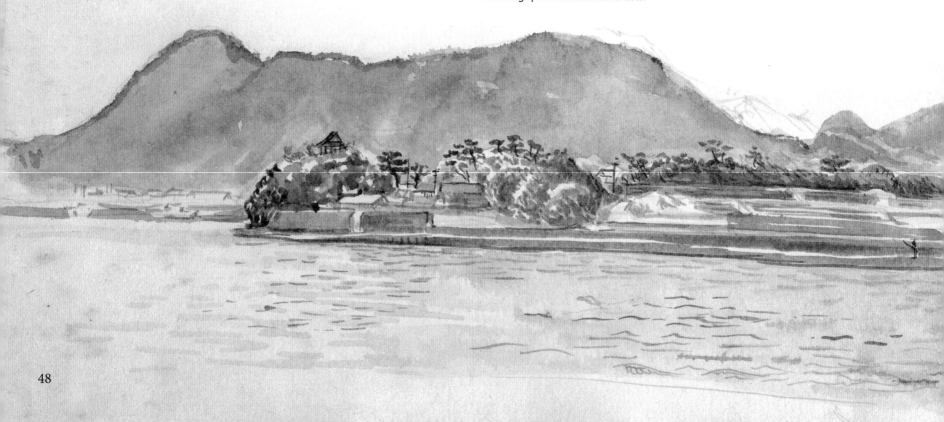

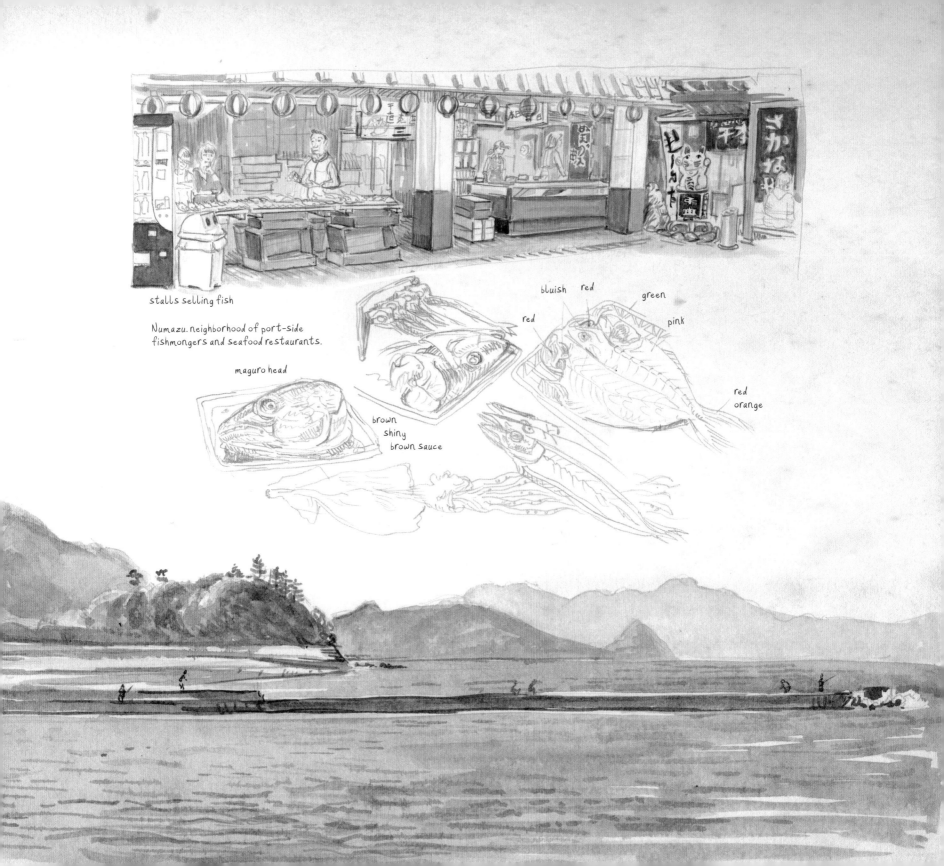

stalls selling fish

Numazu. neighborhood of port-side
fishmongers and seafood restaurants.

maguro head

brown
shiny
brown sauce

bluish red
red green
 pink

red
orange

Hara

More Pine Trees!

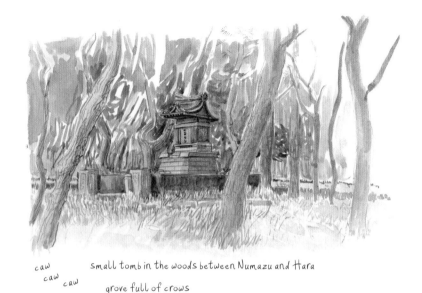

caw
caw
caw
small tomb in the woods between Numazu and Hara

grove full of crows

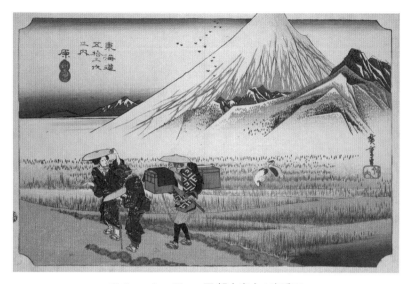

13th station: Hara 原 朝之富士 / 広重画

Mount Fuji in the morning. The station at Hara is famous for its view of Mount Fuji. The majestic volcano dominates the landscape and Hiroshige couldn't help but crop the summit from his design. Three travelers are trudging along the Tokaido seemingly oblivious to their gorgeous surroundings. One of the women seems to be asking her porter: "Is the next station very far?" Nearby, two storks survey the rice fields for food and a flock of birds disperses in the morning sky.

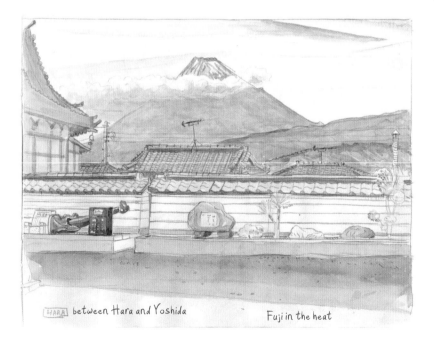

HARA between Hara and Yoshida Fuji in the heat

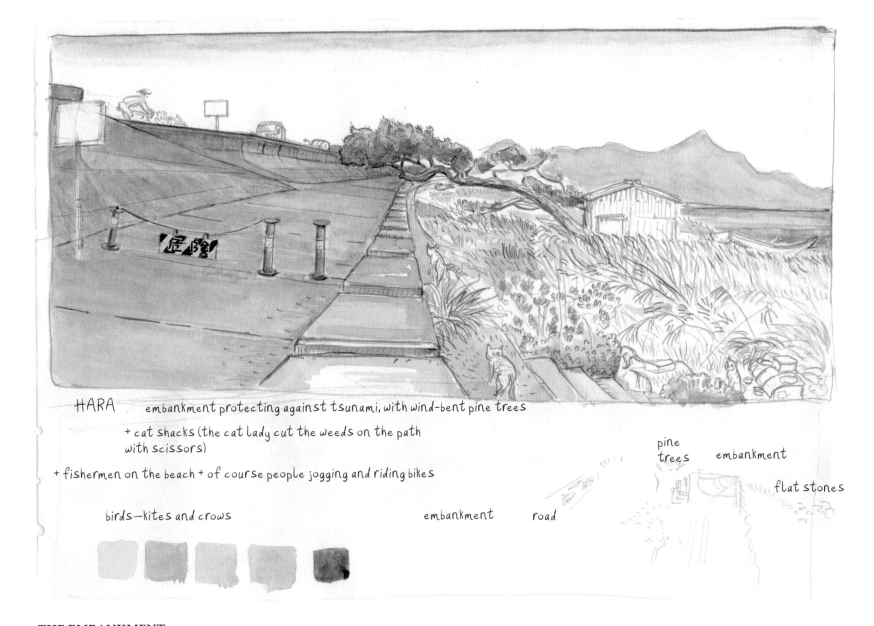

HARA embankment protecting against tsunami, with wind-bent pine trees

+ cat shacks (the cat lady cut the weeds on the path
with scissors)

+ fishermen on the beach + of course people jogging and riding bikes

pine
trees embankment

flat stones

birds—kites and crows embankment road

THE EMBANKMENT

I ride slowly along the high embankment that borders the beach between Numazu and the city of Fuji. I stop to look at a sign that gives instructions for what to do in case of a tsunami. A color-coded map indicates areas at risk of flooding and numbers indicate shelters or evacuation zones. But the explanations are in Japanese; only a single sentence is in English: "In case of earthquake, move to higher ground." To one side of the embankment there's a long strip of pine trees, hiding my view of Mount Fuji.

On the beach, cats shelter in the tall grass that covers the sand. A woman cuts her way through the grass with scissors. Boxes for the cats to live in have been placed within the thicket. She distributes food and water to her brood and then walks up the beach talking to herself.

Evening is coming; I pass joggers, cyclists, then fishermen with their gear heading to the water's edge to try their luck at night fishing. I hang my hammock in a grove of beachside pines, whose trunks have been bent by the sea wind.

Yoshiwara

Baby Sardine Tasting at the Foot Of Mount Fuji

The 14th station at Yoshiwara has now vanished, assimilated into the city of Fuji. Only the train station, close to the port, has kept its name. From the port, Mount Fuji has disappeared beneath the heat haze. The early morning fish market takes place in a hangar. But at 10 a.m., it's all change! The floor is sluiced with water, tables are set, deep pans of oil are set up, and soon the aroma of broth fills the air. The place has metamorphosed into a cantina-like restaurant. I order the specialty, *nama chirasu don*: a portion of raw sardine fingerlings on a bowl of white rice. Wasabi, chives and a bit of soy sauce vamp up the somewhat bland taste, and there is also of course the inevitable miso soup.

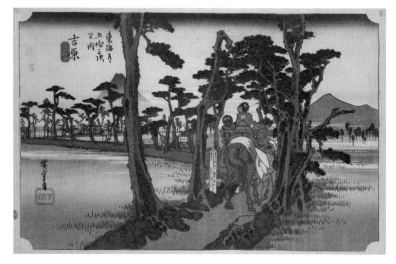

14th station: *Yoshiwara* 吉原 左富士 / 広重画

A path flanked by pine trees zigzags between rice fields. Three children nod their heads on a harnessed horse, its hooves clad with rope sandals.

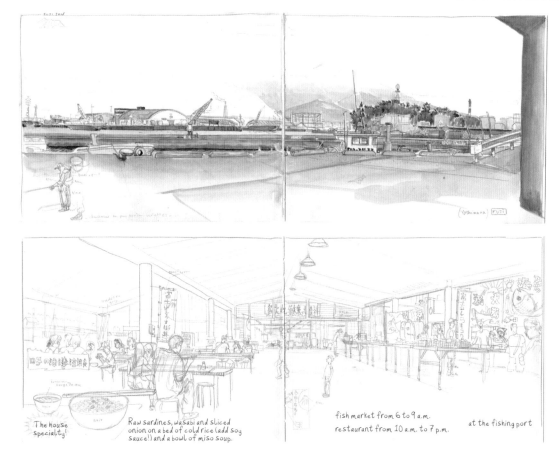

The house specialty!

Raw sardines, wasabi and sliced onion on a bed of cold rice (add soy sauce!) and a bowl of miso soup.

fish market from 6 to 9 a.m.
restaurant from 10 a.m. to 7 p.m.

at the fishing port

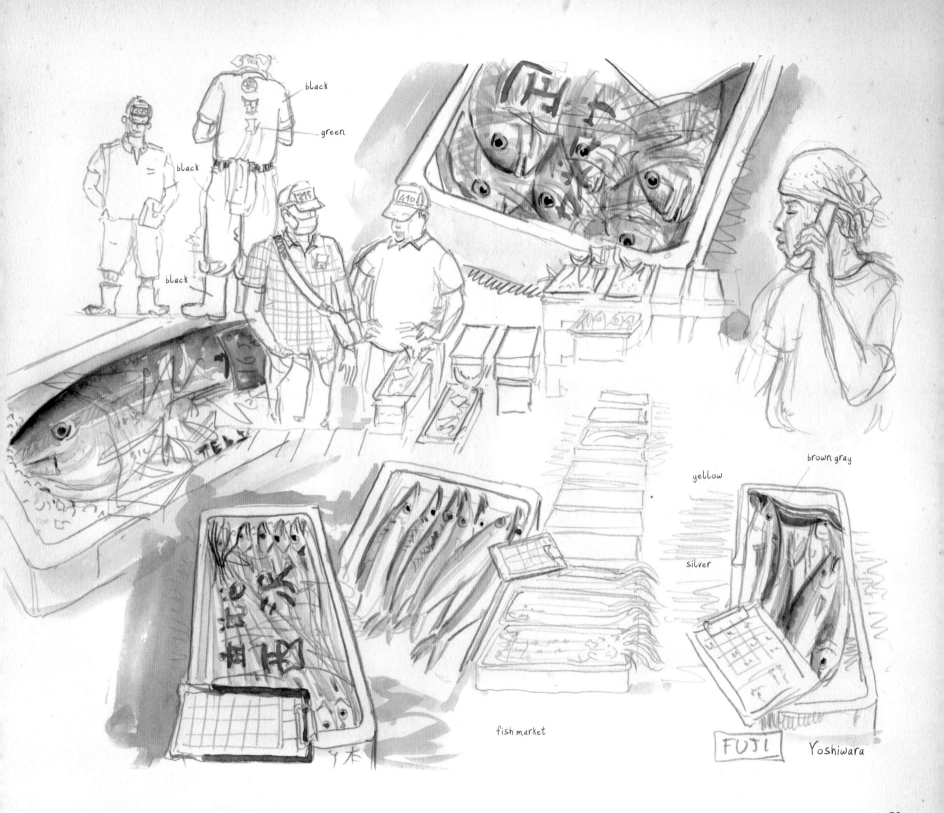

black

green

black

black

brown gray

yellow

silver

fish market

FUJI Yoshiwara

53

Kambara

Orange Trees in the Snow

KAMBARA SEEN FROM ABOVE

I am sitting on the steps that go up to the entrance of a temple. Two young girls watch me draw. From here, I can see the sea, bordered by a line of houses and the pillars of the Tomei Expressway.

A couple of teenage girls appear, dressed in magnificent kimonos. They're going to see the Shizuoka fireworks.

"Do you live here?" I ask them, unsure of whether I'm on private property. "I thought this was a temple."

"Yes, this is my house," answers one of them. "The monk in charge of this temple is my father."

I'm surprised, but there are so many temples, you need to make a few concessions to the rule of celibacy rather than leave them to rot. Monks are authorized to marry; this seems to me a wise and practical decision.

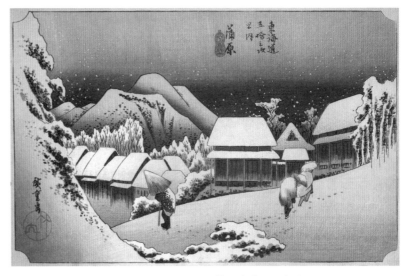

15th station: Kambara 蒲原 夜之雪 / 広重画

A snowy night in Kambara. This is one of the most popular prints in the Tokaido series. An abundant snowfall has accumulated on rooftops and it seems that only the crunch of footsteps in the snow disturbs the deep silence. But this vision of Kambara in the snow is not very realistic. In fact, the region is famous for its temperate climate and the slopes of the mountains going down toward the sea are planted with orange trees.

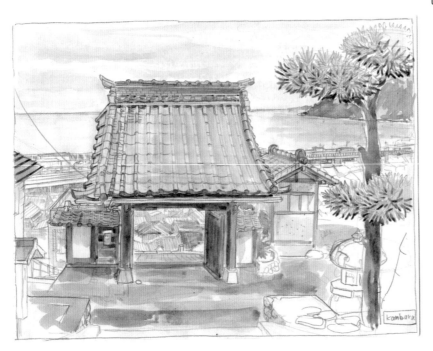

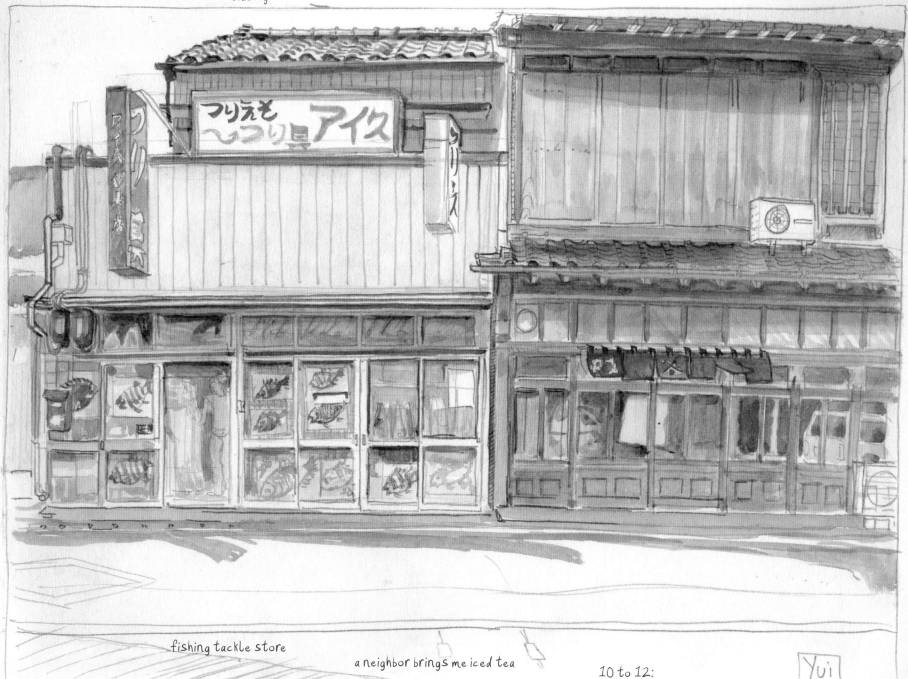

blue sky

つりえそ
つり具 アイス

つりえそ
鈴木店

つりえそ

fishing tackle store

a neighbor brings me iced tea

10 to 12:
no one in the street—it's too hot

SHADOW

Yui

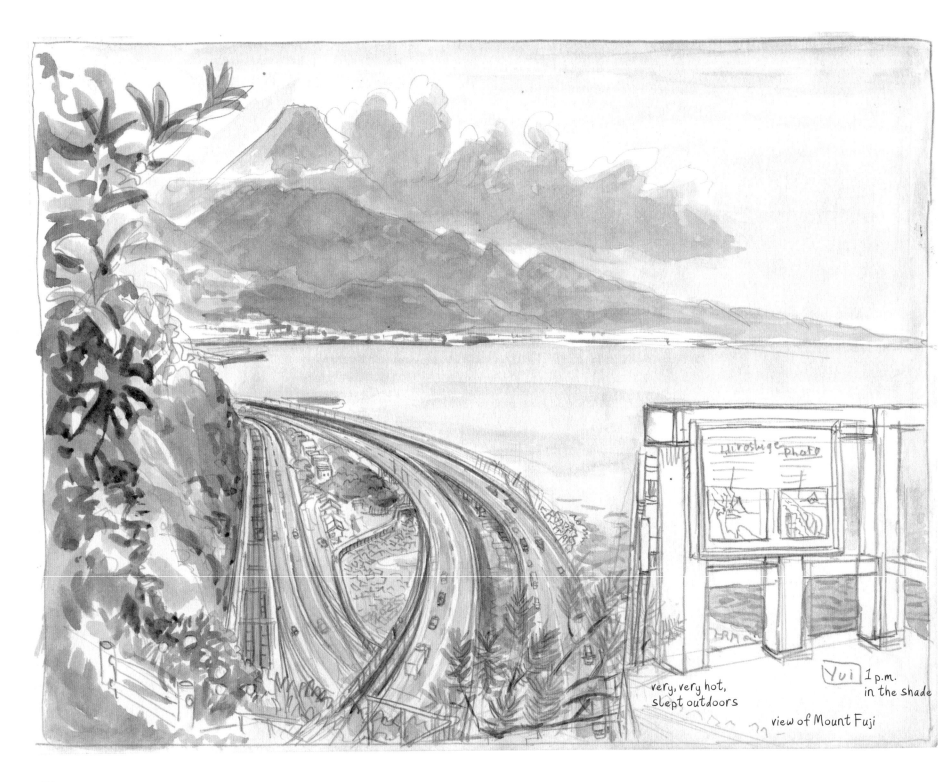

Hiroshige photo

very, very hot,
slept outdoors

Yui 1 p.m.
in the shade

view of Mount Fuji

Yui

Shrimp Capital of the World

MOUNT FUJI SEEN FROM SATA PASS

A wooden viewing platform has been set up in the town of Yui to let hikers and lovers of the old Tokaido road admire the view immortalized by Hiroshige. Two frames affixed to the railing feature a reproduction of the woodblock print and, more surprisingly, a photo of the actual view. Should one prefer the photo to the original? Perhaps it was there for those days when Fuji is obscured by a veil of cloud. But today, rest assured, Fuji-san is here, dominating the area with its imposing stature. The air might be less clear, the sea less blue, the pine trees less twisted and the rocks less steep than in Hiroshige's day, but more than anything it's the relentless hum of the vehicles below that makes you nostalgic for times gone by. Railway, freeway and highway now make up this stretch of the Tokaido.

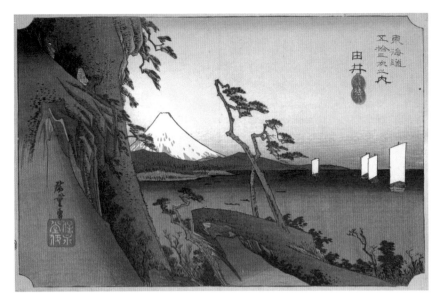

16th station: Yui 由井 薩埵嶺 / 広重画

The Sata Pass. A steep path winds up around the mountain and offers a magnificent view of Suruga Bay and Mount Fuji. On top of a cliff, two tiny people wearing travelers' clothes admire the panorama. A third man's back is bent under the weight of the load that he carries as he climbs. He seems not to care about the beauty of the landscape.

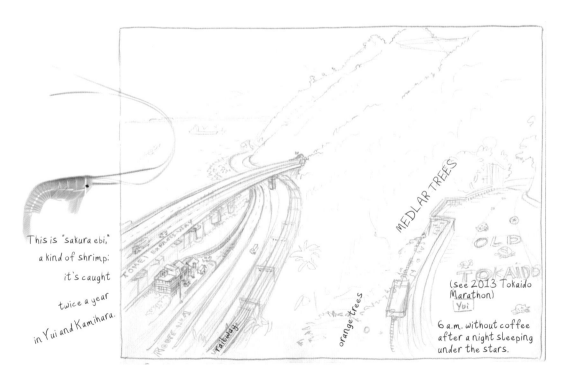

This is "sakura ebi," a kind of shrimp: it's caught twice a year in Yui and Kamihara.

MEDLAR TREES

OLD TOKAIDO

(see 2013 Tokaido Marathon)

Yui

6 a.m. without coffee after a night sleeping under the stars.

orange trees

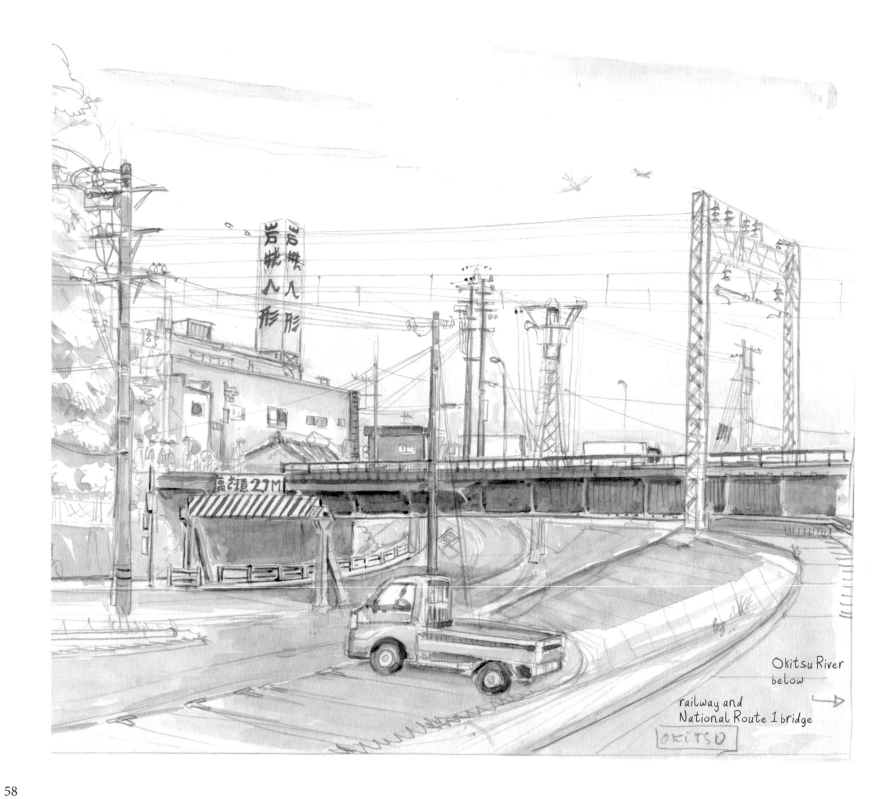

Okitsu River
below
→

railway and
National Route 1 bridge

OKITSU

Okitsu

At the Mouth of the Okitsu River

THE TOKAIDO LINE RAILWAY BRIDGE

Today, a railway bridge and a road bridge span the river. On the Tokaido main line, a troop of railway workers have started construction repairs. Men with yellow helmets lean on the gravel and two men with white helmets keep an eye out for oncoming trains, announcing their approach with a megaphone. At the sound of the megaphone announcement, everyone leaves the tracks in an orderly fashion. Once the train has passed, everyone goes back to their post.

THE BLUE BRIDGE

Under the blue bridge that is part of National Route 1, it looks like a group of homeless people have made a precarious refuge. There are rudimentary huts made of planks covered with tarps, battered armchairs, remnants of a fire and blackened pans, and laundry left to dry on a line.

Now the sun is at its zenith and the pages of my notebook are blindingly white. The completion of my watercolor painting is anything but certain.

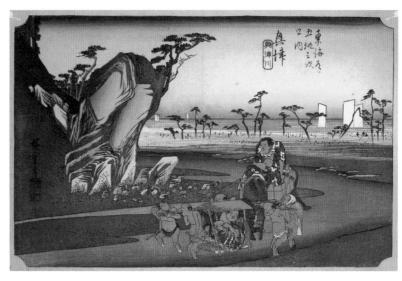

17th station: Okitsu 興津 興津川 / 広重画

Crossing the Okitsu River. After the steep Sata Pass, those two sumo wrestlers must weigh heavily on the porters' shoulders and on the horse's legs. And now, there's still the Okitsu River to ford! Far from the sand of the sumo ring, the fat men seem out of their element. The first one bends down from the palanquin to check the water level. The second one, immobile on his mount, dares not make a movement that would destabilize her.

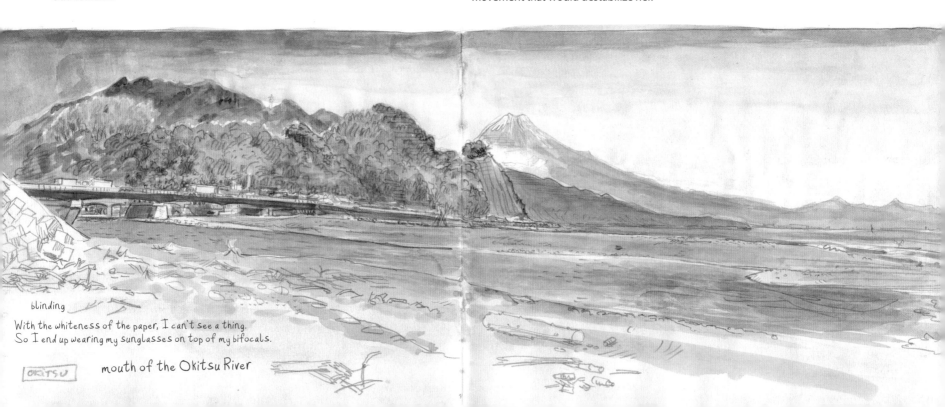

blinding
With the whiteness of the paper, I can't see a thing.
So I end up wearing my sunglasses on top of my bifocals.

OKITSU mouth of the Okitsu River

Ejiri

Shimizu Port View

EJIRI PORT AND MIHO PENINSULA

Nowadays, this neighborhood is called Shimizu, a district of the city of Shizuoka. Only the port has kept the name of the ancient town of Ejiri that was the 18th station of the Tokaido.

I take a steep and narrow path leading away from the main road. My scooter struggles to climb this road as it zigzags between orange groves.

But my tenacity has finally led me to an open vista, where I'm delighted to find that the topography of the panorama is almost identical to the view on Hiroshige's print.

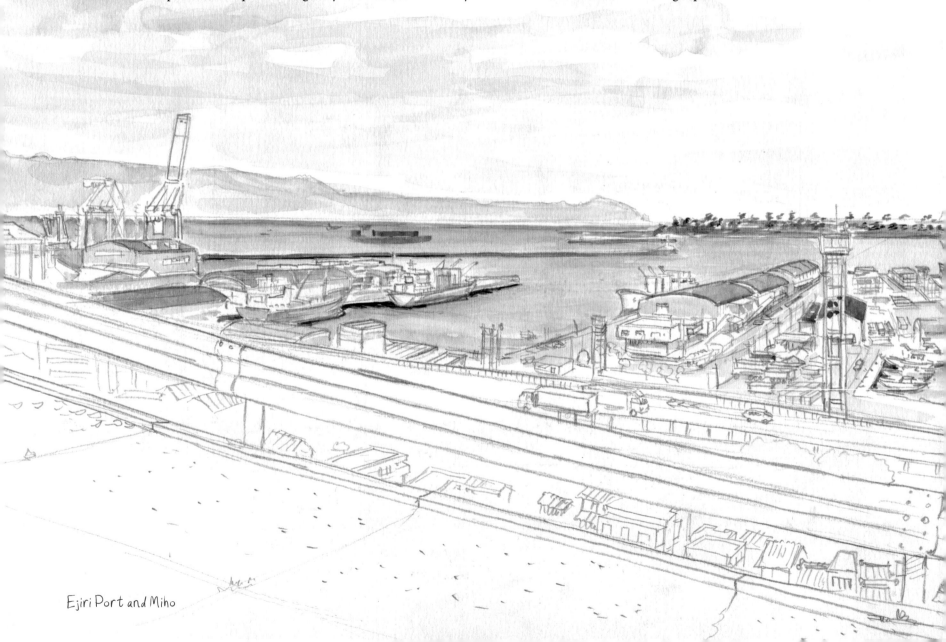

Ejiri Port and Miho

The "Miho no Matsubara" Print, with a view of the distant Miho pine grove. This topographical view shows Ejiri Port in the foreground then the scenic spot Miho no Matsubara with its famous pine trees. The mountains of the Izu Peninsula stretch away in the background. The sea is dotted with white sails and the number of docked ships gives an indication as to the town's prosperity at the time. The shaded color at the top and bottom of this print give depth to an otherwise minimalist depiction.

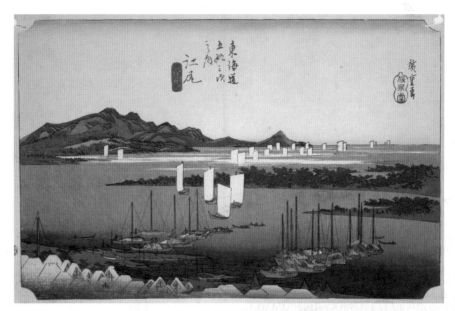

18th station: Ejiri 江尻 三保遠望 / 広重画

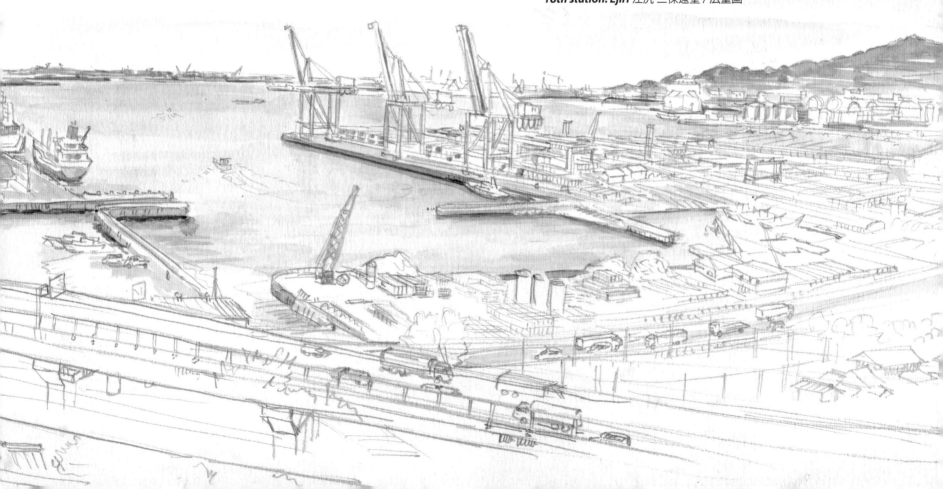

Miho no Matsubara

One of Japan's Most Beautiful Views

Miho no Matsubara is considered one of the most beautiful views in modern Japan. And so, on this beautiful May Sunday, many families have succumbed to the desire to immerse themselves in this picture-postcard landscape. Even though the white-sand beach disappeared during the construction of the *shinkansen* bullet-train railway line, you can still admire Mount Fuji, majestically towering over Suruga Bay, whose ultramarine waters are emphasized by the crooked shapes of the centenarian pines. Don't you think though, that these "most beautiful views" are sometimes too perfect, to the point where you can't really see the beauty any more? To be honest, I'd rather accidentally find a crumbling ruin hidden in a bamboo thicket that I can look at free from any preconceptions.

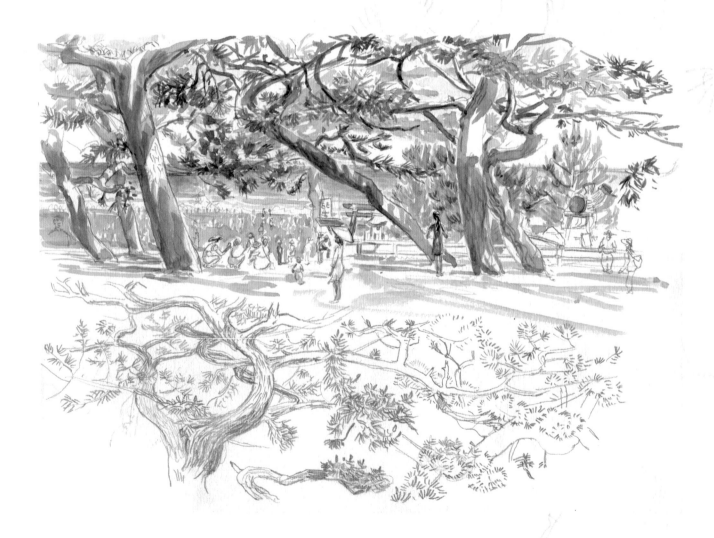

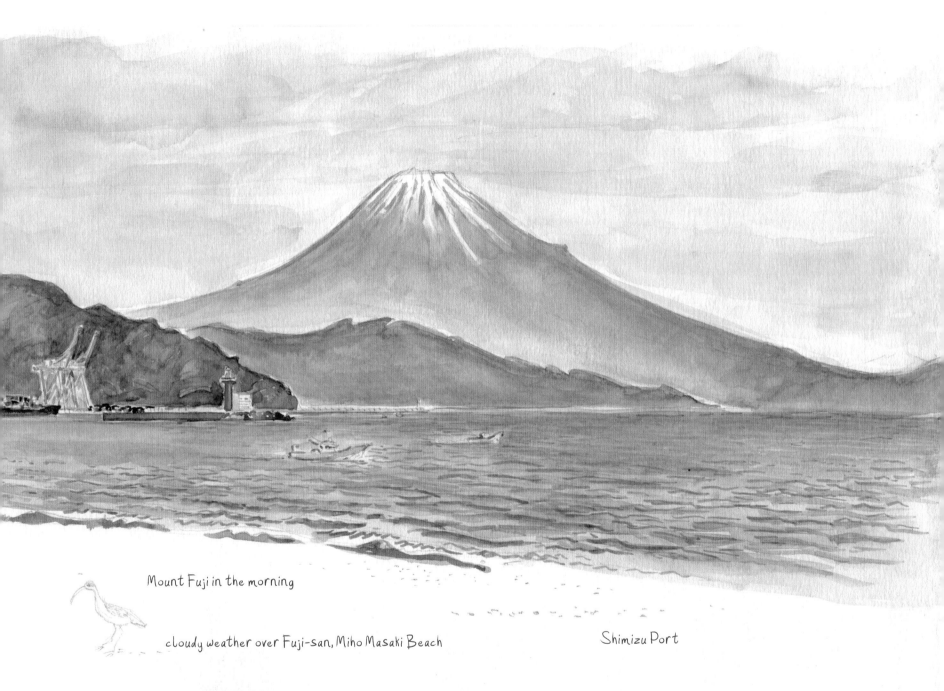

Mount Fuji in the morning

cloudy weather over Fuji-san, Miho Masaki Beach

Shimizu Port

MOUNT FUJI FROM MIHO MASAKI BEACH

At daybreak, I wake up on Miho Masaki Beach. Already a few boats are sailing away toward the high seas. The cone of Mount Fuji dominates the landscape; a majestic, early-morning salute.

Fuchu

A Game of Gateball on the Riverbank

ON THE BANKS OF THE ABE RIVER, SHIZUOKA

It is said that Mount Fuji is home to almost as many divinities as Mount Olympus in Greece. As I watch a group of retirees enter into a competitive game of the croquet-like sport called gateball on this bright and sunny early morning, I can't help but wonder what the watching gods are making of this scene!

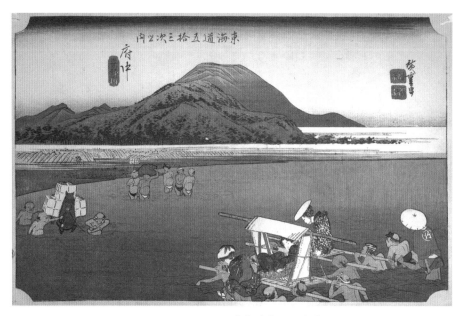

19th station: Fuchu 府中 安部川 / 広重画

River crossings were strictly regulated during the Edo period. Travelers had to enlist watermen who knew the fords. Their rates varied according to the water level but also depending on a customer's status. This print shows travelers crossing the Abe River. A perhaps less-wealthy man and woman cross the river perched on watermen's shoulders. Another woman crosses on a "tray" held by four men, while a high-class passenger stays in his palanquin.

Let's hope these travelers were not cheated like our buddies Kitahachi and Yajirobei! They had to pay sixty-four *mon* for a deep-water crossing, perched perilously on the shoulders of a strong waterman. Once on the other side, our poor travelers noticed, to their chagrin, that the waterman crossed back to the other side by a place in the river where the water was only ankle deep . . . They wrote down this little poem on the spot:

"High upon the shoulders
of a waterman,
a cheating lad,
we rode in high waters,
and were scammed in the end."

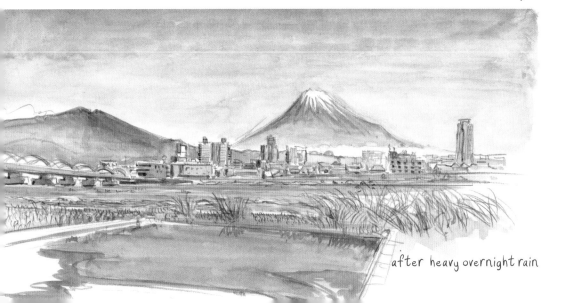

after heavy overnight rain

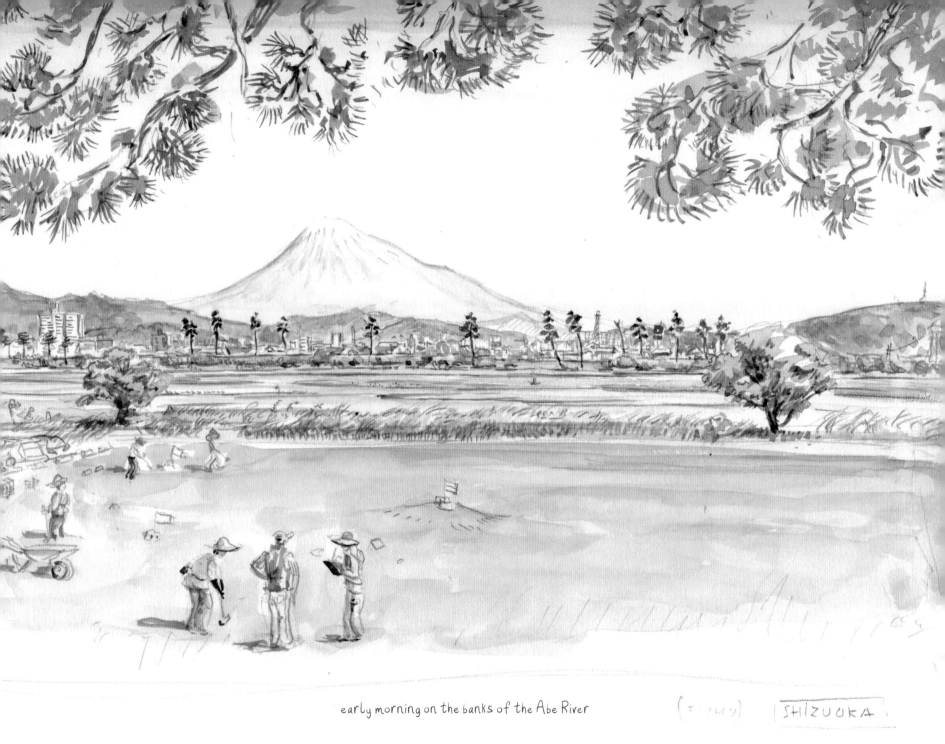

early morning on the banks of the Abe River (あべ川) SHIZUOKA

Mariko

Tororo-jiru Mountain Yam Paste

MARIKO, CHOJIYA INN

I don't know much about this old straw-roofed building I've drawn, except that it must be a restaurant, judging from the satisfied faces of the people coming out. I queue up, and when it's my turn, I push aside a curtain to find myself in a cavernous place, where I'm immediately escorted by diligent and affable staff toward a large room with tatami-mat flooring and prints of Hiroshige's fifty-three stations on the walls.

The local specialty arrives at the table, accompanied by soba noodles. From the steaming, fragrant bowl, a yellow paste that looks like melted cheese beckons. It's grated mountain yam paste. The famous *tororo-jiru!*

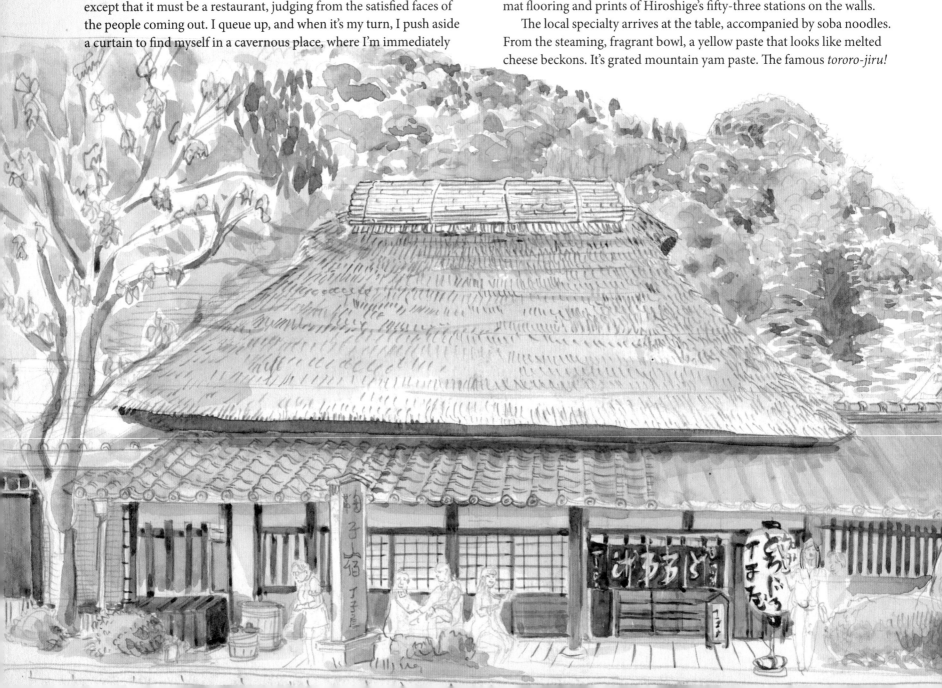

Tororo-jiru is good for your health! Two travelers sit on a bench voraciously eating their bowls of *tororo-jiru*—grated wild yam on a bed of rice. Tokaido travelers were fond of this dish, which gave them the strength they needed to continue their journey. "What if we stopped here to eat?" suggests Kitahachi. "I've heard they make that wild yam gooey paste !"

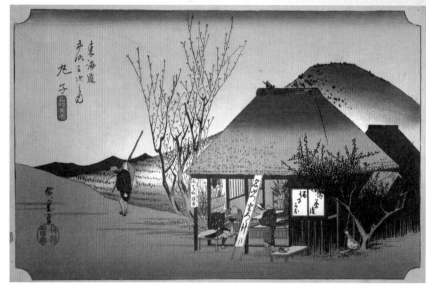

20th station: Mariko 鞠子 名物茶店 / 広重画

とろろじる

丁子屋

東海道　鞠子宿

とろろ（自然薯）一口ばなし
お米や麦の澱粉はベータ型。だから生ではまずく
て食べられない。しかし、炊くとアルファ型になり、
生でアルファ型のとろろ汁にピッタリ合って
美味しい。

土壌作家　農学博士　松尾喜郎

67

Okabe

Steel Calves and Luxurious Palanquins

Leaving aside the main artery, a little road zigzags up the mountain and ends at the entrance to a tunnel. The tunnel was built in the Meiji era (1868–1912) and allows access to the other side of the mountain without having to trek up the long pass. The place is deserted. The thick forest is pierced by bird song and buzzing insects. I can hear a woodpecker knocking on wood with a "tock tock crook," and the "hoo kokeyo" of the Japanese bush warbler.

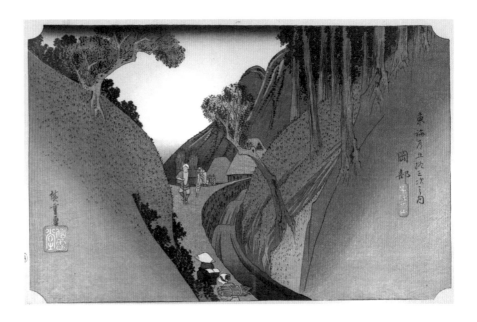

21st station: Okabe 岡部 宇津之山 / 広重画

Utsunoya Pass, and an old tunnel through the forest. The road climbs steeply in order to reach Okabe. It goes through mountains blanketed in dark forest at Utsunoya Pass. Porters of luggage and palanquins need great physical strength for this part of the route. As for our buddies Kitahachi and Yajirobei, their feet are covered with blisters. They are so happy when they finally reach the inn, they break into a little poem:

> "White as tofu
> we reached the inn.
> Beans covering
> too much of our feet
> will burst under our fingers."

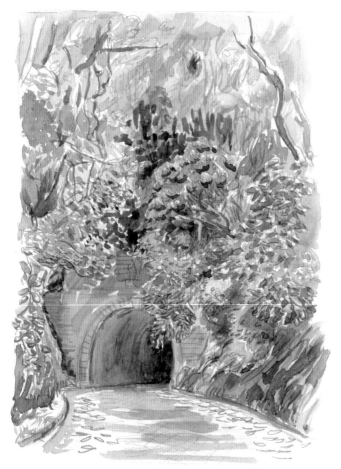

Meiji era tunnel Okabe side

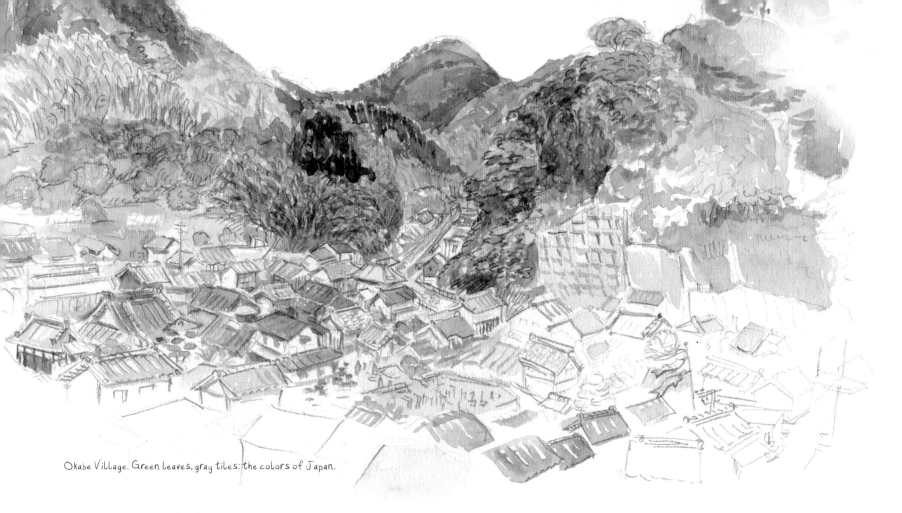

Okabe Village. Green leaves, gray tiles: the colors of Japan.

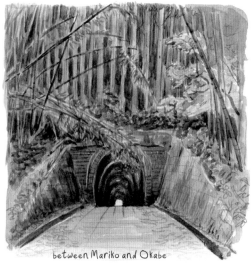

between Mariko and Okabe

Mariko side

Kashibaya Inn Museum, Okabe.
O-kago, daimyo palanquin.

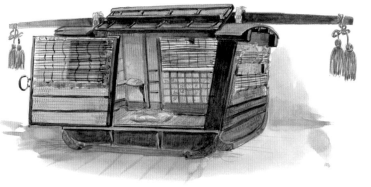

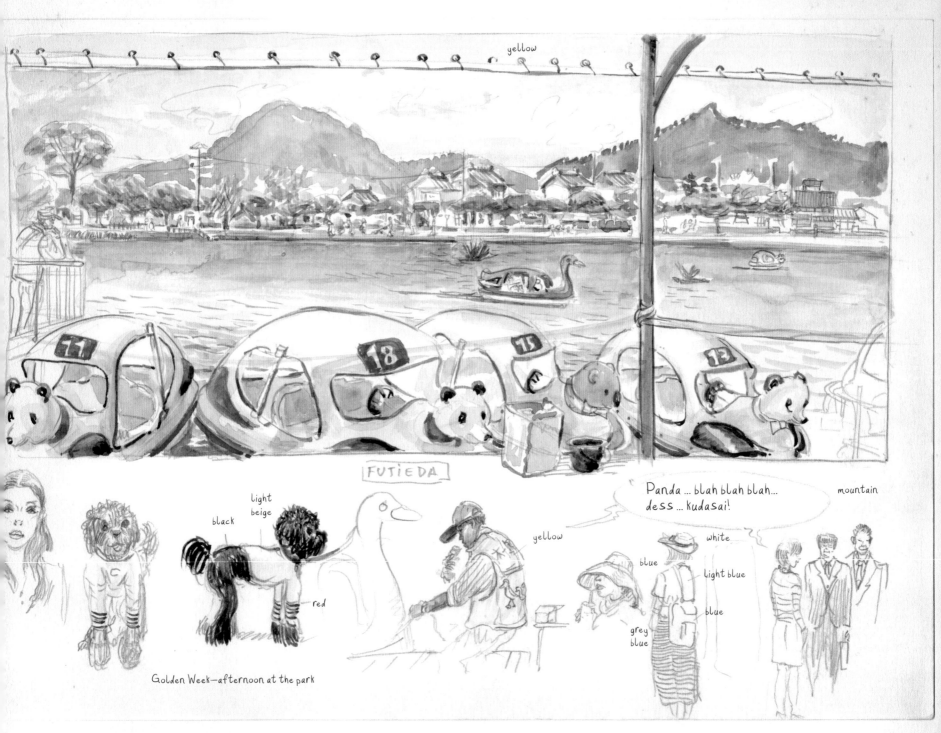

Golden Week—afternoon at the park

Fujieda, a day off in the wisteria park.

Fujieda

A Sunday Picnic by the River

On a Sunday afternoon in Fujieda, the riverbanks are crowded with picnickers. In the wisteria park people are strolling with their dogs, and queuing to ride on boats whose prows are shaped to resemble pandas and koalas.

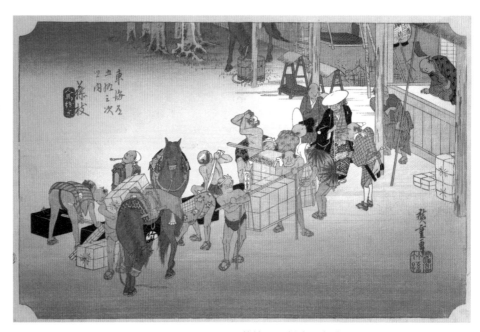

22nd station: Fujieda 藤枝 人馬継立 / 広重画

A change of porters and horses at the Fujieda Inn. The porters who have made the journey here from Okabe pass their load to the porters at the Fujieda Inn, in a scene not devoid of humor. Two strong porters weigh their load with sad faces. Horse grooms are busy around the horses, unloading the trunks and checking the horses' hooves. A porter bends down to lift his load, showing off his *fundoshi* loincloth immodestly. Next to him, a pipe smoker takes a break, with an enigmatic smile. A man wipes off his sweaty back while another adjusts his *hachimaki* headband. From his platform, the accountant checks the ledgers.

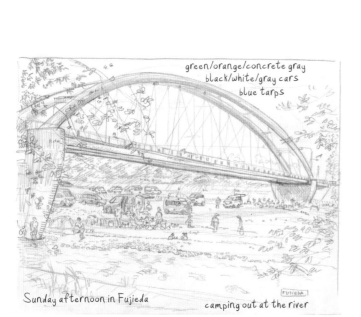

green/orange/concrete gray
black/white/gray cars
blue tarps

Sunday afternoon in Fujieda

camping out at the river

FUJIEDA

Fujieda, picnic by the river.
BBQ, six packs and napping: universally shared values.

Shimada

A Treacherous River Crossing

When relentless rains made the Oi River swell, it was impossible to cross it. Travelers had to wait sometimes several days in Shimada inns, thereby providing the city with considerable income. Even though building a bridge or a ford would have been a solution, the Tokugawa shogunate forbid its construction, fearing the ease of passage for enemy armies.

Hiroshige shows the congestion near the river that can finally be crossed after long rainy days.

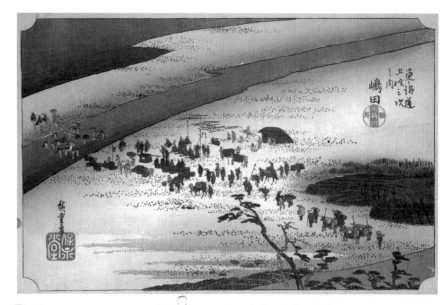

23rd station: Shimada 嶋田 大井川駿岸 / 広重画

THE WATERMAN'S SONG
Heave ho!
From the hills of Hakone,
Heave ho!
Eight leagues
Even a horse can make it
But gotta get up early
Heave away, heave away!
To cross the Oi River
Heave away, heave away!

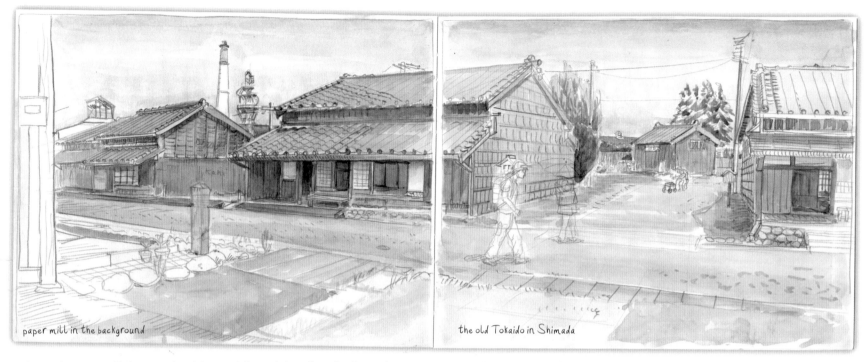

paper mill in the background

the old Tokaido in Shimada

In front of a paper mill chimney, the old inns of Shimada line the Tokaido road.

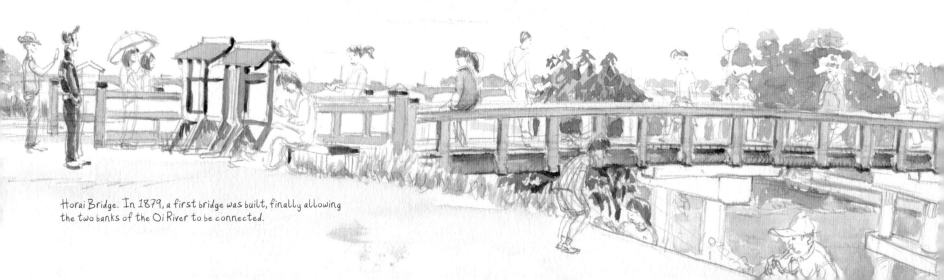

Horai Bridge. In 1879, a first bridge was built, finally allowing
the two banks of the Oi River to be connected.

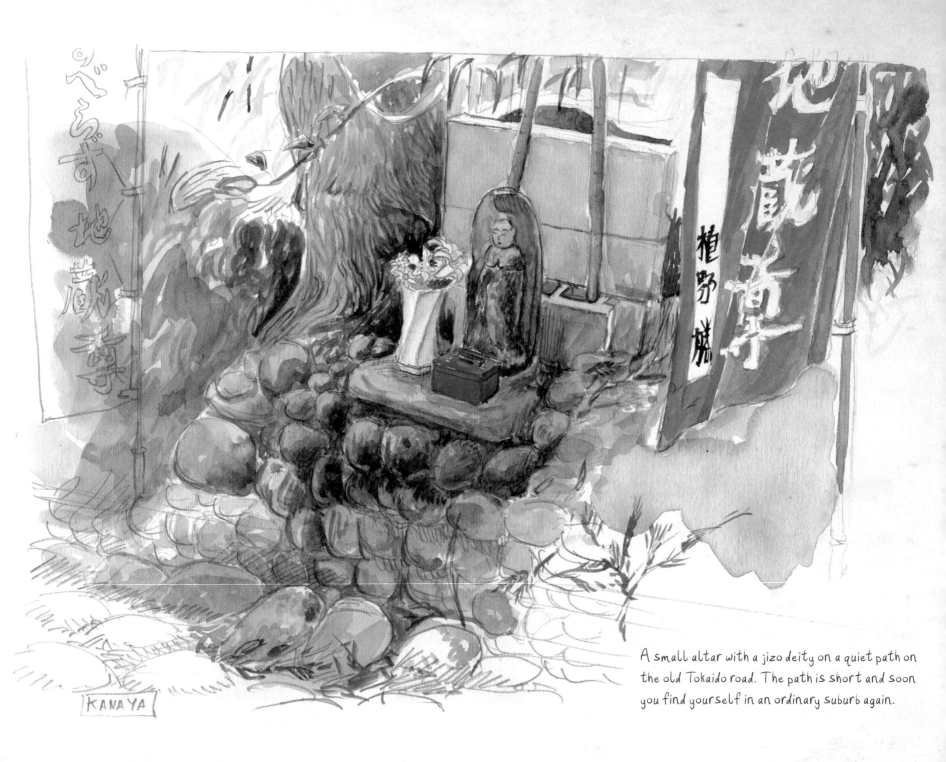

A small altar with a jizo deity on a quiet path on the old Tokaido road. The path is short and soon you find yourself in an ordinary suburb again.

KANAYA

74

Kanaya

In the Footsteps of Kitahachi and Yajirobei

A JIZO DEITY STANDS GUARD

On this rocky and shaded path, you could almost believe yourself to be walking in the footsteps of Kitahachi and Yajirobei, straight to the heart of an ancient forest. But the big cobblestones, polished by the rubbing of thousands of straw sandals, soon give way to gray asphalt leading to suburban neighborhoods.

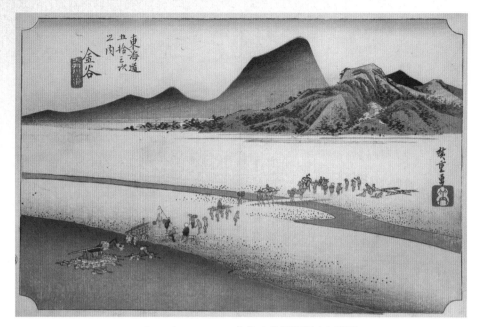

24th station: Kanaya 金谷 大井川遠岸 / 広重画

The procession of watermen and travelers has finally crossed the Oi River. In this print, you can just about see the village of Kanaya nestled between the hills.

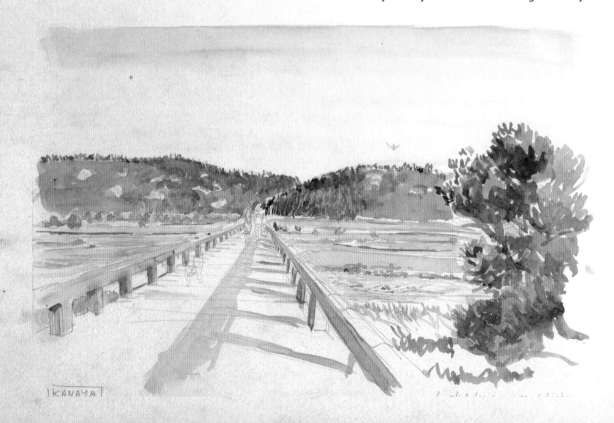

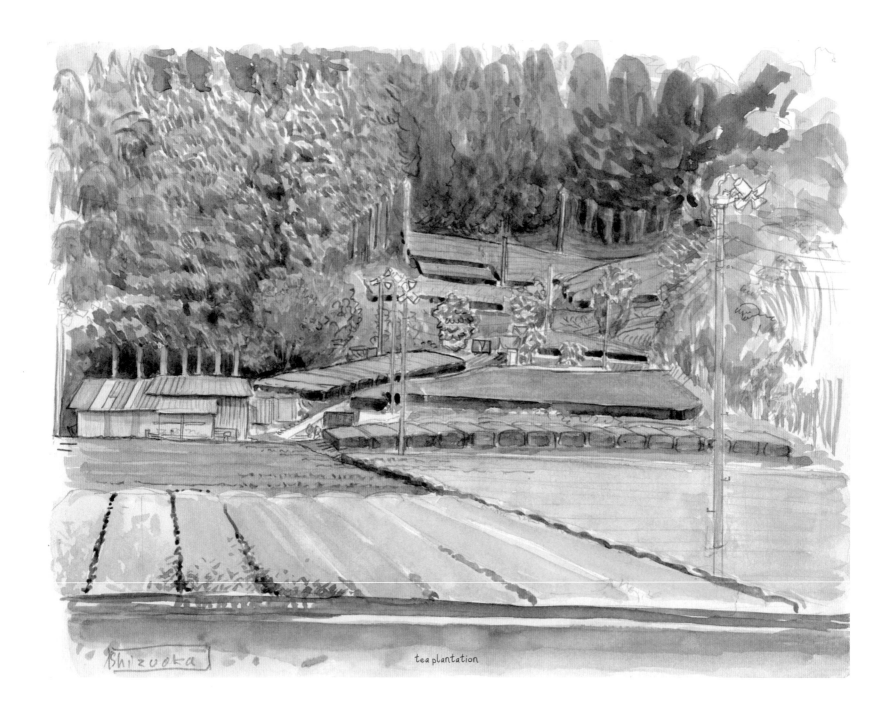

Shizuoka

tea plantation

Nissaka

Shizuoka's Green Gold

I wander along the small roads that meander between hills and valleys, forested groves and tea plantations. The region's agriculture is centered on the production of green tea. At the mountain peak, topiary bushes spell out the kanji characters for "tea."

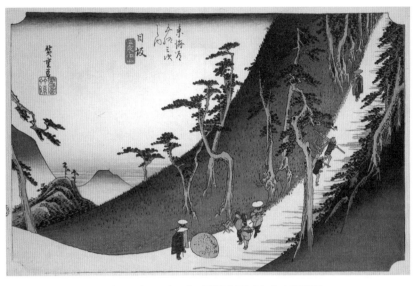

25th station: Nissaka 日坂 佐夜ノ中山 / 広重画

The path goes up the side of the mountain at an extremely sharp gradient and ends at Sayo no Nakayama Pass. A few travelers linger around a rock placed right in the middle of the road. This is Yonakiishi, the legendary rock that weeps at night. A long time ago, the story goes, this rock was the receptacle for the blood of a mother murdered by highwaymen.

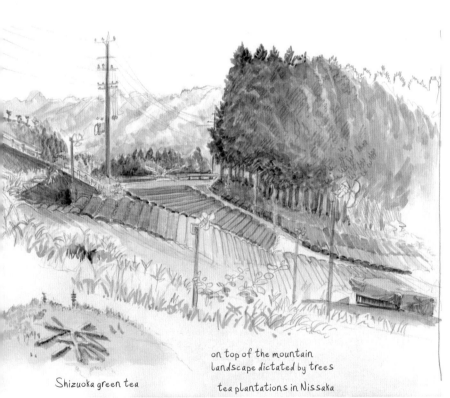

on top of the mountain
landscape dictated by trees

tea plantations in Nissaka

Shizuoka green tea

Kakegawa

Training on the Castle Grounds

Kakegawa Castle was the scene of many a battle; it was destroyed and rebuilt several times over the course of its history but it was completely annihilated during the 1854 Tokai earthquake.

It wasn't until 1994 that the castle was reconstructed, using traditional building methods.

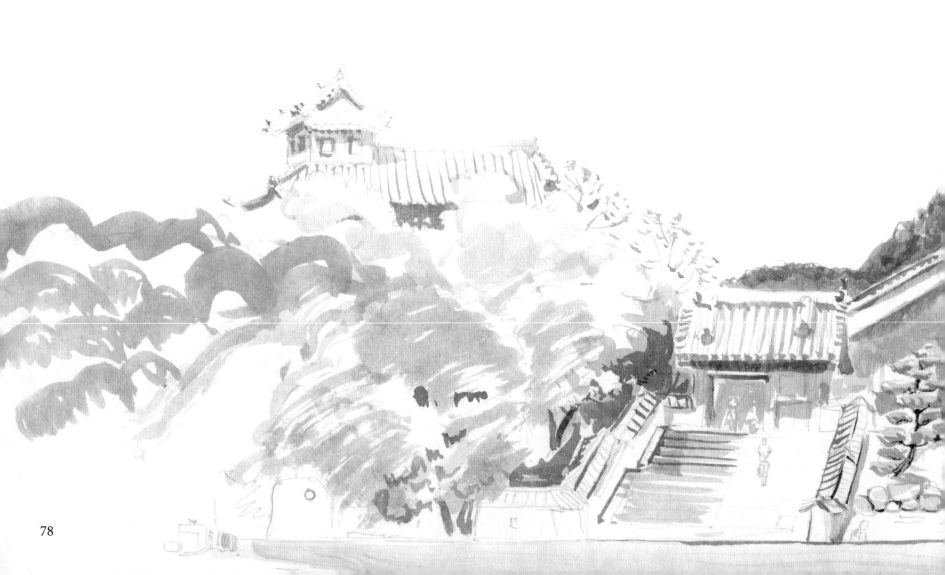

A light breeze lifts kites high in the sky. On the bridge, a pilgrim passes two elderly men hobbling along with the help of their canes. They are being followed by a scoundrel mimicking their every gesture.

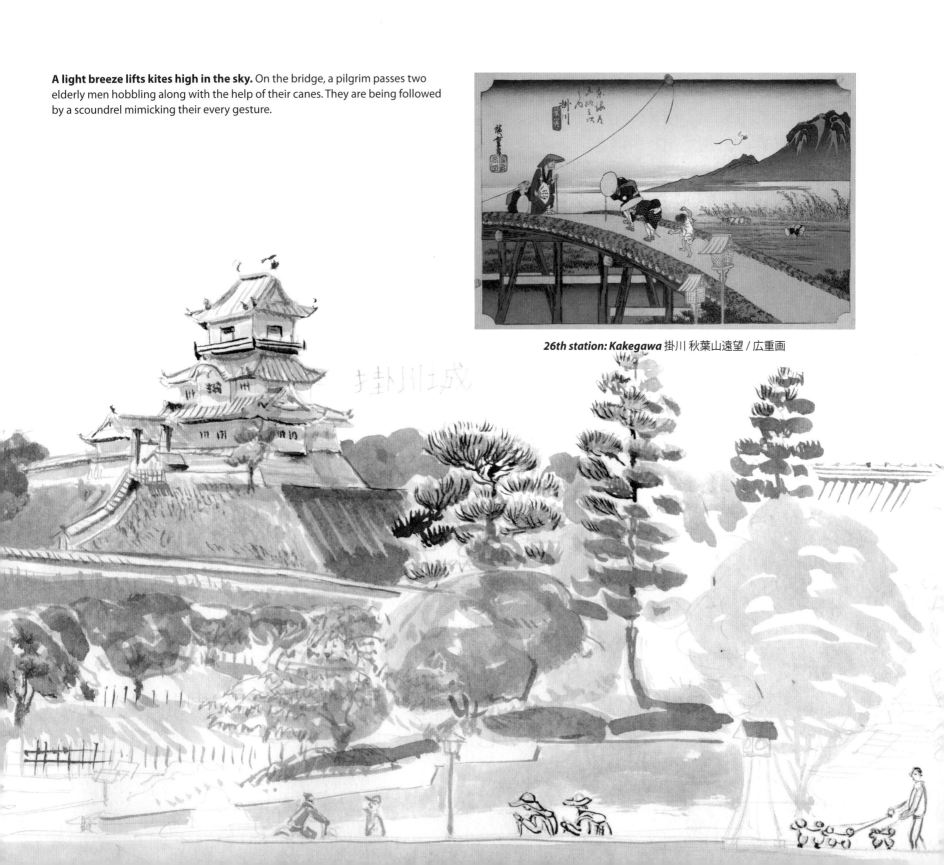

26th station: Kakegawa 掛川 秋葉山遠望 / 広重画

street of small bars

KAKEGAWA

In the castle grounds, high-school students wearing black uniforms rehearse an exercise. With military rigor, they practice wielding a banner, doing their best to repeat the set movements over and over again with chronometric precision.

They face this challenge by marking the rhythm with short shrieks; dust clouds follow them as they move back and forth.

stopwatch

flag-hoisting training

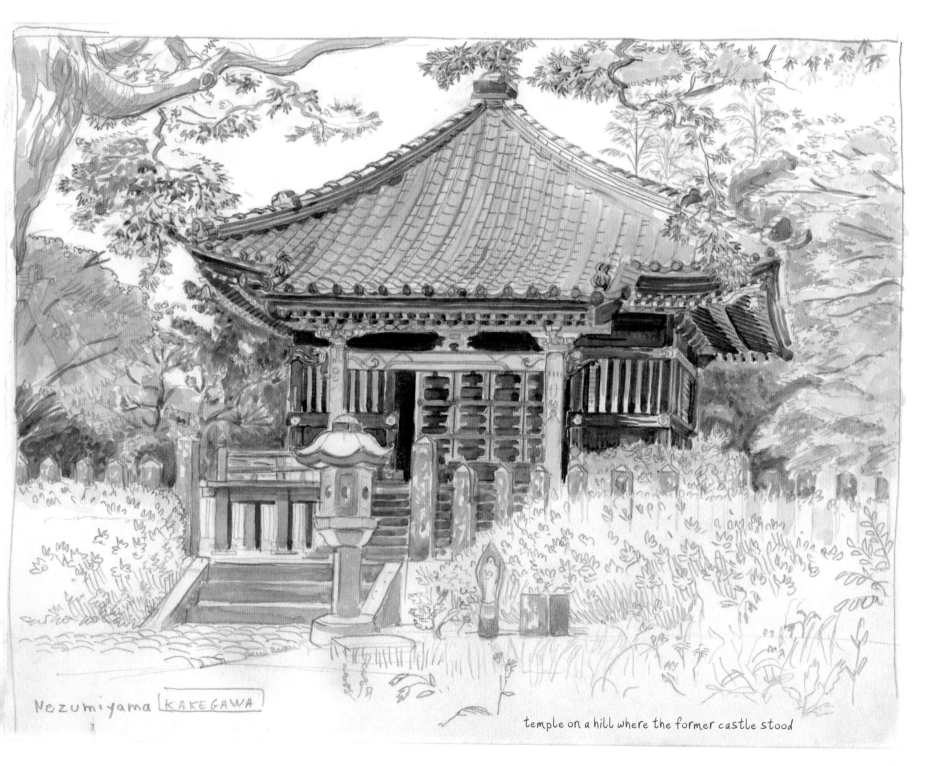

Nezumiyama KAKEGAWA

temple on a hill where the former castle stood

81

Fukuroi

Admiring the Moon on the River

I've hung my hammock between two cypresses on the river bank. I glimpse the moon rising between the tangle of tree branches. Below me in the tall grass, fireflies flicker like candles. In the morning, I draw an abandoned hut in the rice fields. I catch sight of a weasel, running along a wall.

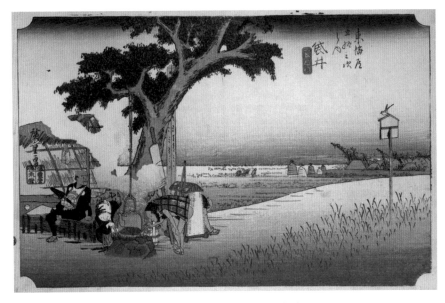

27th station: Fukuroi 袋井 / 広重画

The journey to the 27th station of Fukuroi was arduous for Tokaido travelers. Located in the middle of a rice-field plain, a lack of shade would make summer heat unbearable, and in winter the whole region was swept by wind. Still, the porters and palanquin bearers in this print seem glad of the rest. One tries to light up his pipe from ashes in the hearth. Another massages his feet bruised from the walk. Their customer, comfortably lounging in the shade by the trellis with his sword in his belt, waits patiently for the kettle to boil. The tea lady blows on the flames to make the wet wood burn quicker.

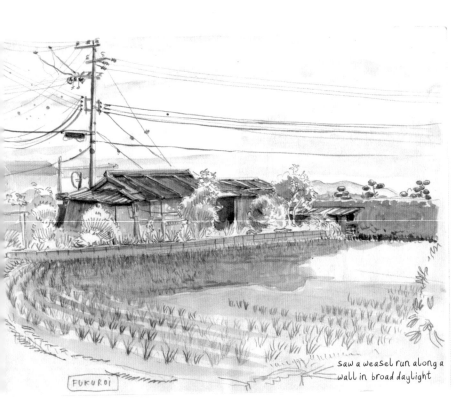

FUKUROI

saw a weasel run along a
wall in broad daylight

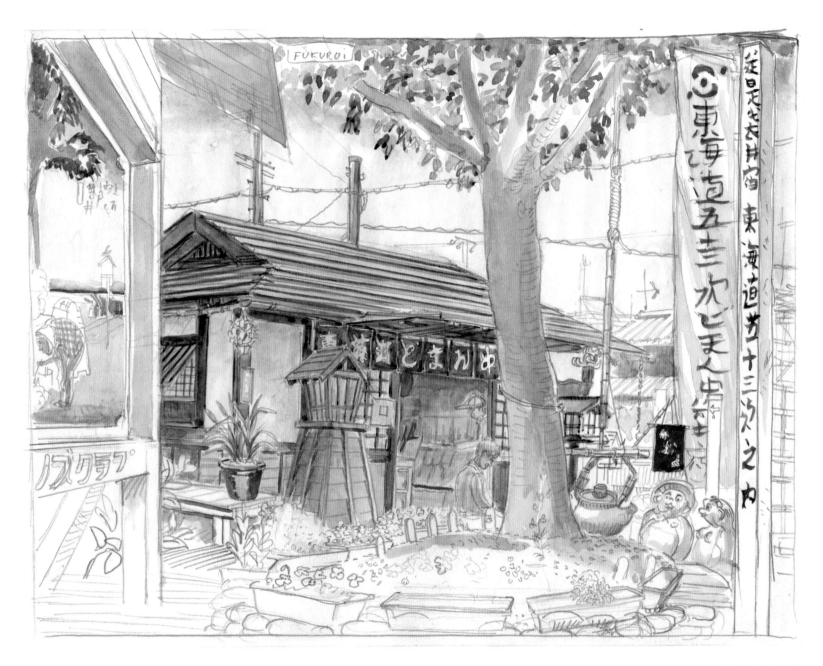

At a crossroad in the village of Fukuroi, there's a little souvenir shop decorated with banners that float in the wind. This is a popular attraction for cyclists riding this stretch of road. There's a tree outside the shop where various Edo-period artifacts have been placed: a teapot hangs from a branch, an engraved road sign has been planted in the dirt. Two wooden lanterns frame the store entrance and there's a bench with a bamboo canopy. As in a "spot the difference" game, many of these elements can be found in Hiroshige's print of this 27th station of the Tokaido. You can see for yourself by looking at the large poster of the print that hangs beneath a wooden awning.

Mitsuke

Midway along the Tokaido

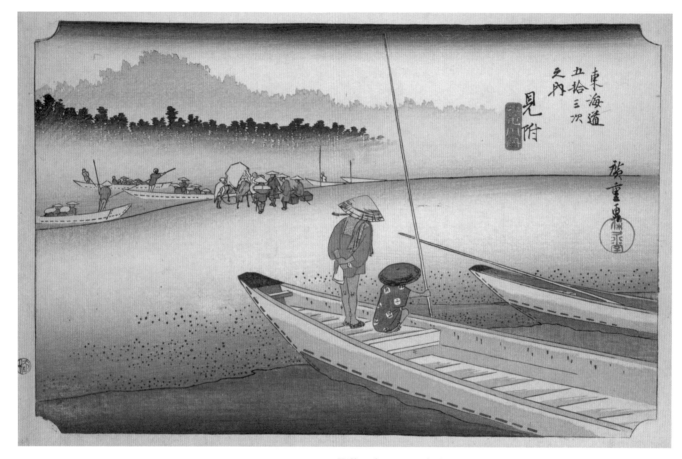

28th station: Mitsuke 見附 天竜川ノ図 / 広重画

In a well-thought-out composition, Hiroshige successfully achieves his goal of indicating that this station is midway between Edo and Kyoto. In the foreground, the first part of the trip is over. The two ferrymen are immobile and bored. They have ferried people up to the sand bank in the middle of the Tenryu River. One is holding a pole that bisects the image with a vertical line as though a barrier is being lifted. The other side of the river is a hive of activity, as *chokibune* flat-bottomed boats are loaded with travelers and their wares. The fog that wreathes the far banks of the river symbolizes the unknown part of the journey still to come.

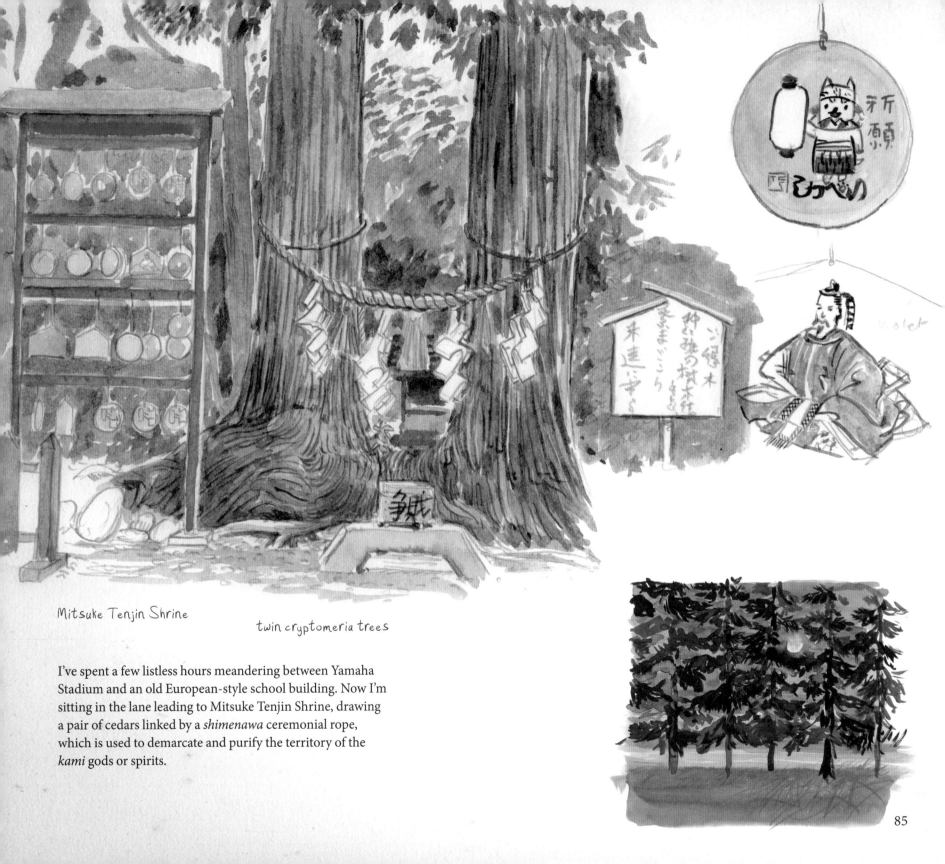

Mitsuke Tenjin Shrine

twin cryptomeria trees

I've spent a few listless hours meandering between Yamaha
Stadium and an old European-style school building. Now I'm
sitting in the lane leading to Mitsuke Tenjin Shrine, drawing
a pair of cedars linked by a *shimenawa* ceremonial rope,
which is used to demarcate and purify the territory of the
kami gods or spirits.

85

Hamamatsu

Gusting Winds at Hamamatsu Castle

A strong wind gusts around the castle. It has already blown my cap into the moat and my sketchbook into the dust. The heavy, studded doors are now open and there are lots of tourists. A team of women basketball players have taken advantage of a meet to tour this area rich in culture.

A very elegant grandmother, in a pale yellow suit with a contrasting orange scarf, is reading the information plaques carefully. A young couple strolls by. The woman, in a blue jacket, plaid skirt, and blouse with a plaid bow tie, leans on her companion. He is wearing a blazer that has a gold coat of arms, plaid pants with a well-pressed crease and light brown slip-on shoes. From the lookout point, they admire the peak of Fuji-san that the wind has cleared of clouds.

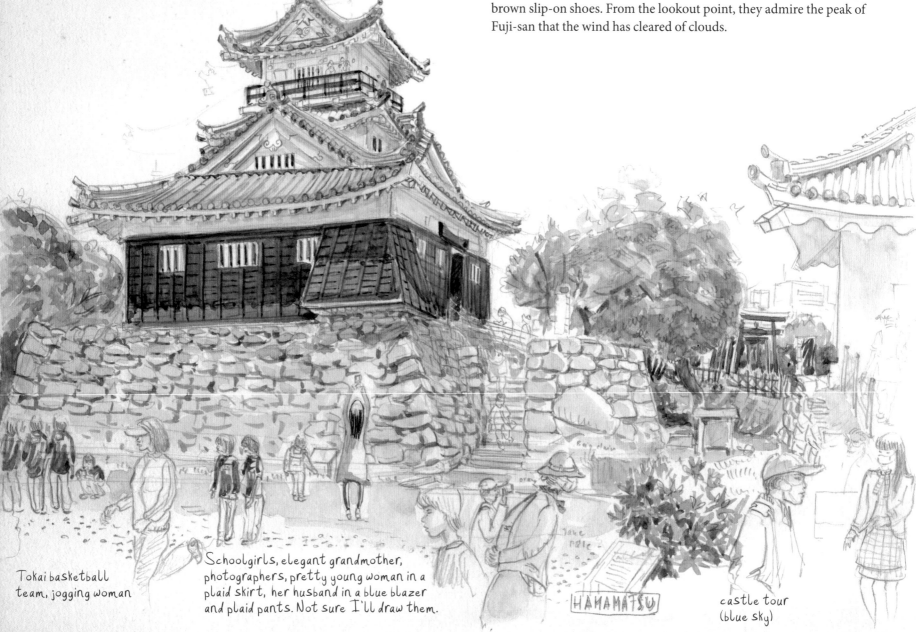

Tokai basketball team, jogging woman

Schoolgirls, elegant grandmother, photographers, pretty young woman in a plaid skirt, her husband in a blue blazer and plaid pants. Not sure I'll draw them.

HAMAMATSU

castle tour (blue sky)

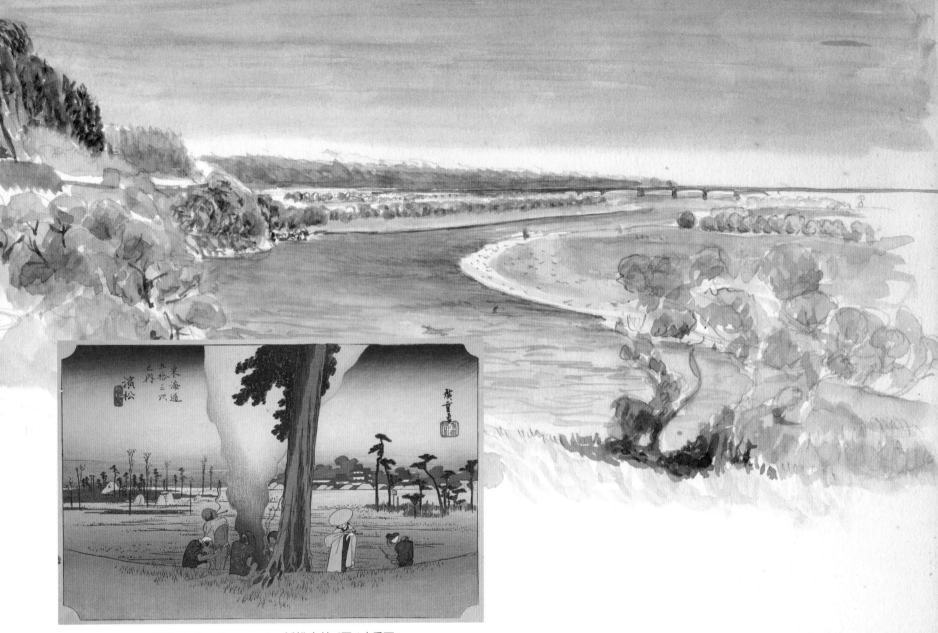

29th station: Hamamatsu 浜松 冬枯ノ図 / 広重画

A winter scene in Hamamatsu. The foreground resembles a stage set, with all the main characters assembled around a solitary pine, where they've made a fire. Semi-naked porters share the warmth. A traveler in rain gear hesitates to join them. He may fear being the butt of tasteless jokes on the part of these lads. A young woman carries an infant on her back; she's just passing as she goes about her everyday life. Despite the houses that can be seen nestling against the castle in the background, the rest of the landscape is devoid of human presence, and the almost-monochrome color scheme gives a sad and desolate air to this portrait of chilly winter on Hamamatsu plain.

Maisaka

A Printmaking Lesson among the Pine Trees

The little woman interested in my drawing of the road lined by hundred-year-old trees has crossed the street again. Squatting in front of a roadside milestone, she beckons me to join her. She opens her bag and takes out a pile of cloths and papers. Pointing to the engraved plate on the stone, she wants to tutor me in the art of rubbing. I watch her proceed methodically and nod at the detailed explanations that she gives me in Japanese after each step of the process. Finally, she delicately pulls off the wet paper, where the embossed design of Hiroshige's print has appeared.

"Kanaya—the 24th station!" I exclaim.

"Yes! Hiroshige—Kanaya!" she echoes.

She wraps the print in newspaper and gives it to me.

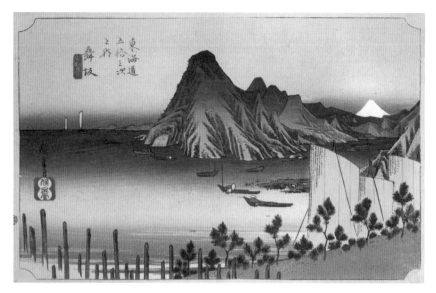

30th station: Maisaka 舞坂 今切真景 / 広重画

In this print, Hiroshige is keen to show us the consequences of the 1498 earthquake and the tsunami that followed. The sand barrier that had previously separated Lake Hamana from the sea was destroyed and the freshwater lake was flooded with sea water. Hiroshige's view is fanciful: it shows Lake Hamana as a fjord receding between the mountains even though the actual topography is a flat plain. It would also be a challenge to find a hill that offers this perspective of the coast.

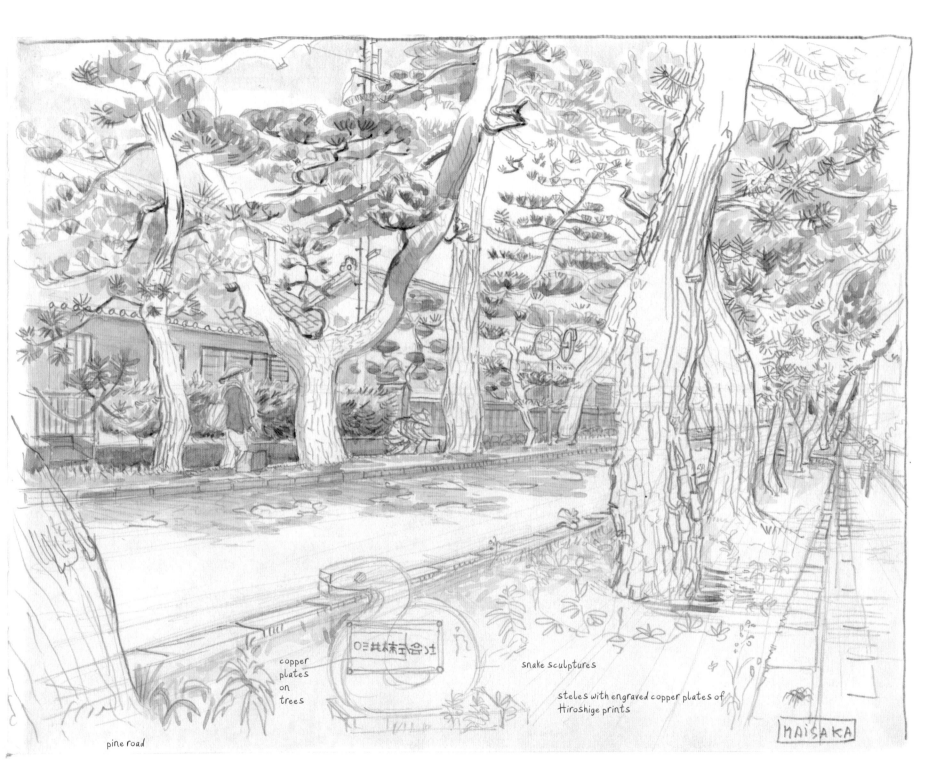

copper
plates
on
trees

snake sculptures

steles with engraved copper plates of
Hiroshige prints

pine road

MAISAKA

89

Arai

The Next Checkpoint

After Hakone, Arai was the next checkpoint on the Tokaido road. Today, a trench lined with stone blocks marks the place where the old wharf used to be. Farther along, an old inn has been transformed into a museum of the Tokaido.

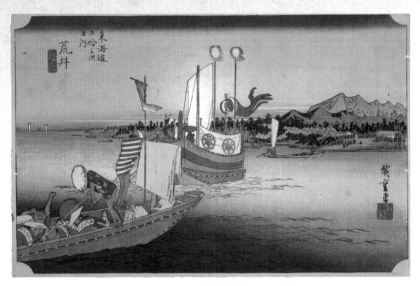

31st station: Arai 荒井 渡舟ノ図 / 広重画

A strange fleet sails in the direction of the 31st station at Arai. First comes a *gozabune* samurai warship decorated with banners and flags that conceal people of high rank. Following it is a *chokibune* flat-bottomed boat carrying liveried servants, who are yawning and sluggish as they rest during the short crossing. The tall lads steering the boat also seem to have fallen into torpor, judging from the lethargic way they handle their poles.

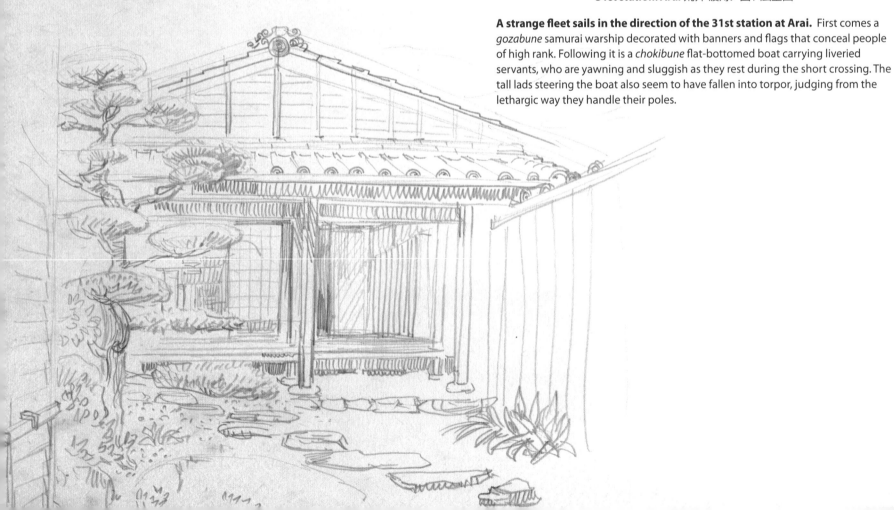

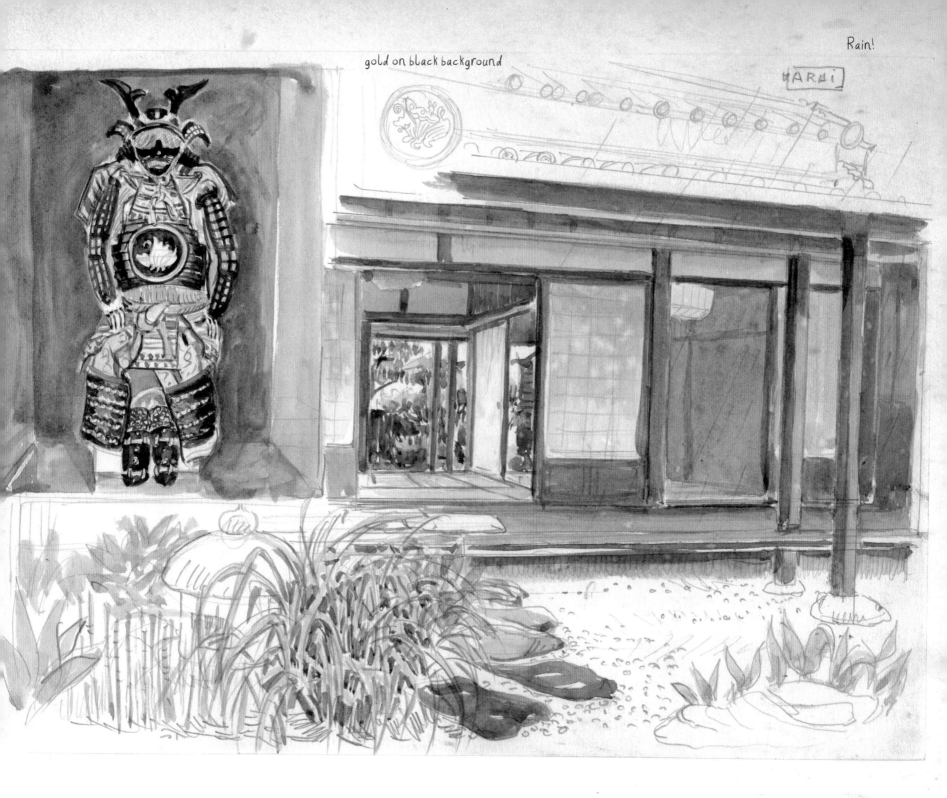

gold on black background

Rain!

HARAI

Shirasuka

A Dark Bamboo Grove

I've looked in vain for the scene that matches Hiroshige's. I'm either unable to stop because of the traffic coming down the off-ramps of the freeway, or the view is masked by an impenetrable curtain of trees. Tired of these fruitless attempts, I park my scooter on the side of a small road and go into a dark bamboo grove. The fresh air, the light filtered through the foliage and the reigning silence all appease me.

A storm breaks out and I shelter in a truckers' restaurant. *Yakisoba* noodles, beer, cigarettes and drawing until the end of the evening.

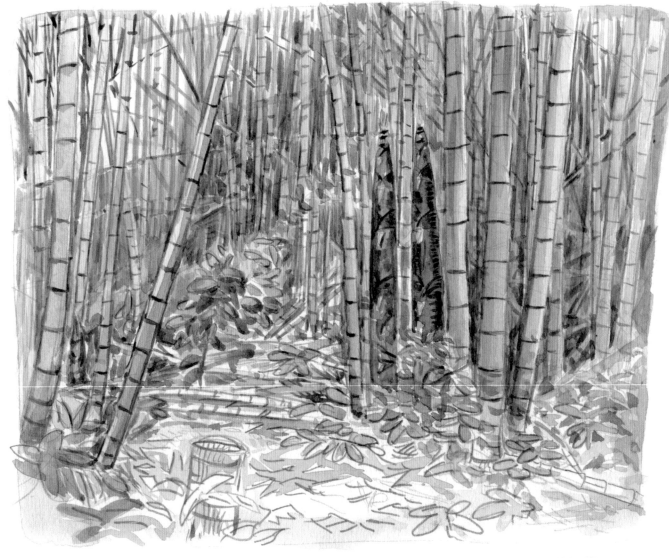

bamboo grove

SHIRATSUKA

92

bamboo shoot

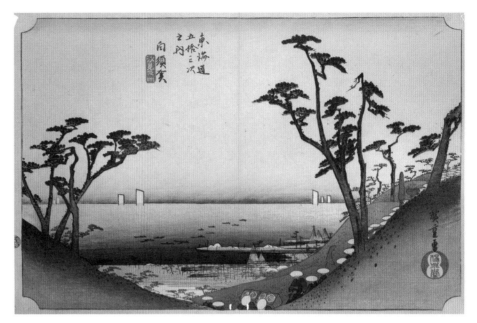

32nd station: Shirasuka 白須賀 汐見阪図 / 広重画

Crossing a frontier. A rift between the hills offers a magnificent panorama of the Enshu-nada coast. A daimyo's retinue en route to Edo makes its way to the Shimomi slope. After days of traveling inland from Nagoya the sudden appearance of the Pacific Ocean must have delighted travelers. This station marked the border of the former Totomi and Mikawa provinces; to this day it remains the boundary between the prefectures of Aichi and Shizuoka.

Futagawa

A Museum Dedicated to the Tokaido

The old Tokaido goes through the village of Futagawa, on the outskirts of the town of Toyohashi. Old wooden structures still line the narrow road. One of them is home to a museum dedicated to the Tokaido: the Futagawa Shuku Honjin. You have to remove your shoes, wearing only your socks on soft tatami mats. Clever little plank bridges allow you to go from room to room without having to slip on your shoes again.

Futagawa Honjin

knapsack

rice bowl

vegetables

blue

fish

black

soup

black

rice-serving dish

tree type: asebi

garden

miniature Japanese garden

fabric

straw sandals

(rice straw)

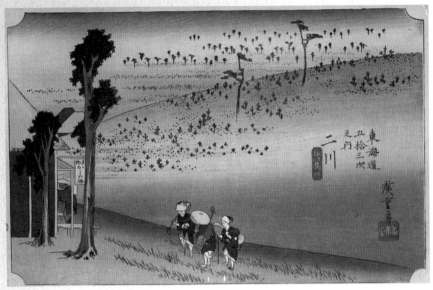

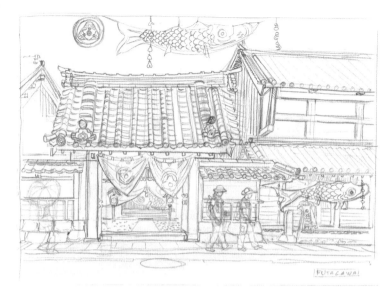

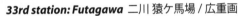
33rd station: Futagawa 二川 猿ケ馬場 / 広重画

Three women climb up a hill in a desolate landscape. Each of them carries a *shamisen* three-stringed lute. Might they be *goze* blind female musicians who make a living on the road? Leaning on their canes, they are slowly inching their way toward an eatery offering the local specialty, *kashiwa mochi*, a steamed glutinous rice cake wrapped in an oak leaf.

jacket

traveler's attire

brown white stripes

hat

hand protectors

yellow ocher

honjin: high class inn for daimyo feudal lords only

waki-honjin: a bit less luxurious

shuku: inn for the common people

luggage

light beige

calf protectors blue gray

Tokaido hikers

straw sandals

95

Yoshida

Shijimi are Good for Your Liver

I contacted Katsuhiko via the Internet. He agreed to let me crash at his place in Toyohashi for a few nights. We are meeting at Funamachi train station, not far from the concrete-lined banks of the Toyo River. The neighborhood is one of low houses that seem vulnerable to tsunami. The station is a single platform squeezed between the tracks with just a vending machine for tickets. I am early, so I start drawing the view— the complex network of railways, roads and cables that forms the backdrop to the monotonous daily commute for Funamachi residents. Katsuhiko arrives on a mini bicycle, a black bag in one hand. He guides me through the maze of alleys to his doorstep.

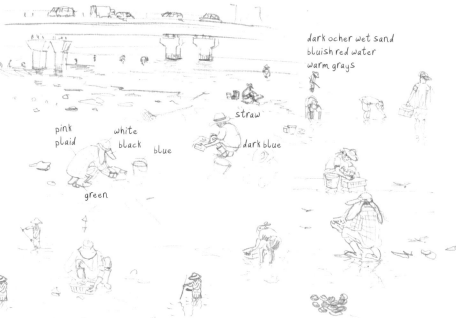

dark ocher wet sand
bluish red water
warm grays

straw

pink plaid
white
black
blue
dark blue

green

digging for shells at low tide

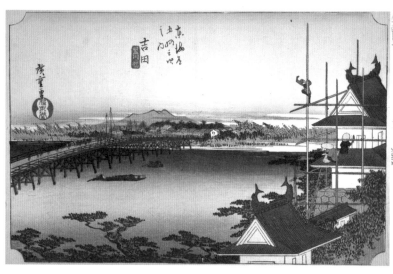

34th station: Yoshida 吉田 豊川橋 / 広重画

The view from the top of Yoshida Castle. On the left, a large bridge crosses the Toyo River. On the right, the corner tower is surrounded by bamboo scaffolding. At the very top, a fearless climber seems to be performing an acrobatic dance, unless he is simply calling out to his coworkers down on the ground. Two masons are spreading whitewash on the wooden building to protect it from fire. During the Edo period, fire was the foremost danger to dwellings and temples. The roof ridge is decorated with *shachihoko*, fantastic monsters with tiger heads and carp bodies, believed to have the power to make rain.

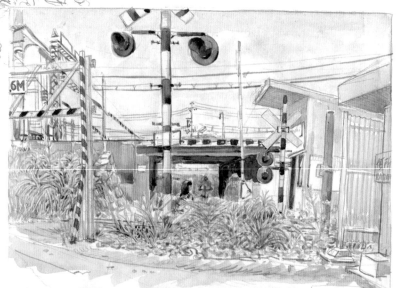

Funamachi Station, where I'm meeting Katsuhiko so I can stay at his place. Instead of an actual station there is just a platform between two tracks and a tiny office with a ticket vending machine.

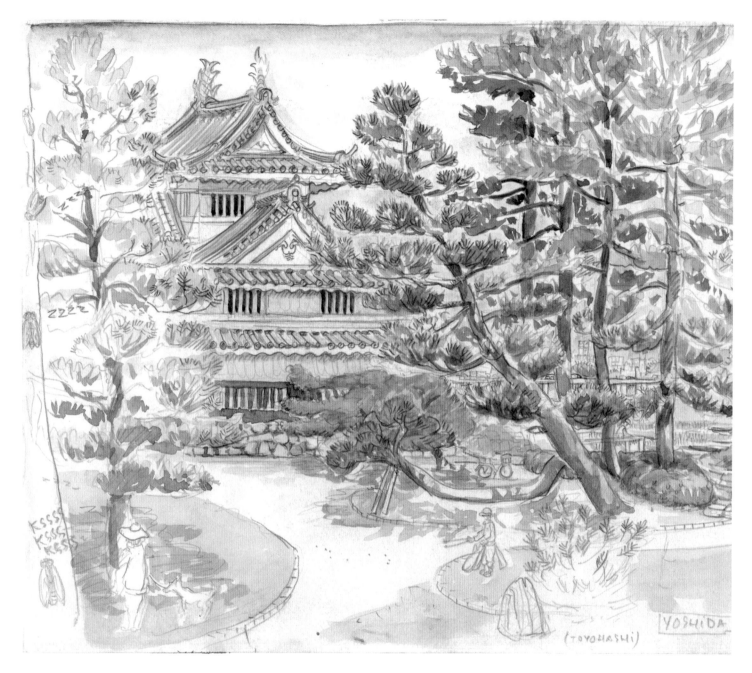

(TOYOHASHI)

YOSHIDA

Yesterday's Yoshida is today's Toyohashi. A sweltering heat weighs down on the city. The pine trees in the park that surrounds the castle deliver a warm resin aroma and the fine needle bouquets filter the sun's intensity a little. In the distance, on the bridge crossing the river, vehicles are broiling in the heat haze. But above all, it's the jarring song of the cicadas, camouflaged on tree bark, that makes you want to give up and take refuge in some air-conditioned building.

People pace the wet sand of the sandbanks revealed by the low tide, faces covered with scarves, digging for clams called *shijimi*. These are cooked in a clear broth; not very tasty but a good hangover cure.

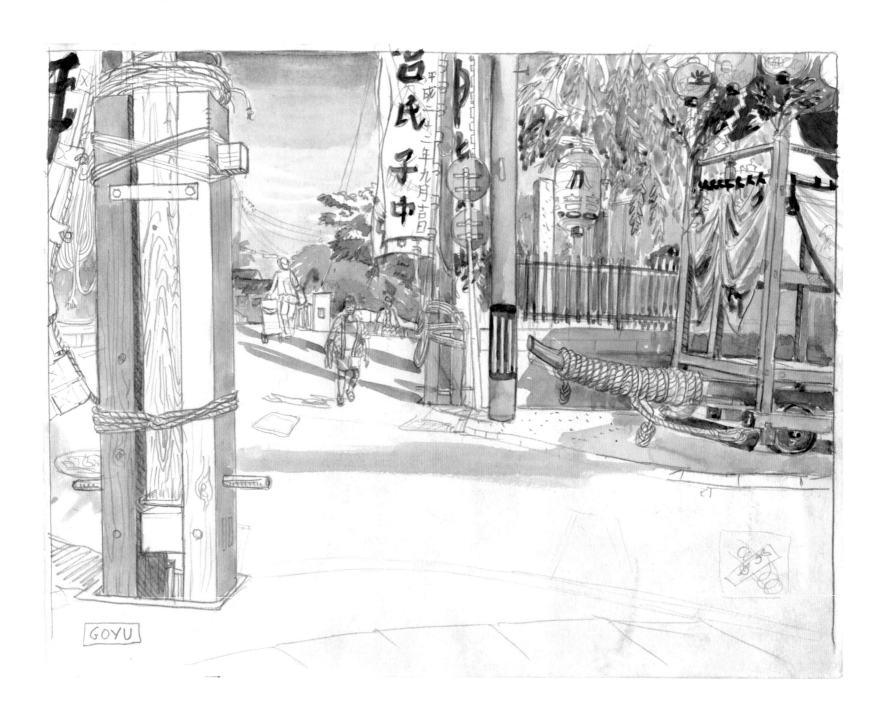

GOYU

Goyu

Getting Ready for a Local Festival

FESTIVAL PREPARATION

What is happening in this normally quiet village? The village boundary is marked by tall masts adorned with bamboo fronds and *kakemono* hanging scrolls bearing calligraphy. Goyu inhabitants are rushing around feverishly. *Mikoshi* portable shrines are being hauled out of sheds by men in indigo jackets with crest patterns. Tomorrow the annual *matsuri* festival begins and everything has to be ready for this memorable day.

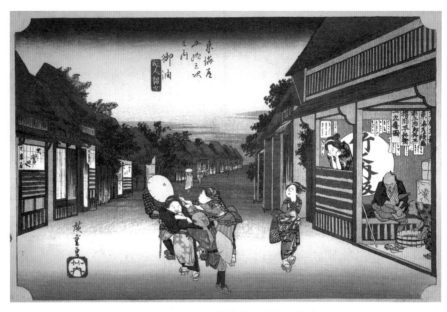

35th station: Goyu 御油 旅人留女 / 広重画

At sunset, two heavily made-up geisha eagerly call travelers to their teahouse. On the right, the inn seems lit from within by a white circle. A man is about to wash his feet in a basin brought to him by an old servant. A woman leaning from the window observes the desperate attempts of the men to extricate themselves from the eager women and waits impassively for the outcome of the brawl.

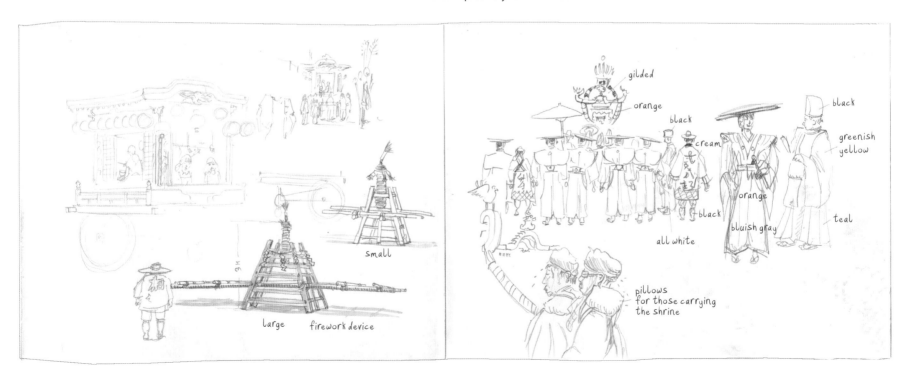

large firework device

small

gilded
orange
black
cream
black
orange
bluish gray
all white
black
greenish yellow
teal

pillows for those carrying the shrine

THE GOYU FESTIVAL

The next day, in scorching heat, the festival processions begin. People wearing *tabi* split-toe socks and *geta* clogs walk alongside Shinto priests wearing black gauze hats and carrying parasols; on their feet are shiny wooden clogs. Men enthusiastically shoulder golden *mikoshi* shrines, decorated with phoenixes. Samurai in pleated skirts carry fans on their belts as if they were swords. All day long, the procession goes on in the street, accompanied by the rhythm of drums and the whistling of flutes.

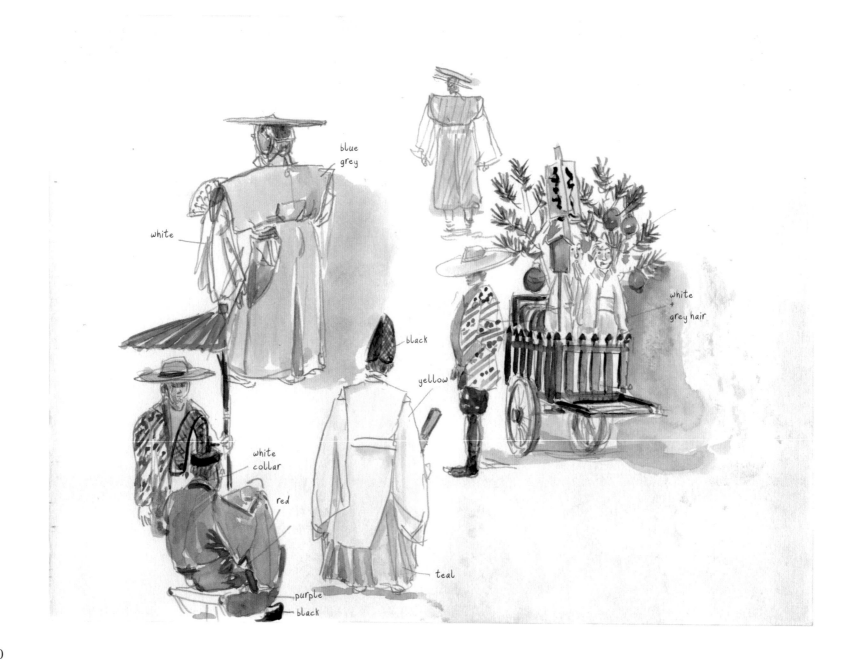

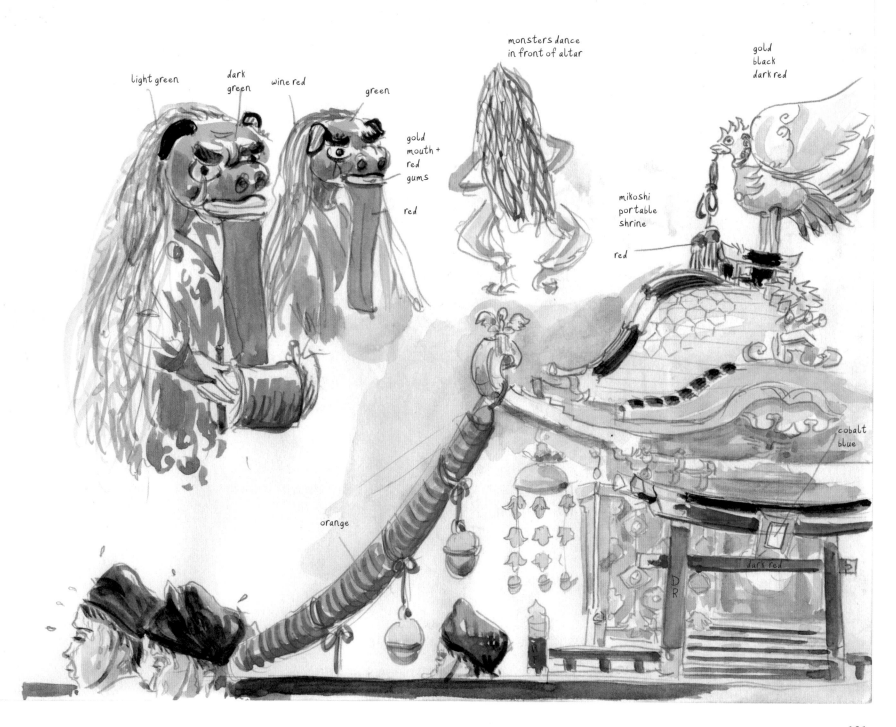

light green

dark green

wine red

green

gold mouth + red gums

red

monsters dance in front of altar

gold black dark red

mikoshi portable shrine

red

cobalt blue

orange

dark red

101

Akasaka

The Ohashiya Inn

The old Ohashiya inn in the town of Akasaka closed down several years ago. Originally constructed in 1716, it must have provided shelter for many Tokaido-road travelers during its long history.

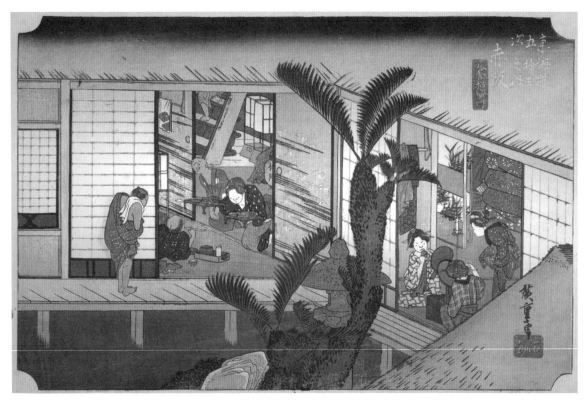

36th station: Akasaka 赤坂 旅舍招婦ノ図 / 広重画

An evening at the inn. A stone lantern, a wrinkled rock, and a palm tree make up the garden courtyard of the inn. Around the garden is a veranda with sliding doors that let you see the space inside. A man is coming back from the bath. Another man lounges, smoking a pipe, a sake cup within reach. A maid brings in trays of appetizers and a blind masseur offers his services. In another room, two young women are applying makeup under the owner's keen eye before taking part in the upcoming libations. A pile of futons is visible in an open cupboard; they will be unfolded on the tatami later in the evening.

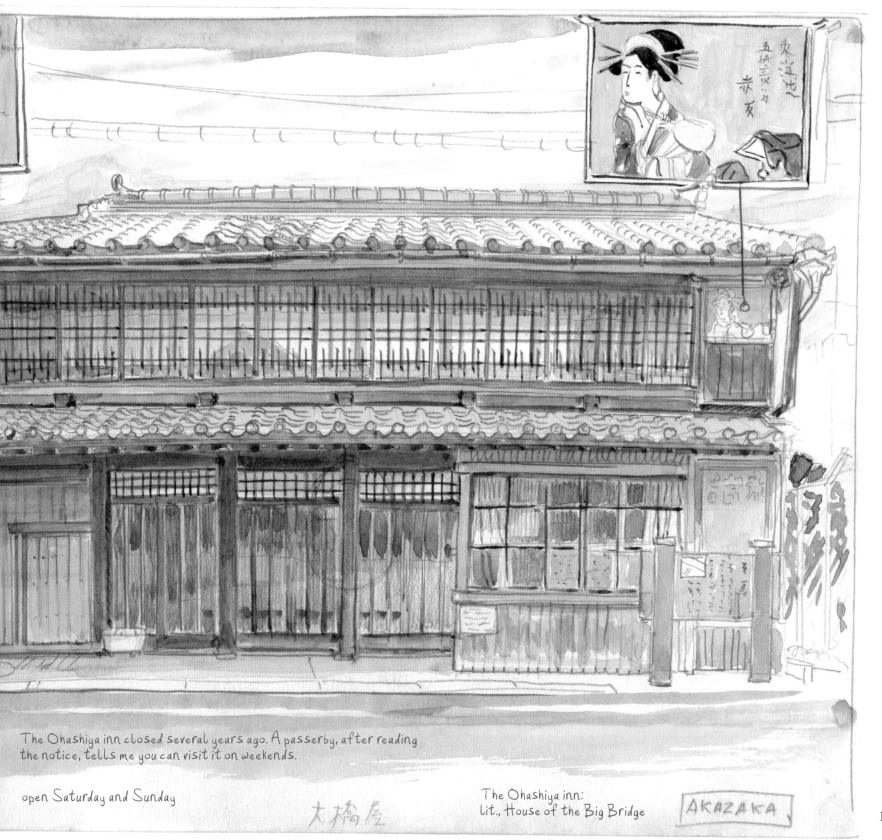

The Ohashiya inn closed several years ago. A passerby, after reading the notice, tells me you can visit it on weekends.

open Saturday and Sunday

大橋屋

The Ohashiya inn: lit., House of the Big Bridge

AKAZAKA

103

Fujikawa

A Morning Market and a Hiroshige Poster

On National Route 1, the Fujikawa-shuku rest area invites drivers to enjoy the market and services available next to the parking lot. There's a tourist information desk, a shop selling souvenirs and local specialties, the unavoidable *konbini* convenience store and a noodle restaurant. This morning, locals are selling their vegetables at stalls set up next to the shops. The smell of food emanates from food trucks selling everything from *takoyaki* dough balls stuffed with octopus to sausages. Onion and yam sellers fill up their customers' shopping bags in front of a huge poster of Hiroshige's print of the 37th station.

In the village, there's a tall house that seems cut in half. Its first floor is home to a shop selling festival gear. Children's Day is approaching. The front window is decorated with huge colorful fabric carp streamers tied to poles. In the store's dark interior, suits of samurai armor are displayed on red velvet: only a few lucky children will get to wear them.

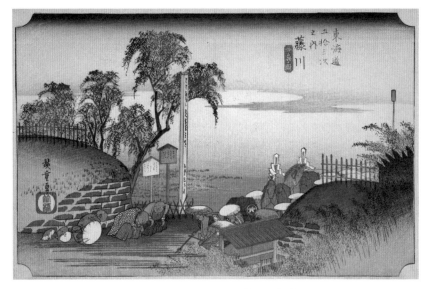

37th station: Fujikawa 藤川 / 広重画

Barriers fixed on mounds contained by stone walls indicate the city's entrance. Signs and wooden posts inform travelers of the distance between stations and of various regulations. Three men bow as a feudal lord passes by on his way to bring presents to the emperor. For this special occasion, two horses are kitted out in sacred decorations made of white paper.

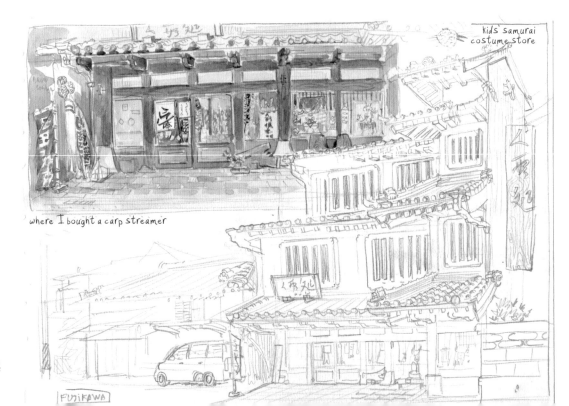

kids' samurai costume store

where I bought a carp streamer

FUJIKAWA

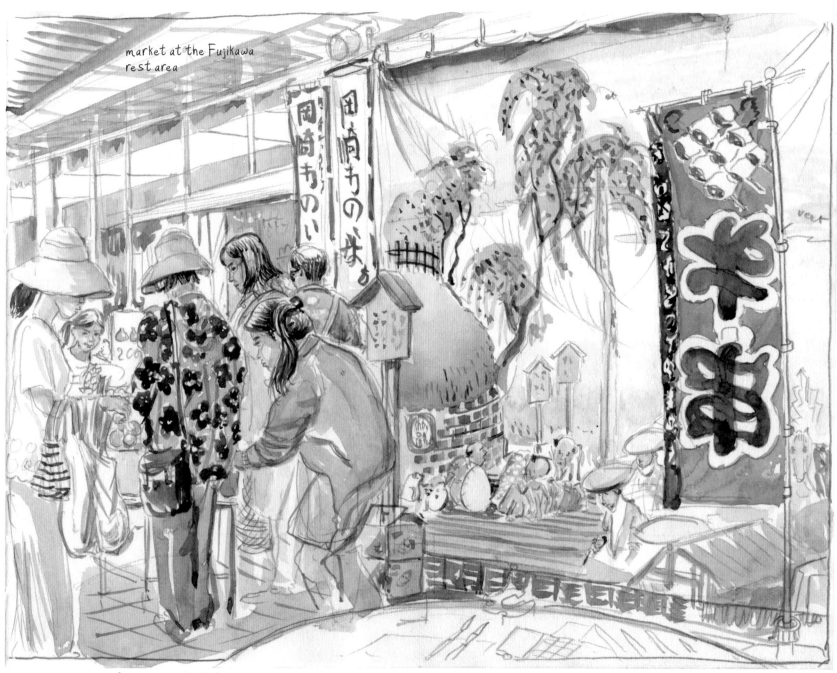

market at the Fujikawa
rest area

seller of onions and potatoes

Okazaki

Japan's Red Miso Capital

RED MISO PRODUCING DISTRICT

From the thirteenth century onward, the clear water of the Yahagi River became an essential ingredient for the local makers of red miso. Today, eight blocks away from Okazaki Castle, you can still find workshops where local people make *hatcho* miso (*ha* means eight; *cho* means block of houses). Curiosity pushes me to visit one of them, where a guide with encyclopedic knowledge leads me on a tour.

Red miso paste is prepared from soy beans fermented in large cedar barrels for over a year. Four tons of river stones, placed in a cone formation, compress the paste to squeeze out the water.

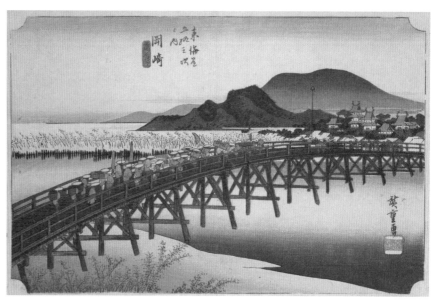

38th station: Okazaki 岡崎 矢矧之橋 / 広重画

An official procession crosses the Yahagi River. Yahagi Bridge, 400 yards (370 meters) long, was the longest wooden bridge on the Tokaido. Far in the background, the roofs of Okazaki Castle can be seen; this was the birthplace of the first shogun, Tokugawa Ieyasu.

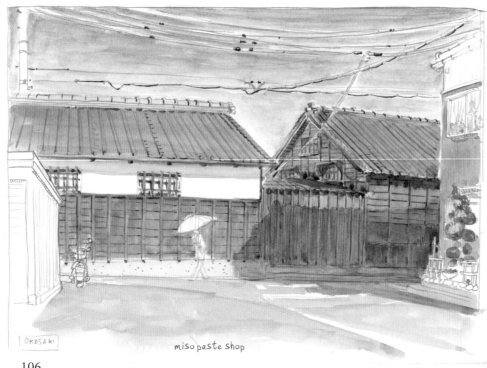

miso paste shop

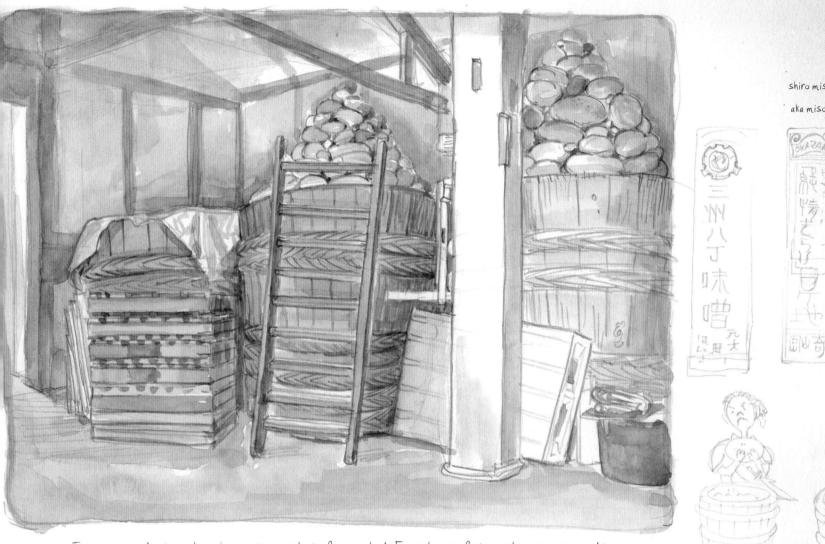

shiro miso: white miso

aka miso: red miso

yellow

brown

Japanese cedar barrels, where miso paste is fermented. Four tons of river stones, arranged in a cone shape, compress the paste to extract excess water.

Chiryu

Rain on the Iris Garden

It's been raining nonstop all afternoon. At nightfall, I take shelter under a bridge but my sleeping bag is soon drenched and I have to move again. As I'm gathering up my belongings, a car comes zooming along the wet road, a terrible sound coming from its exhaust pipes. The out-of-control car goes through a red light, skids and finally comes to a stop at an intersection. The engine starts to rev up again slowly; other vehicles give the car a wide berth.

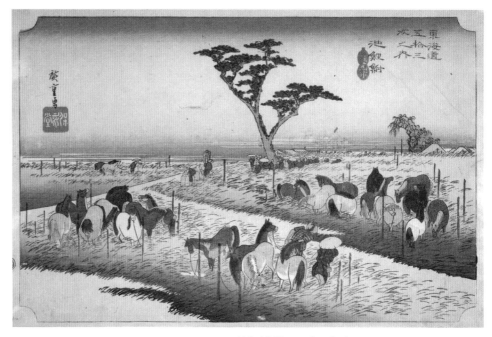

39th station: Chiryu 池鯉鮒 首夏馬市 / 広重画

The annual horse auction. Every spring a horse market takes place in the fields next to the village of Chiryu. A network of posts zigzags among the grass as far as the eye can see. Buyers gather under a large pine tree. In front of them, a groom leads two horses away by the reins.

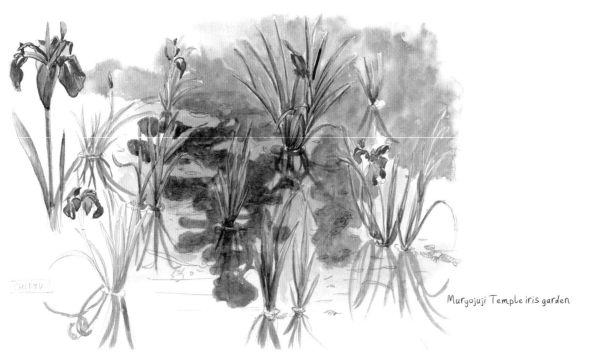

Muryojuji Temple iris garden

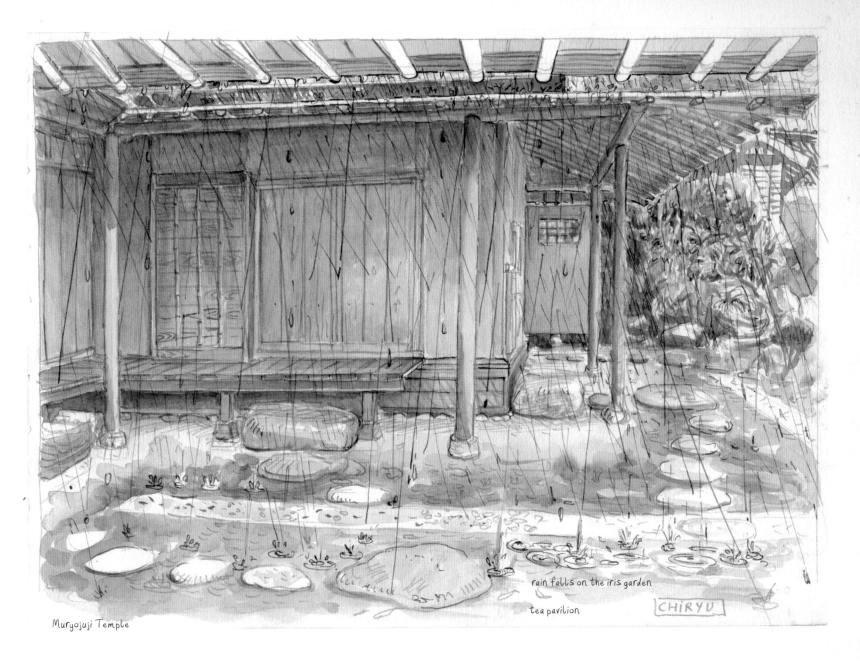

Muryojuji Temple

rain falls on the iris garden

tea pavilion

CHIRYU

In the lamplight, the car seems to be green, with maybe a purple band. The beam from its headlights flickers in the rain. All of a sudden, the car starts again, water flying from the screeching tires. It disappears down the road, the sound of its motor lingering. I remain fixated; I've just witnessed my first *bosozoku* (lit., "crazy rides" *boso*; "gang" *zoku*), Japanese "Hells Angels" who drive bikes or customized cars with screaming exhausts.

I will end this troubled night sheltering under the awning of the teahouse in the iris garden of Muryojuji Temple.

Arimatsu

The Home of Shibori Tie-dye

Shibori dyeing is still practiced in Arimatsu, the present-day location of the 40th station of the Tokaido, Narumi. In shibori dyeing, a piece of silk or cotton fabric is knotted tightly, then plunged into vat of dye. The dye doesn't penetrate the knotted parts, creating a series of white patterns. In Arimatsu, many craftspeople have their workshops in old wooden houses. There is also a small museum where you can learn all about this tie-dyeing technique.

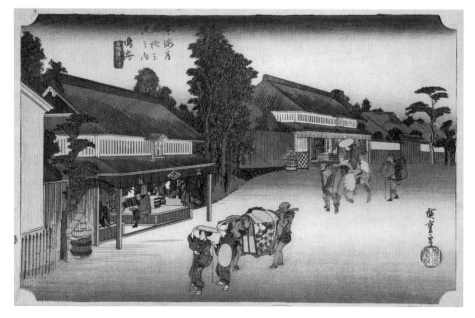

40th station: Narumi 鳴海 / 広重画

Narumi, the 40th station is known all over Japan for its dyeing technique called *shibori*. Right now, the day is ending. A veil of shadow is enveloping treetops and rooftops and it's not the time to be haggling with shibori merchants over the price of fabric. The merchants have already tallied everything and started thinking about the next day. Travelers, tired by the journey, don't even glance at the still-lit shop fronts with their displays of indigo fabric.

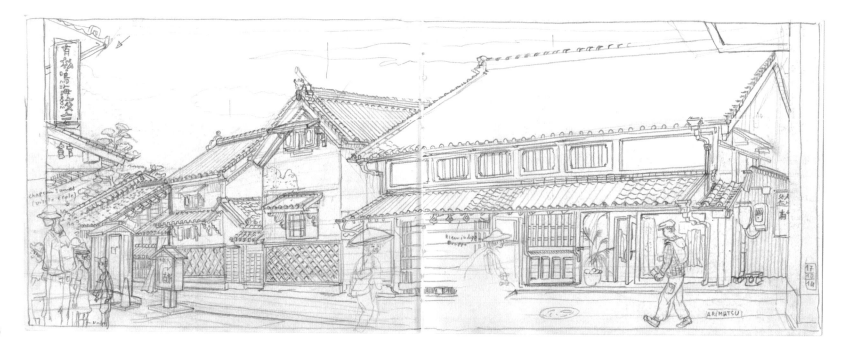

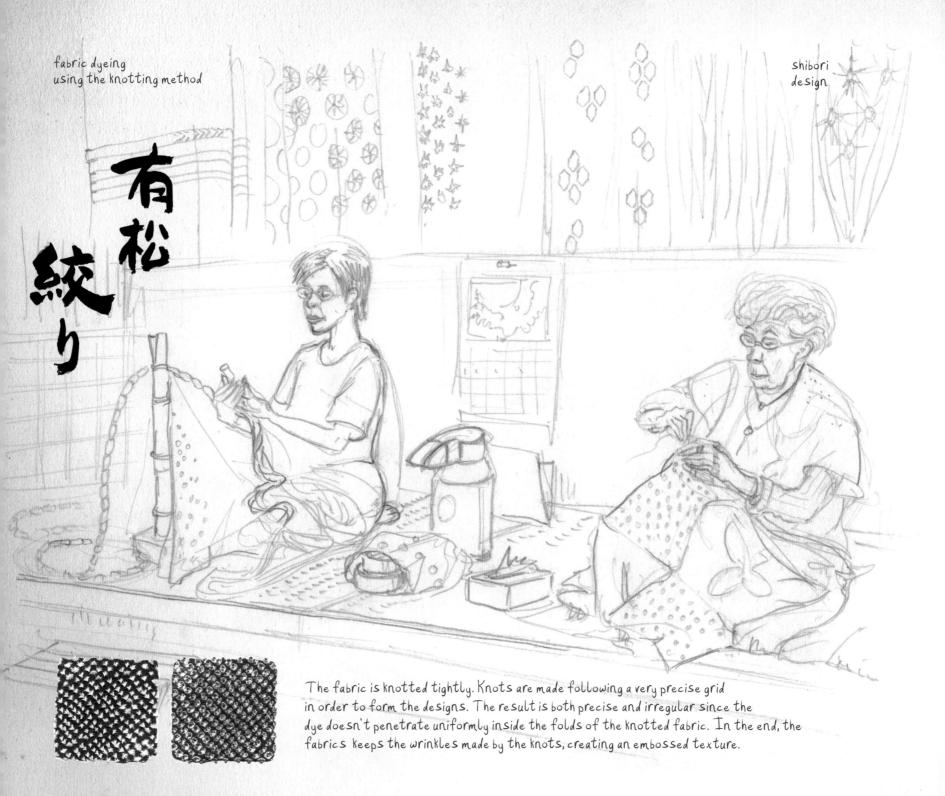

fabric dyeing
using the knotting method

shibori
design

有松
絞り

The fabric is knotted tightly. Knots are made following a very precise grid in order to form the designs. The result is both precise and irregular since the dye doesn't penetrate uniformly inside the folds of the knotted fabric. In the end, the fabrics keeps the wrinkles made by the knots, creating an embossed texture.

111

Miya

Boarding the Ferry for a Seven-League Crossing

THE SHICHIRI FERRY

Shichiri no Watashi is the pier for the seven-*ri* (seventeen-mile or twenty-seven kilometer) crossing from which it took its name: *shichi* means seven and *ri* is an ancient Japanese unit of measurement that is a very rough approximation to one European league or two and a half miles (four kilometers). Many travelers preferred to take the ferry in order to avoid the perilous road across the muddy delta of the Ibi, Kiso and Shonai rivers.

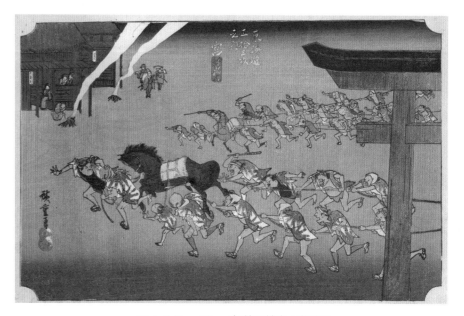

41st station: Miya 宮 熱田神事 / 広重画

A nighttime race at Atsuta Shrine. Miya, the 41st station, at the junction of several roads, was an important stop during the Edo period. This print seems to depict a Shinto festival horse race, at night, inside Atsuta Shrine. Tokaido travelers would board the ferry in Miya to cross Nagoya Bay to Kyoto, the imperial capital, or to the Ise Shrine pilgrimage road.

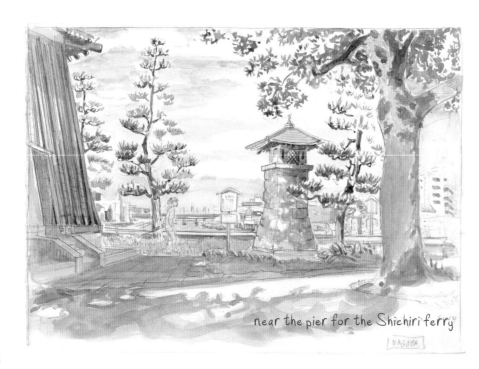

near the pier for the Shichiri ferry

NAGOYA

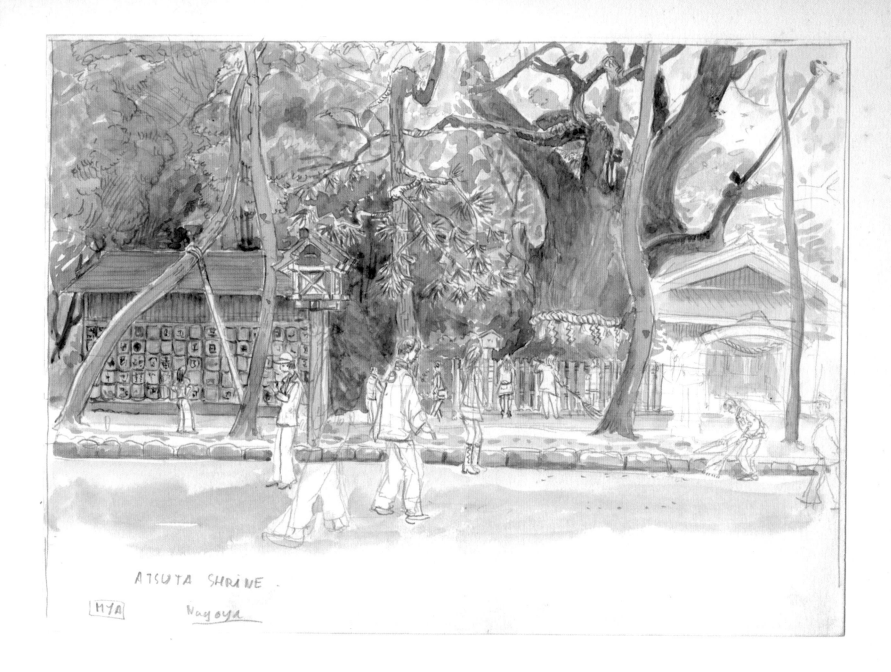

ATSUTA SHRINE

MYA Nagoya

ATSUTA SHRINE

The entrance to the park that surrounds Atsuta Shrine, nestled in the heart of Nagoya, is marked by a huge white wooden *torii* gate. Farther along the path, monumental moss-covered stone lanterns are buried under fronds. A majestic camphor tree grows on the main path to the shrine. "The day before yesterday, the gardeners found a ten-foot [three-meter] snake inside a tree trunk!" says a man who's watching me draw.

113

Nagoya

A Night in a Capsule Hotel

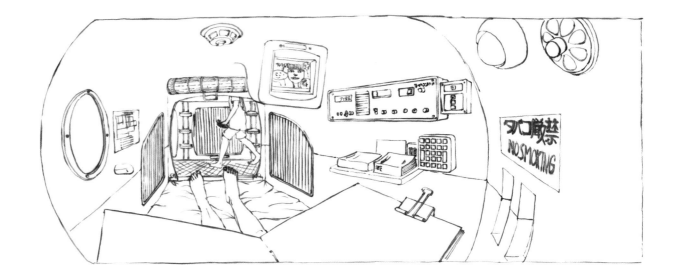

NAGOYA CAPSULE INN

I circled Kanayama train station many times before finding the capsule hotel, above a pachinko parlor: you need to look up to see the blue neon sign that spells out "Nagoya Capsule Inn."

At the seventh-floor reception, I'm relieved to hear that my reservation is confirmed. The receptionist wears a mask; she hands me a key and a pair of blue pajamas that I first think are sheets. The key bears the number 7078 and matches the locker where I have to store my belongings. Pajama-clad men wander around, barefoot or wearing slippers. I too have put on slippers. I don't really get how this works: take off your shoes, put on slippers, put away your stuff in a too-small locker, wear the blue pajamas? For the bath, go down two stories, put on your shoes again to get in the elevator. On the fifth floor, hand over your bath ticket, take off your shoes, take a new key, find locker 250, put away all your clothes in the locker and find yourself naked except for a ridiculous yellow towel in the middle of the locker room, surrounded by men of all ages who are displaying a disarming serenity. No one

talks, as if to do so would harm these precious moments spent solely on your body. Healing your body is healing your mind. Inside the bathhouse, squatting on plastic stools, men are rubbing their calves vigorously and rinsing off liberally with scalding water. At steamed-up mirrors, they shave meticulously and brush their teeth with brushes provided pre-spread with toothpaste.

I wash myself at the faucet and rinse off the soap, knowing that you have to be clean to enter the bath, then I relax for a few moments in a bubbling water. The thermometer shows a scary number. After a few dips in a cooler pool, I flee to the sauna.

The bathroom changing room has a sign in English that says:

1. Take a shower and wash yourself
2. Sauna and bath, or bath and sauna
3. After a sauna always take a shower, using soap and shampoo
4. Relax, do nothing, or have a massage
5. Have a cigarette and a beer
6. Have dinner

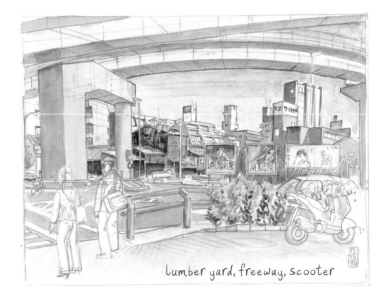

lumber yard, freeway, scooter

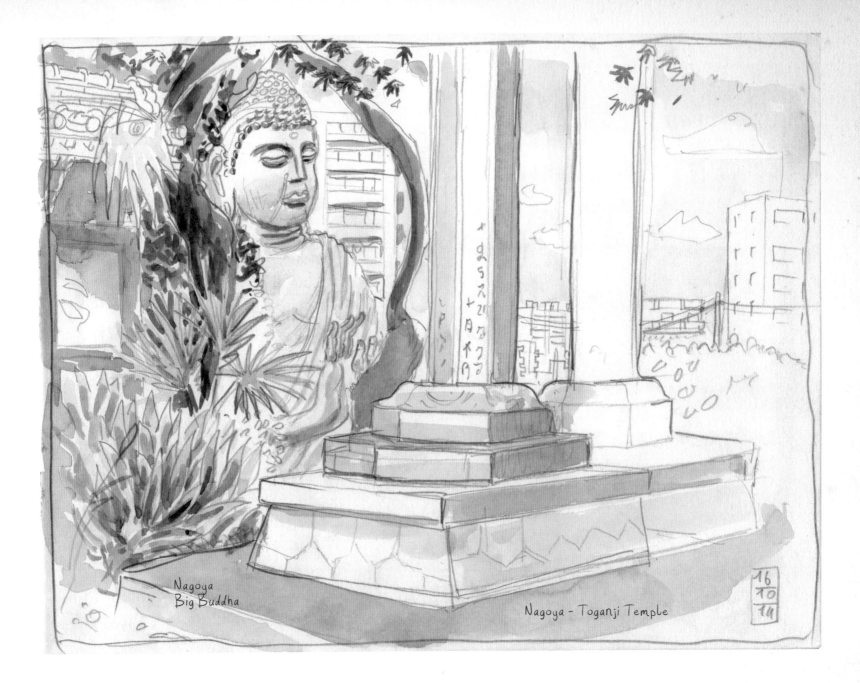

Nagoya
Big Buddha

Nagoya – Toganji Temple

THE GREAT BUDDHA OF MOTOYAMA

At the back of a small temple stands a large Buddha. He is sitting cross-legged on a pedestal carried by elephants; a thick green coat of paint covers him entirely. His eyelids and lips, outlined in gold, are closed. His impassive smile defies time: this peaceful giant seems to be protecting the city. As for me, I am at war with mosquitoes. They are taking advantage of my vulnerable position, since I am drawing, and they attack me from every side. I defend myself and they lose a few members but the fight is poorly matched and I have to retreat.

115

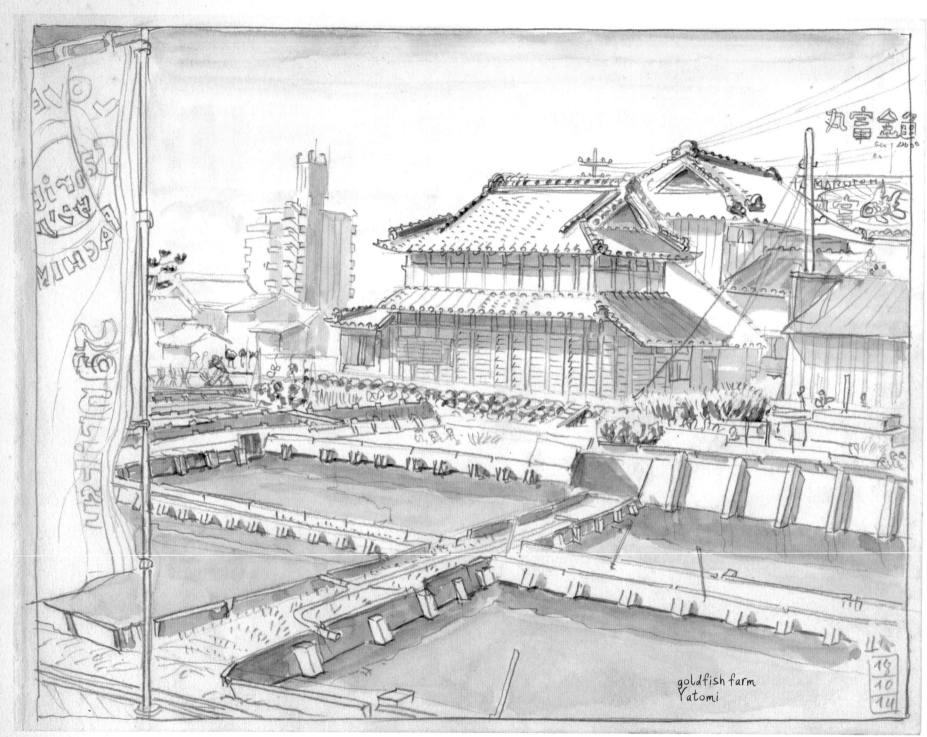

goldfish farm in Yatomi, a suburb of Nagoya.

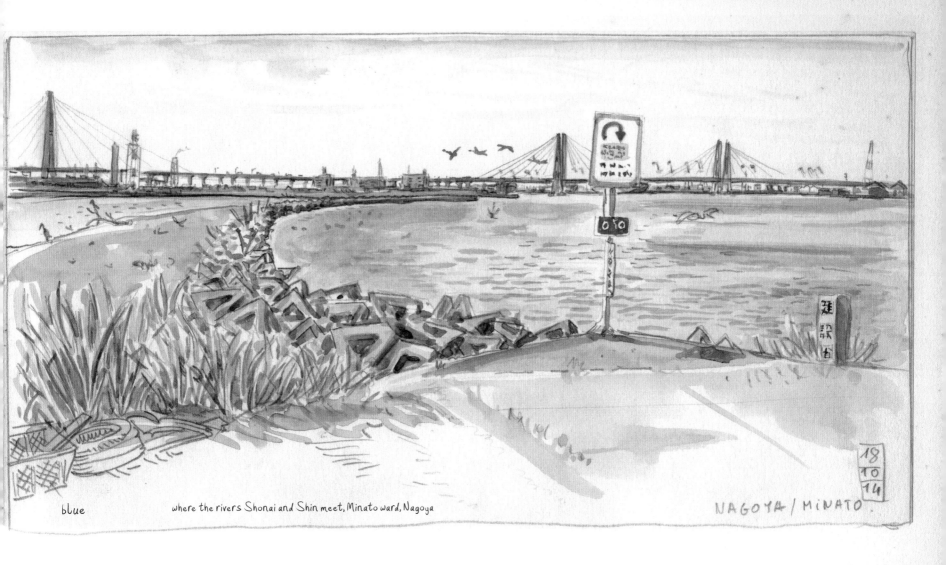

blue where the rivers Shonai and Shin meet, Minato ward, Nagoya NAGOYA / MINATO.

It hasn't been easy to locate the next station of the Tokaido, in the suburbs of Nagoya. I had to ride for a long time through a maze of commercial districts and loading docks, crossing waterways and dodging traffic, until I finally reached the little port of Kuwana on the banks of the Ibi River.

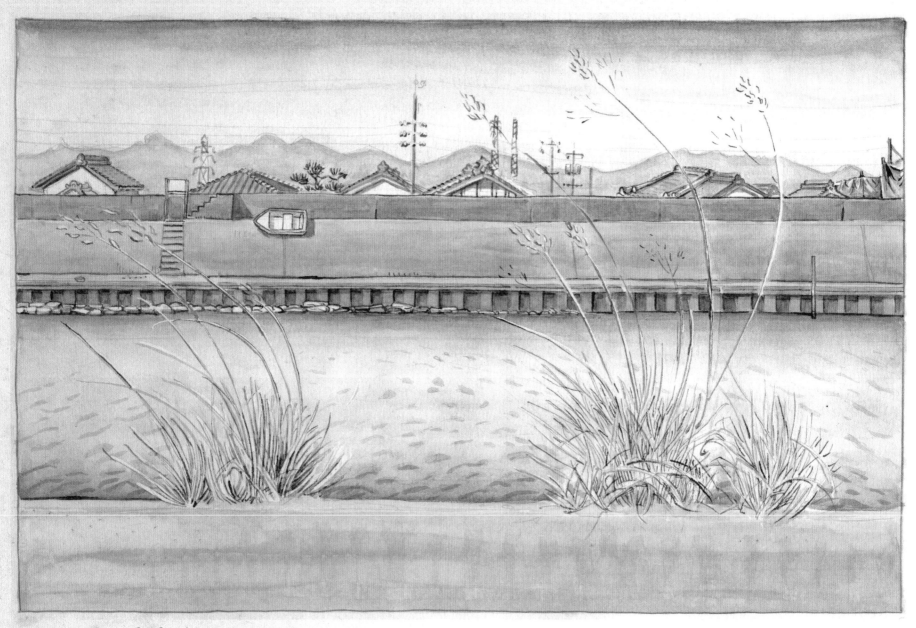

the banks of the Shin River, Nagoya.

rock merchant along Route 1, Yatomi, suburb of Nagoya

Kuwana

Where We Leave Yaji-san and Kita-san

The reconstructed Banryu Yagura tower of Kuwana Castle watches over the entrance to the old Shichiri no Watashi pier. But only the large foundation stones remain of the once-imposing castle—these can be seen along the moat in Kyuka Park.

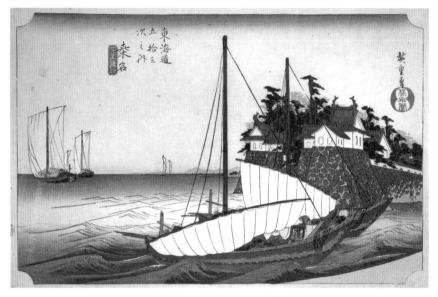

42nd station: Kuwana 桑名 七里渡口 / 広重画

Ferries arrive in Kuwana. Kuwana Castle dominates the sea upon a breaker of solid rocks. Two boats, tossed this way and that by the waves, are lowering their sails to enter the port. As for our two friends, Yajirobei and Kitahachi, the story of their arrival at Kuwana comes at the end of Book IV of *Shank's Mare*. A kind innkeeper had given Yajirobei a bamboo tube so that he could relieve himself discreetly during the long crossing. But silly Yajirobei manages so poorly that "as the tube was exactly like a fire-blower and had a hole at each end, as fast as he made water into it at one end it came out at the other into the boat. Soon the passengers began to be astonished at the water in the boat."

I'll let the reader imagine the commotion that followed.

The passengers are relieved to finally arrive at their destination:

"'Here we are, here we are,' they all cried. 'The boat's got here safely in spite of its being defiled. Thank goodness for that.'

So they all went on shore and indulged in sake in honour of their safe arrival."

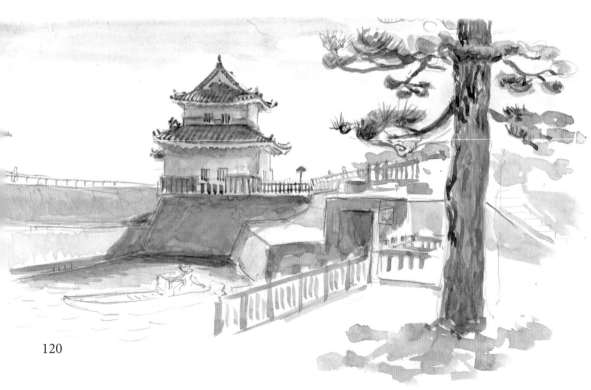

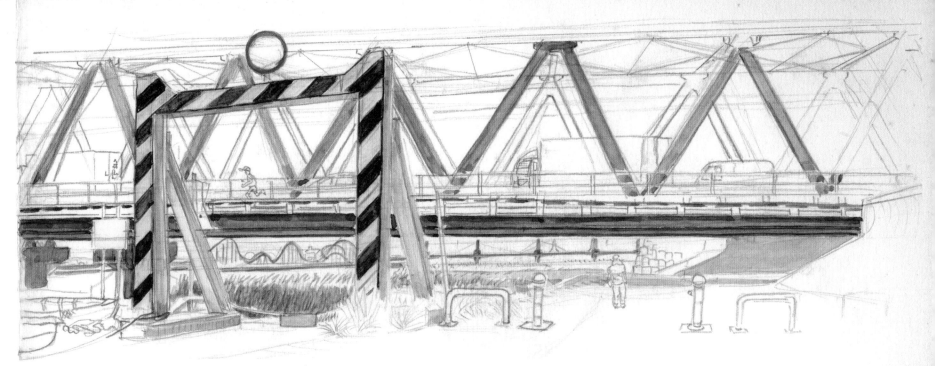

National Route 23 bridge crosses the Kiso, Nagara and Ibi rivers before reaching Kuwana.

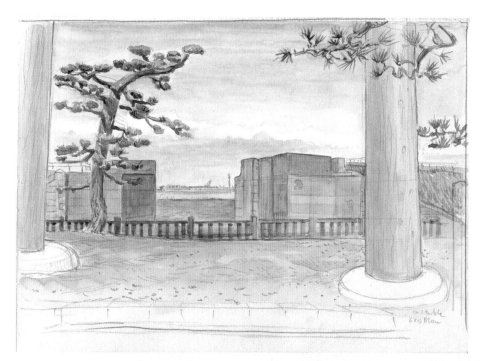

green

straw hat

NAGARA GAWA

blue background

車両進入禁止

Yokkaichi

Surfing past Factory Chimneys

After World War Two, Yokkaichi became an important petrochemical hub. All along the Suzuka River estuary, chimneys throw up a dense cloud of pollution. But surfers are not discouraged even though the waves in Ise Bay are mediocre at best. The surfers try to stay steady with the help of paddles.

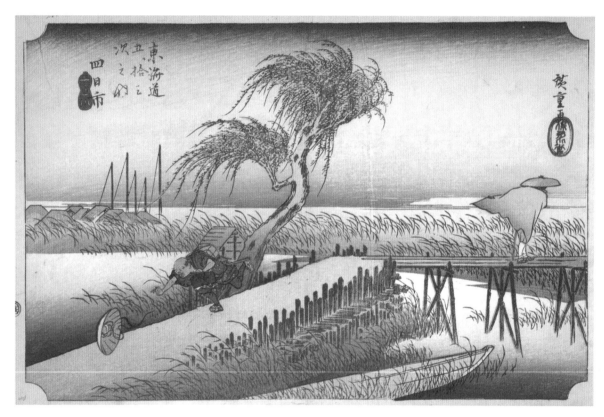

43rd station: Yokkaichi 四日市 三重川 / 広重画

The Mie River. Reed fields stretch across the mouth of the Mie River and hide the maritime horizon. Under a low sky, the masts of docked boats rise behind the thatched roofs of a cluster of houses. A dirt bank, where a willow grows, stops suddenly at the edge of a swamp. A fragile-looking bridge extends over it. Upon this sad fall landscape, Hiroshige calls forth a sudden gust of wind, with an ironic nod to the old joke of the hat that blows away.

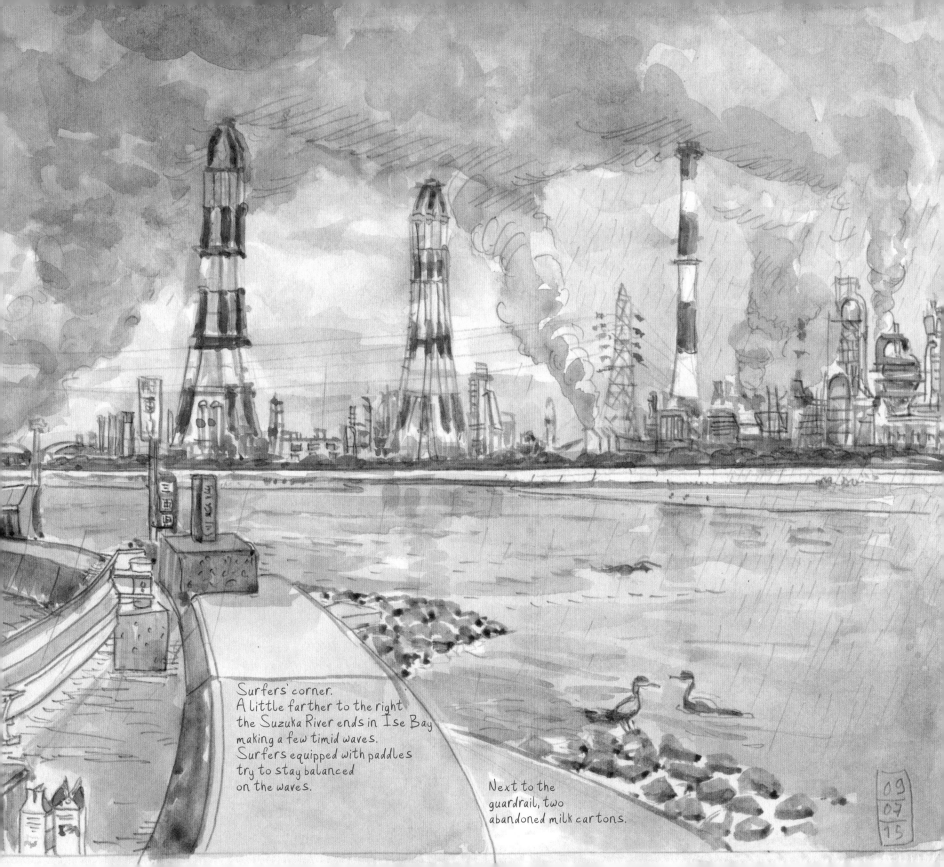

Surfers' corner.
A little farther to the right
the Suzuka River ends in Ise Bay
making a few timid waves.
Surfers equipped with paddles
try to stay balanced
on the waves.

Next to the
guardrail, two
abandoned milk cartons.

09
07
15

Ishiyakushi

A Night in a Buddhist Temple

The head monk at Ishiyakushi Temple gave me permission to sleep on the wooden verandah of the main building of Ishiyakushi Temple. Way before dawn, an indistinct shadow bends down toward me and leaves a few gifts in a paper bag. Still half asleep, I mutter a few thanks to the robed monk. Chanting begins, accompanied by the crystalline sound of a bell, and keeps going until daybreak.

In the bag I find a set of postcards, a pilgrimage notebook with a dedication written in beautiful calligraphy, some rice cakes stuffed with bean paste, and a banana.

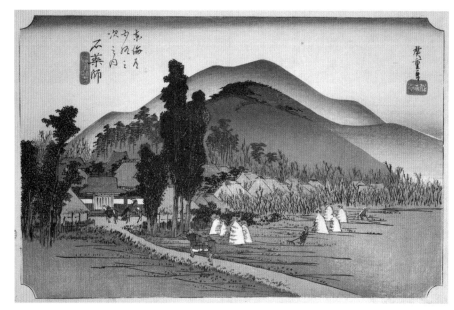

44th station: Ishiyakushi 石薬師 石薬師寺 / 広重画

The path leading to Ishiyakushi Temple leads through quiet countryside. In the fields, the rice harvest has ended. Straw is left to dry in bales and men rake the last stalks.

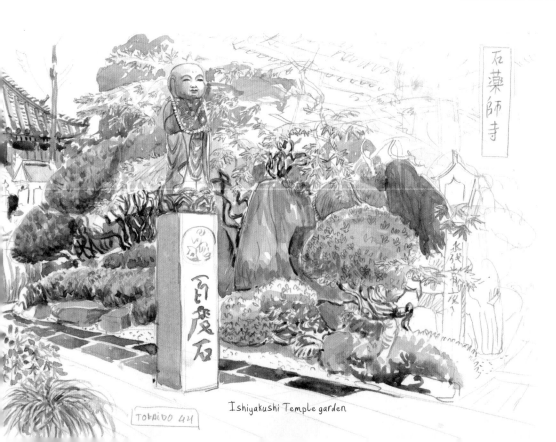

Ishiyakushi Temple garden

TOKAIDO 44

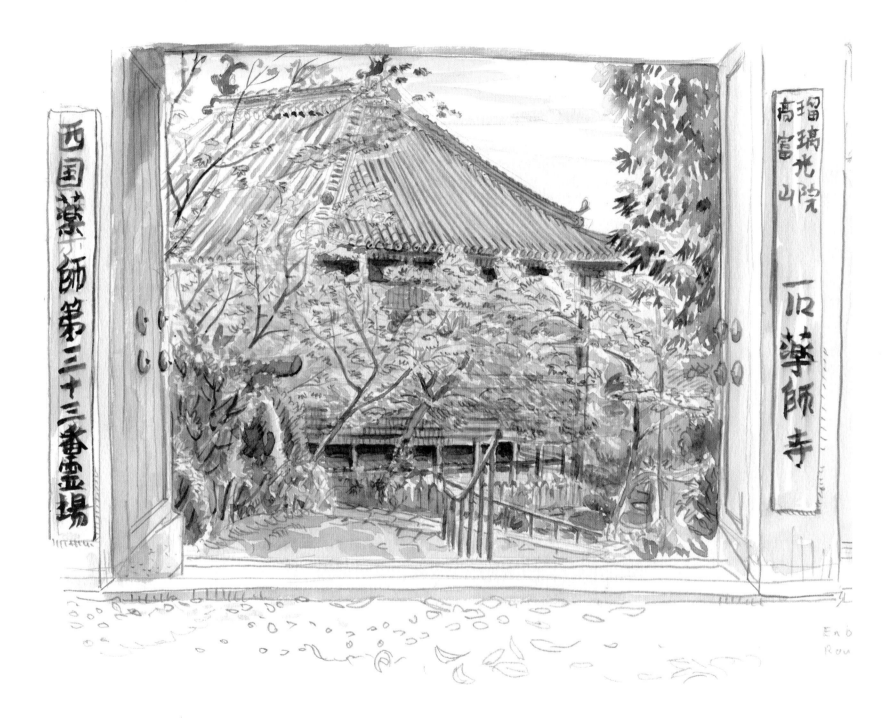

西国薬師第三十三番霊場

瑠璃光院
高富山

一乗薬師寺

Shono

Spring Rains in Suzuka

A BAD NIGHT IN THE PARK

I have to move from the bench I had fallen asleep on because of the rain. I run to take shelter under an awning in the barbecue area. I unfold my sleeping bag on the wooden table and lay my clothes out to dry, to the surprised looks of the first joggers of the day, who are not deterred by the rainy morning. Never mind. There's a coffee vending machine nearby.

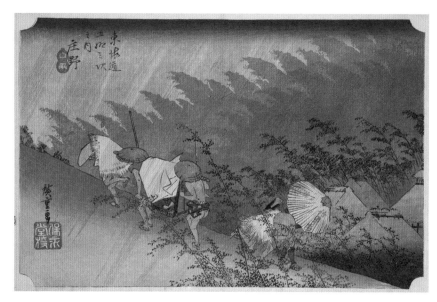

45th station: Shono 庄野 白雨 / 広重画

Spring rain in Shono. A heavy rain "like wagon axles" batters the unfortunate travelers. This evocative metaphor brings to mind the hammering of raindrops on waxed paper umbrellas, the slapping of footsteps through mud, the ruffling of leaves in the gusty wind and, in the distance, muffled thunder.

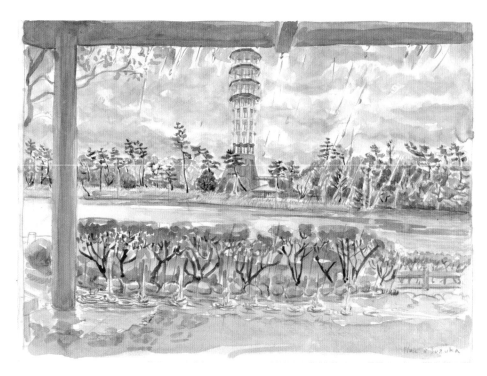

Pavilion on the lake, Seishonen no Mori Park, not far from the Suzuka racetrack.

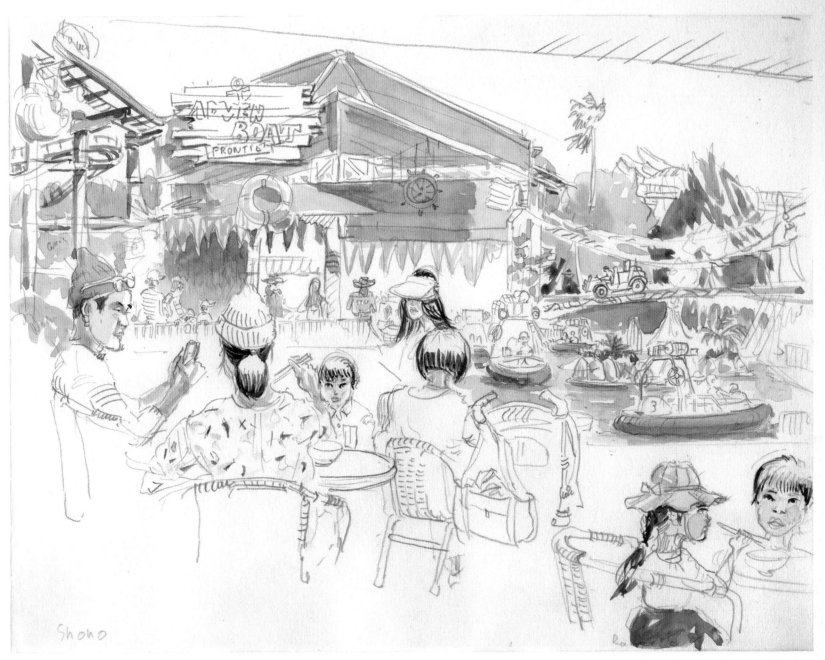

Shono

The Motopia amusement park at Suzuka Circuit
race track.

Kameyama

The Architecture of Love

On the outskirts of Kameyama, I notice a few garish buildings on National Route 1. These are "love hotels," where Japanese bad taste is limitless. One is called The Coconut Hotel; its name is written on a colonial-style chapel featuring a bell tower adorned with four dolphins riding waves. All around are palm trees made of corrugated metal where toucans perch, while a waterfall-shaped fountain fails to mask the traffic noise. Then there's the Deep See Hotel (sic), its name spelled out in pebbles surrounded by a rippling white-capped waves, like whipped cream, held up by fuchsia-pink columns . . .

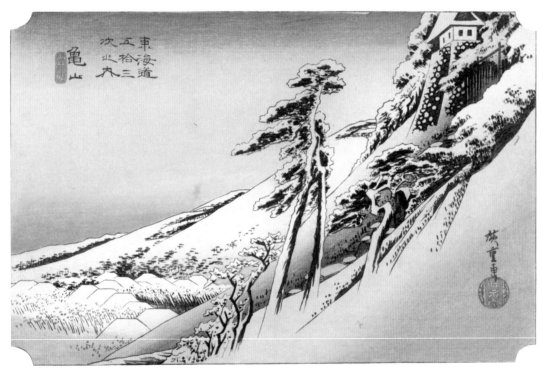

46th station: Kameyama 亀山 雪晴 / 広重画

The Suzuka Mountains are the last hurdle before reaching Kyoto. Close to Kameyama, the ridges become sharper; a clear and cold morning breaks on the landscape buried under a new coat of snow. The procession climbs the sharp gradient of the hill leading to the castle: the latter has been placed so high on the image that its roof is cut off by the print's border.

Love Hôtel
Deep

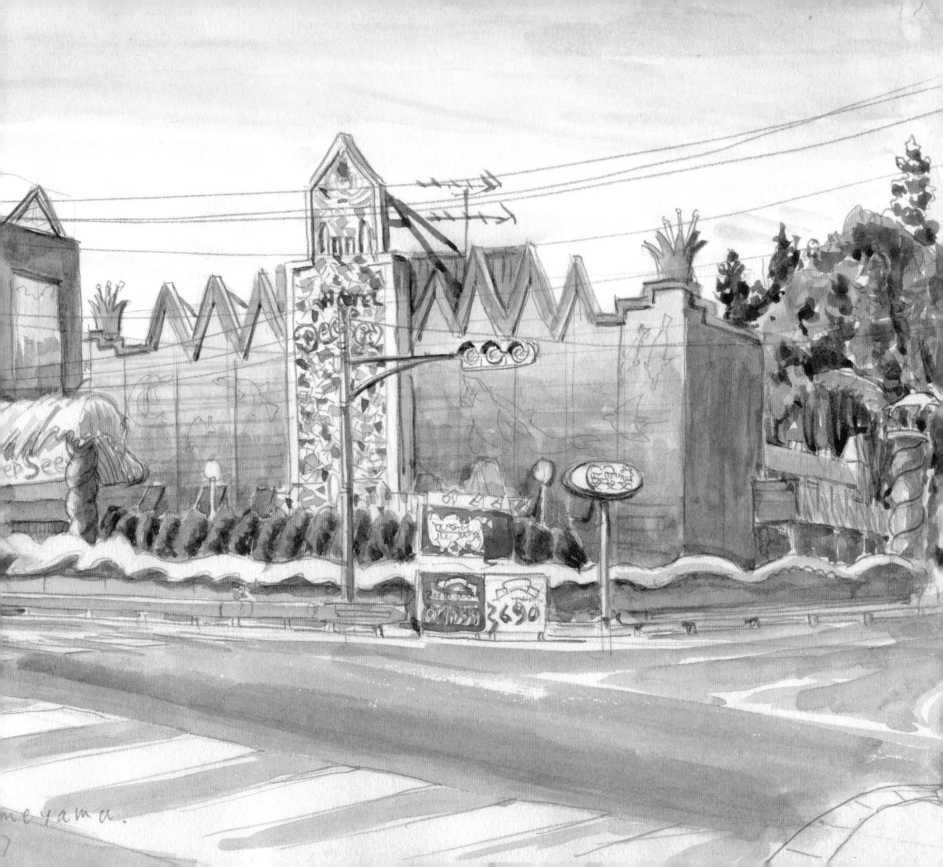

Seki

"A Moment, a Connection"

SEKI, THE ISHIGAKIYA INN

The Ishigakiya inn welcomes less wealthy visitors. It operates in a fashion similar to the *kichinyado* lodging houses, one of the lowest categories of inn that used to be found on the Tokaido road. You'd only pay for the room and firewood: food was not provided. Today, the inn is a rallying point for Japanese bikers, and youths fleeing the city, preferring life on the road for months at a time.

The atmosphere is warm and long evenings around a communal meal are very convivial, thanks to large quantities of sake, shochu, beer and other liquor. There's talk of the future, hurtful experiences, and friendship.

The motto of the Ishigakiya, calligraphied in black ink on washi paper, reads *ichi go ichi e* which means "a moment, a connection." This evokes the Zen Buddhist idea that there is a unique and present moment that cannot come again and needs to be treasured.

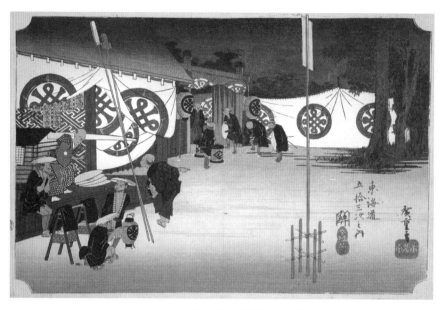

47th station: Seki 関 本陣早立 / 広重画

Early morning departure from the honjin. A *honjin* was a category of inn reserved for high-ranking officials traveling on the Tokaido. Half-hidden behind draperies stamped with the crest of the lord who has spent the night here, a palanquin is being prepared for departure. A samurai gives the last instructions; armed guards, porters and servants wait in the lamplight.

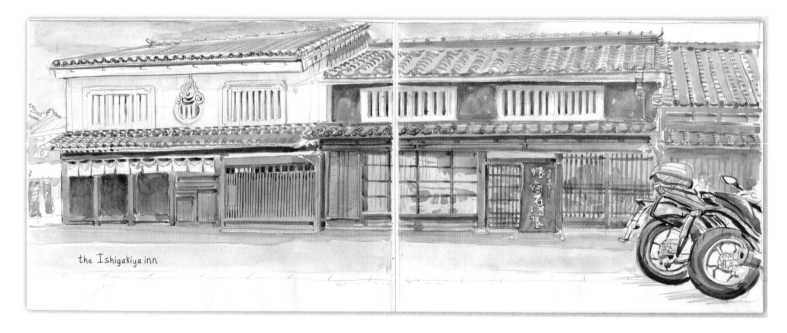

the Ishigakiya inn

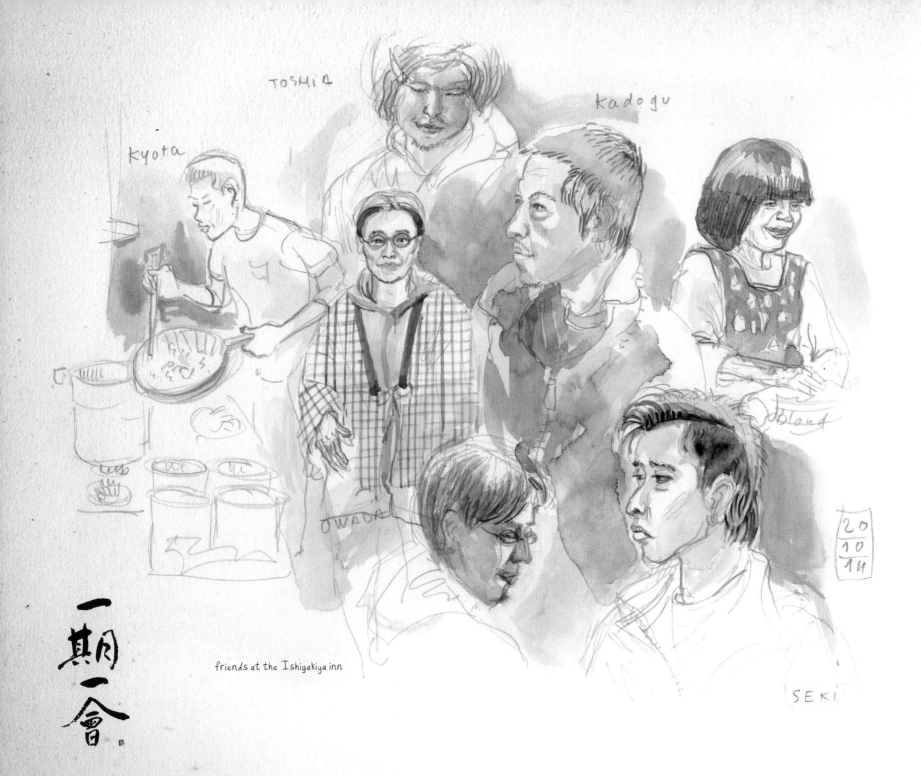

KYOTA

TOSHIA

Kadogu

OWADA

SEKI

友 一期一會

friends at the Ishigakiya inn

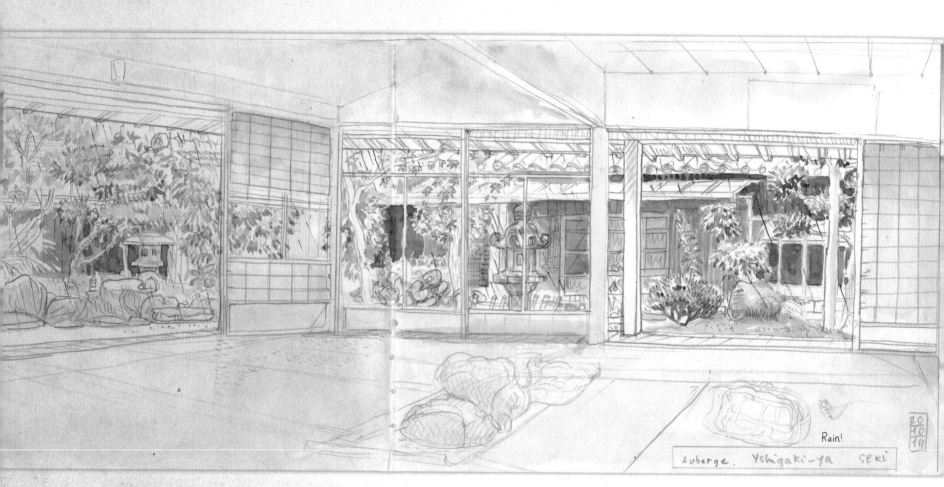

Rain!

Auberge. Ychigaki-ya SEKI

the spacious sleeping quarters and garden courtyard at the Ishigakiya inn

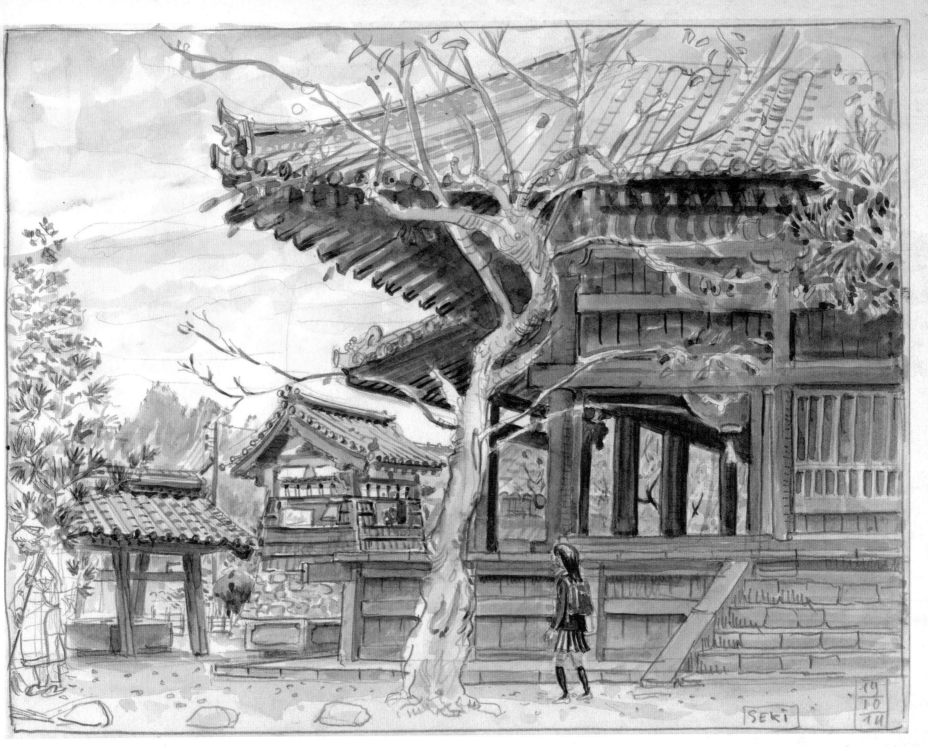

Seki Jizo-in Temple, founded in 714, showing the main building, the bell tower and the ablution basin

133

Sakanoshita

Rain Trickling in the Gutters

It's raining heavily when I arrive at the village of Sakanoshita and the streets are deserted. Despite that, I have a number of unexpected encounters while drawing. First, a large monkey crosses the street on his way from the riverbank to the forest. He stops to look at me briefly before continuing on his way. Then comes a hiker wearing a rain poncho who stops to watch me draw and chats to me for a while. A little later, lullaby music comes closer and closer until finally a truck appears, with speakers on the roof broadcasting the childish voice of a female singer: "Hello, dear Sakanoshita residents. Here is the truck of Mr. Yamaguchi, the traveling grocer whose produce is guaranteed fresh." All of a sudden, there is a flurry of activity as three customers materialize. One of them points to her house and invites me over for tea. Mr. Yamaguchi comes too.

We take a group photo and he hands me his business card. The truck drives away and silence comes down on the village, punctuated only by the sound of rain trickling down the gutters.

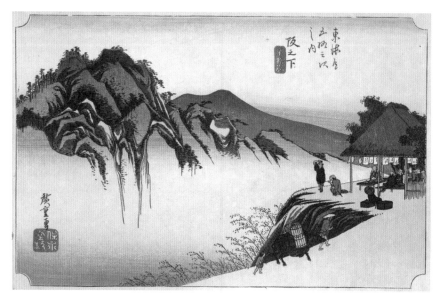

48th station: Sakanoshita 阪之下 筆捨嶺 / 広重画

"Thrown-Paintbrush Mountain." Travelers take a break on the edge of the ravine in order to admire Mount Fudesute (lit., "thrown-paintbrush mountain"). Legend has it that Kano Motonobu, a famous sixteenth-century painter, threw away his ink-soaked brush in a rage because he couldn't adequately capture the beauty of the landscape.

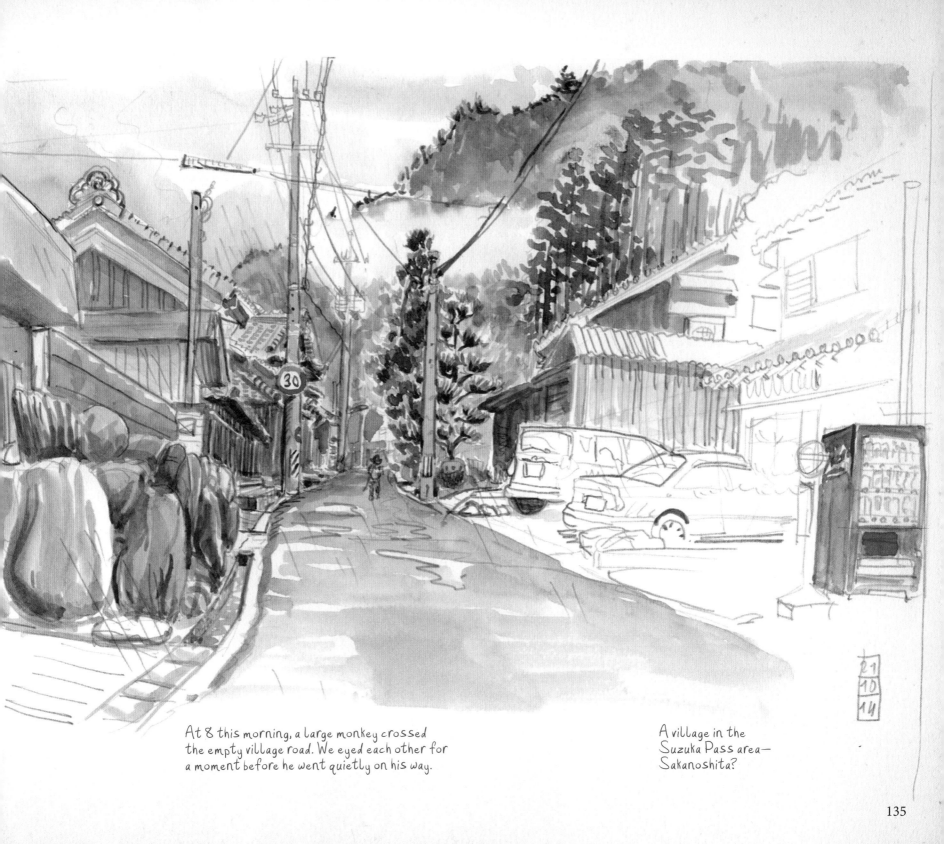

At 8 this morning, a large monkey crossed the empty village road. We eyed each other for a moment before he went quietly on his way.

A village in the Suzuka Pass area— Sakanoshita?

135

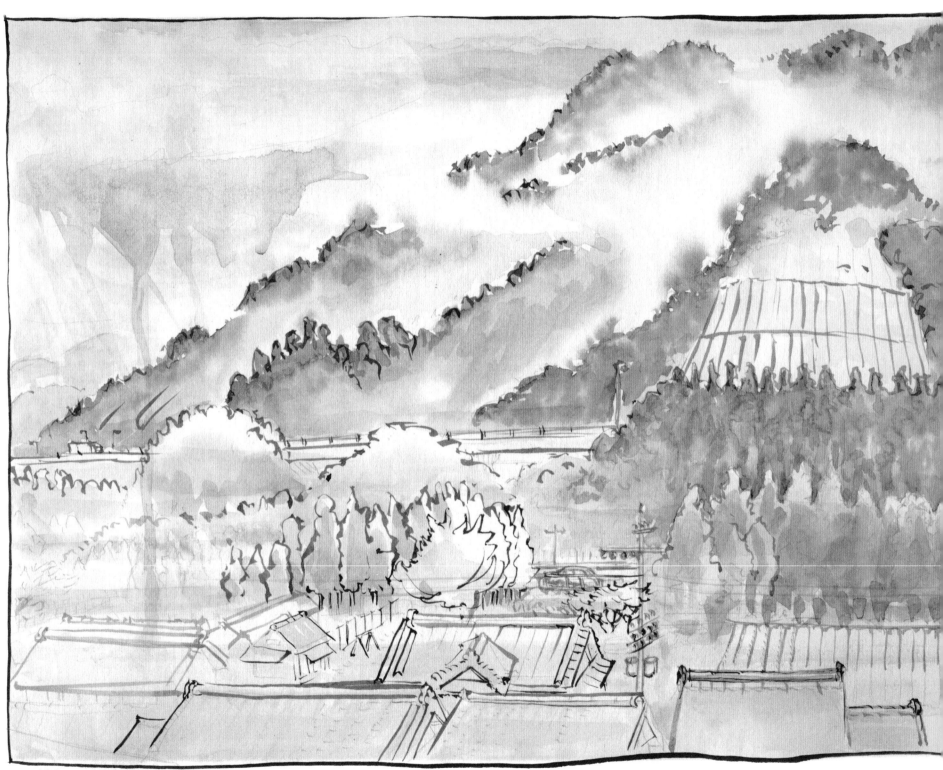

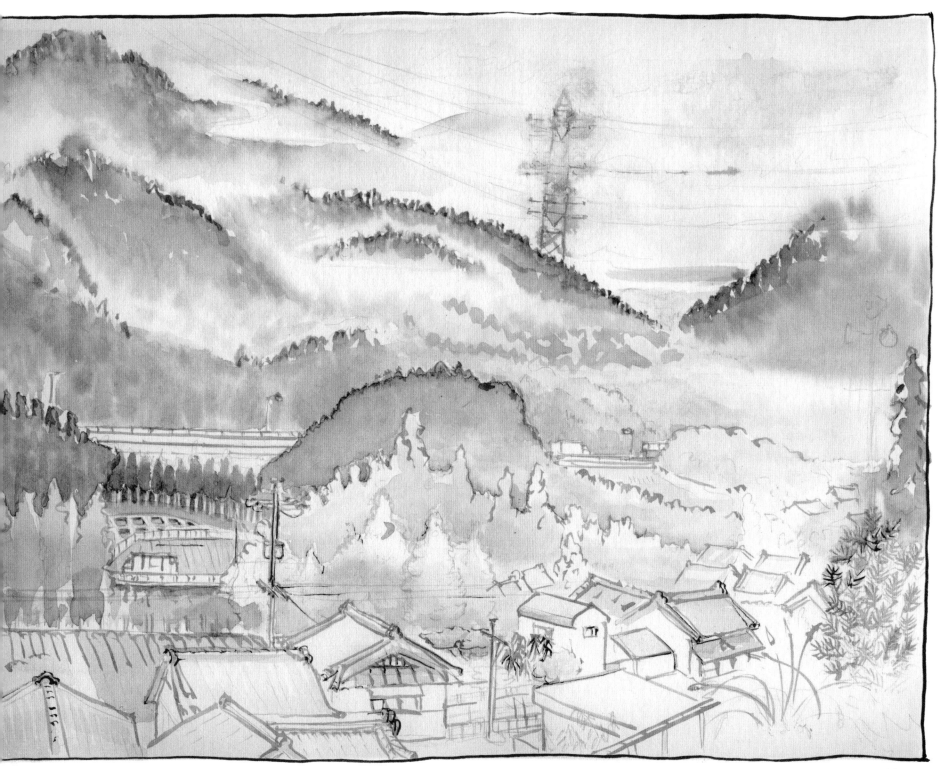

the Suzuka Pass

Tsuchiyama

The Route of the Old Tokaido

Just as the print shows, the bridge leading to Tamura Shrine crosses a mountain river but there is no sign of a retinue.

The route of the old Tokaido runs through the village of Tsuchiyama. Next to a wooden sign engraved with two travelers from the Edo period, a grocer displays his wares.

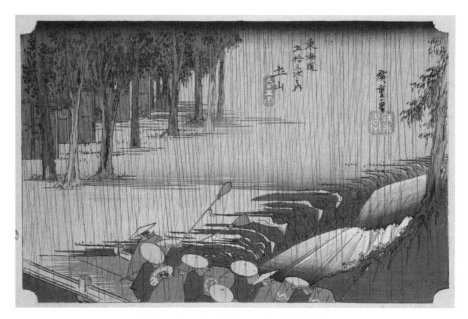

49th station: Tsuchiyama 土山 / 広重画

A daimyo's retinue crosses the bridge above a creek overflowing from the spring rains.
In capes and large hats, the men have taken the precaution of wrapping the ends of their halberds to protect them. Between the trees, the shrine entrance can be glimpsed.

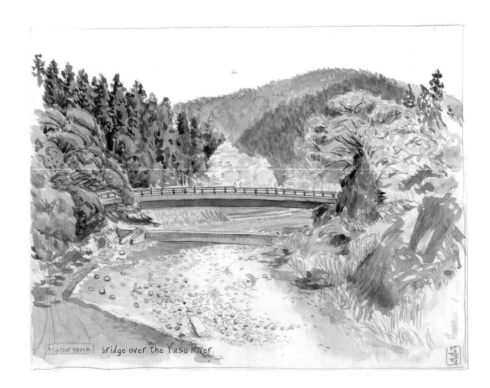

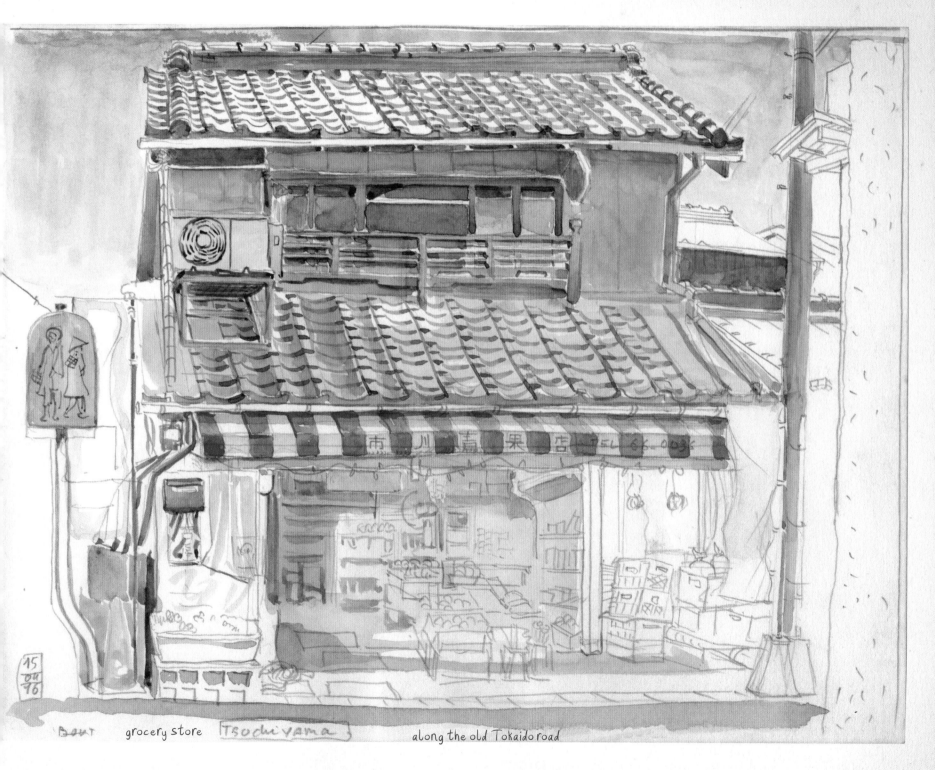

15
04
96

BOUT grocery store Tsuchiyama along the old Tokaido road

139

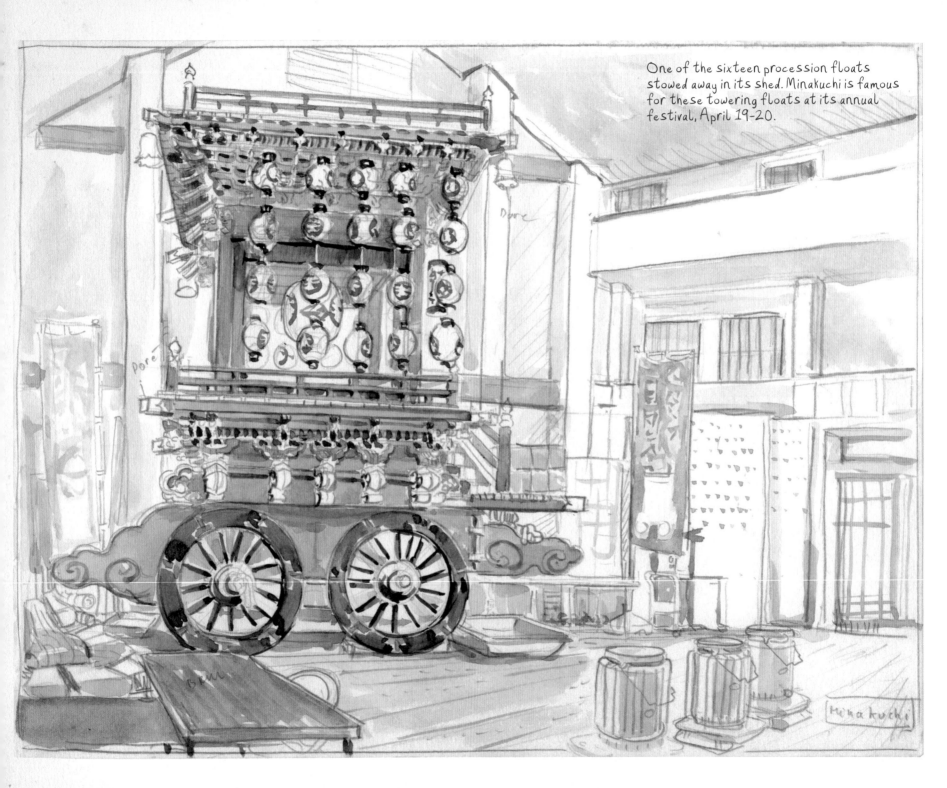

One of the sixteen procession floats stowed away in its shed. Minakuchi is famous for these towering floats at its annual festival, April 19-20.

Minakuchi

140

Minakuchi

Sixteen Festival Floats

MINAKUCHI FESTIVAL FLOATS

A festival float is stowed in this huge storage space, waiting to take part in the annual festival procession through the streets of Minakuchi. Inside, the float is kept in good condition and a range of oil heaters can be lit up at any moment to combat humidity on rainy days.

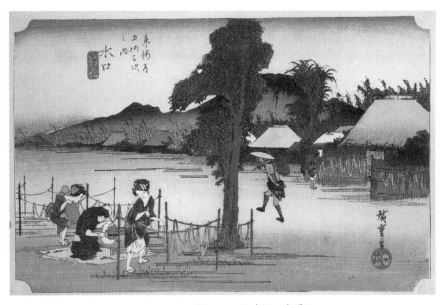

50th station: Minakuchi 水口 / 広重画

Kanpyo gourd, a local specialty. A young woman is finely slicing the flesh of a *kanpyo* calabash gourd. Another is wrapping slices on a string to sun-dry them. Next to them, a child with a baby on her back is bringing a freshly picked gourd. Kanpyo is a traditional ingredient in Japanese cooking and is often used in sushi rolls.

Ishibe

Day-to-day Small Town Life

In the little train station in Ishibe, a man has spread out a map on a table. He shows me how to get to the restaurant his wife manages. It's a down-to-earth, clean place where they serve udon noodles in broth. I choose the classic *kitsune udon*, whose slice of fried tofu tastes exactly as it should. An elderly couple, regular customers, order soba noodles, which are considered healthy.

As I travel onward, the countryside is bathed in rays of light streaming through the gaps in huge white clouds. I stop at the side of a stream, where I draw a strange little farm painted pink and green; on its roof is a bell tower of red bricks. A farmer in his truck stops to see what I'm doing: I show him my drawing and he says something about it in Japanese.

Cars pass. Next to me, a crow observes the freshly tilled soil while a cat observes the crow. There are days such as this one, without surprises, where you're happy to follow events as they unfold and there's no shame in that.

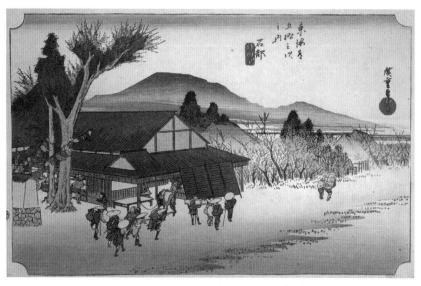

51st station: Ishibe 石部 目川ノ里 / 広重画

The route of the Tokaido passes a restaurant specializing in *nameshi dengaku*—rice and daikon leaves, served with tofu skewers dipped in miso paste. But what's happening in front of the inn? Some samurai in blue-and-white striped *yukata* summer kimonos are panicking as three women go by. Is it possible that too much sake has stirred discord among these noble warriors? One of them seems intent on not letting these beauties go. Another seems to have lost his hat in the panic and scratches his head as he wonders what to do. As for the third one, he seems less bothered, and has taken out his pipe. Their three servants barely manage to keep the group together.

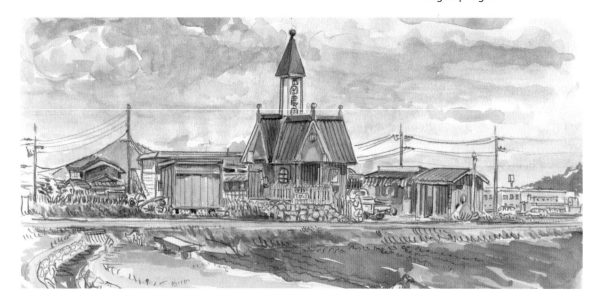

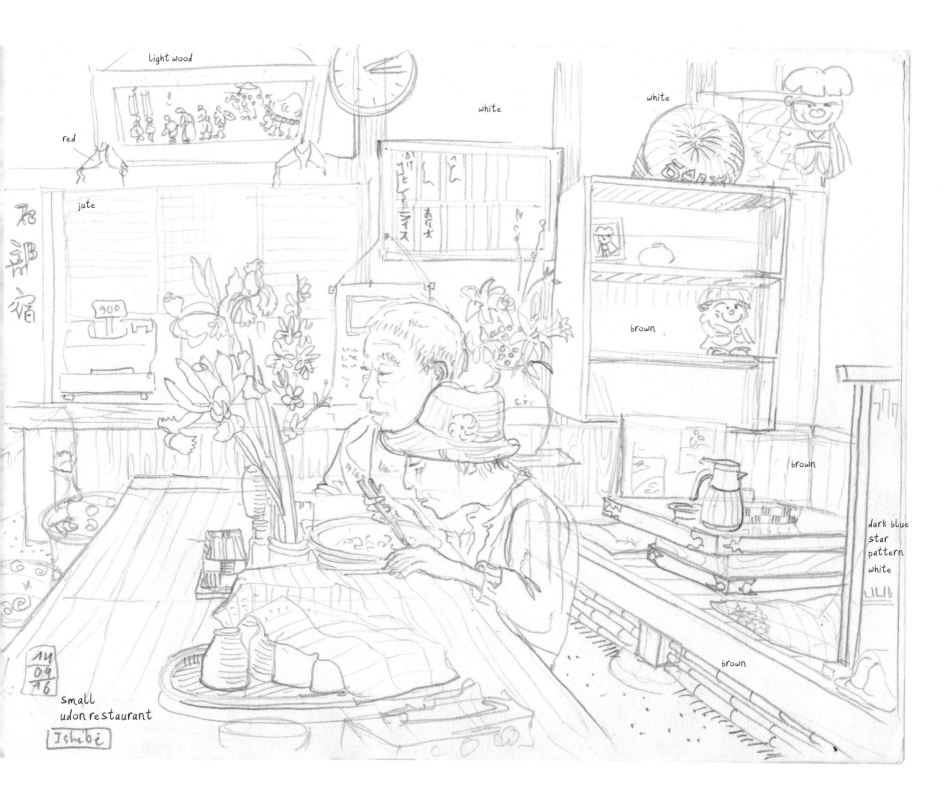

light wood

red

jute

white

white

brown

brown

dark blue
star
pattern
white

brown

14
04
16

small
udon restaurant

Ishibi

143

Kusatsu

Into the Interior

Between Ishibe and Kusatsu, there's a small village surrounded by rice fields, unaffected by the contamination of concrete architecture.

A Shinto shrine, built in the *nagare-zukuri* style with an asymmetrical roof, stands in the middle of the village.

On the banks of the Yasu River, club members have gathered to play their daily game of gateball, a croquet-like pastime. The players seem oblivious to the loud whistle of the *shinkansen* bullet trains going by on the Tokaido line bridge.

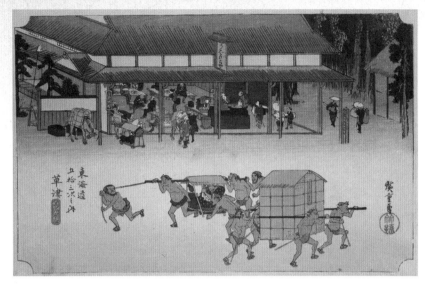

52nd station: Kusatsu 草津 名物立場 / 広重画

A restaurant has opened up its windows so we can see inside. When you see all the people sitting down for a meal, you know the place has a solid reputation. People come from all over to enjoy the famous Kusatsu *ubaga mochi*, sticky rice cakes with slightly sweetened red bean paste in the middle. An important crossing place, this station is situated where the paths of the Tokaido and the Nakasendo intersect. On the road, palanquin porters hurry in opposite directions.

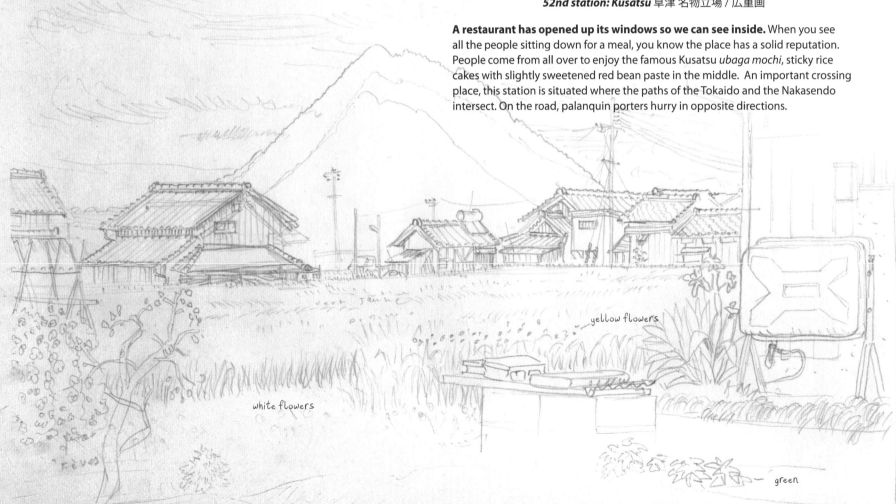

white flowers

yellow flowers

green

black

red

red + brown

blue

13
04
16

Ground Golf
Gate Ball

8

11

blue line

POST

この公園は 月曜 日が 休園 日です
有料 施設の 無断 使用 禁止

between Kusatsu and Ishibe

train

Tokaido line bridge—
shinkansen

145

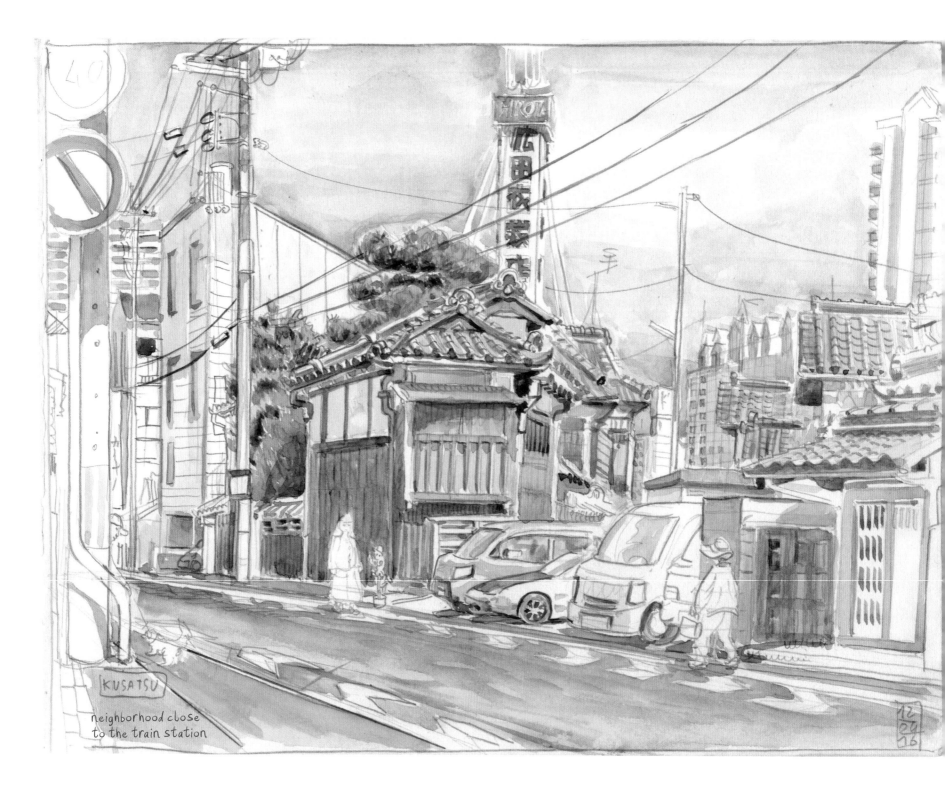

KUSATSU

neighborhood close
to the train station

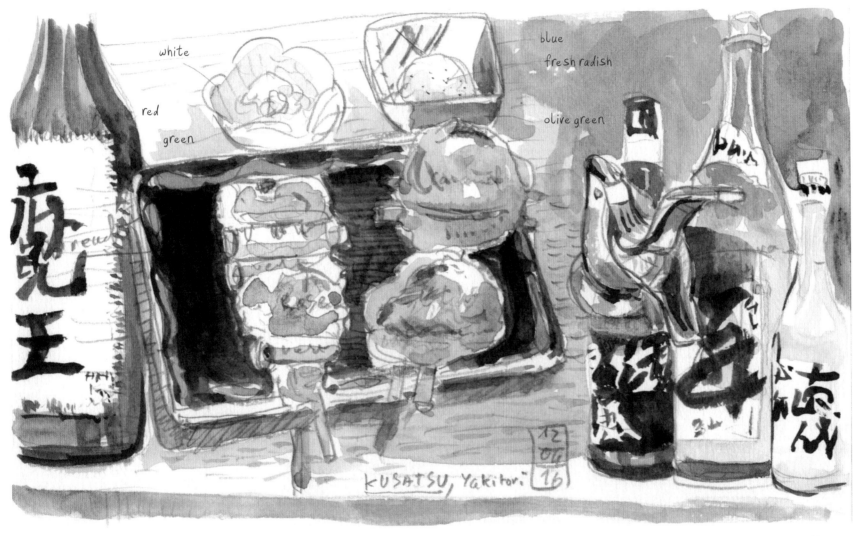

white

red

green

blue
fresh radish

olive green

KUSATSU, Yakitori

yakitori restaurant, Kusatsu

Traditional gray-tile roofs have almost disappeared from the center of Kusatsu. The neighborhood around the train station is a perpetual construction site with tower blocks too tall for the city's size. National Route 1 as it heads toward the city of Otsu is an alignment of advertising billboards interrupted from time to time by a wooded temple.

During the Edo period, Kusatsu was the place where the east coast road, the Tokaido, intersected with the interior road, the Nakasendo. Today, freeways and railroads crisscross this small plain stuck between the mountains and Lake Biwa.

Otsu

The Koi Carp of Lake Biwa

FISHING IN LAKE BIWA

The chimes of the fishing-bite alarm have woken up the sleeping fisherman. Then everything happens at once. The man jumps out of his beach chair, scaring a flock of pigeons. He runs to his fishing lines, ready with a net. The fish is hooked: it only takes seconds to lay it on the ground. The fisherman measures it and sprays its shiny white belly with something. What a gorgeous carp—twenty-three inches (sixty centimeters) long!

Satisfied, he unhooks the fish and gently puts it back into the water, where it vanishes beneath the reflected blue sky. On the path around the lake, joggers, salarymen and dog walkers cross paths with indifference on this clear and dry morning.

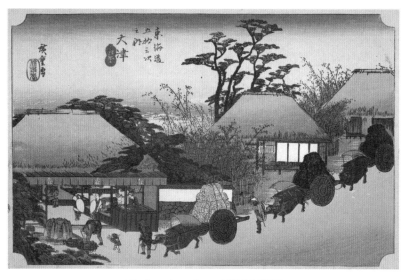

53rd station: Otsu 大津 / 広重画

The Hashiri Teahouse The Hashiri, a well that was famed at the time for its "running" or gushing water (*hashiri* means "run"), is on the left of the image, in front of the teahouse. *Hashiri mochi*, red-bean-paste cakes steamed in the well's water are sold here. Otsu is the last station of the Tokaido before reaching Kyoto.

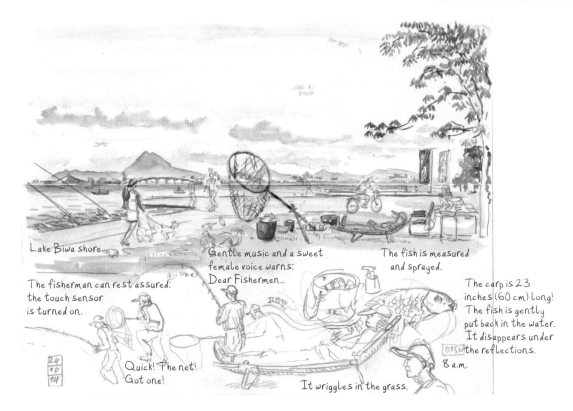

Lake Biwa shore.

The fisherman can rest assured: the touch sensor is turned on.

Gentle music and a sweet female voice warns: Dear Fishermen…

The fish is measured and sprayed.

Quick! The net! Got one!

The carp is 23 inches (60 cm) long! The fish is gently put back in the water. It disappears under the reflections.

8 a.m.

It wriggles in the grass.

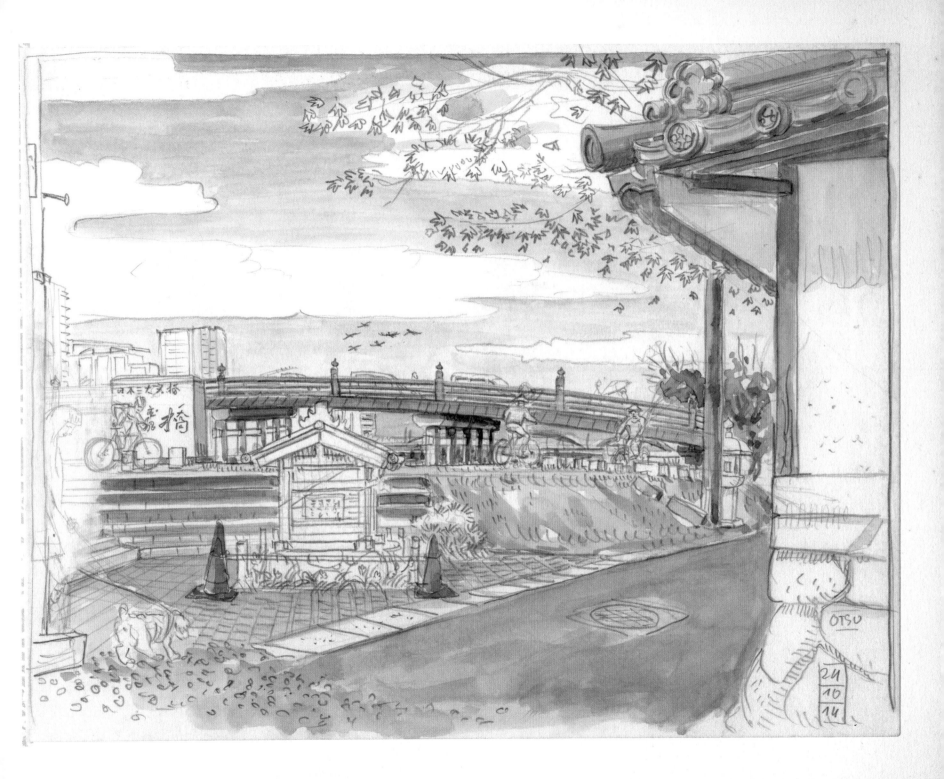

日本三大名橋
橋

OTSU

24
10
14

149

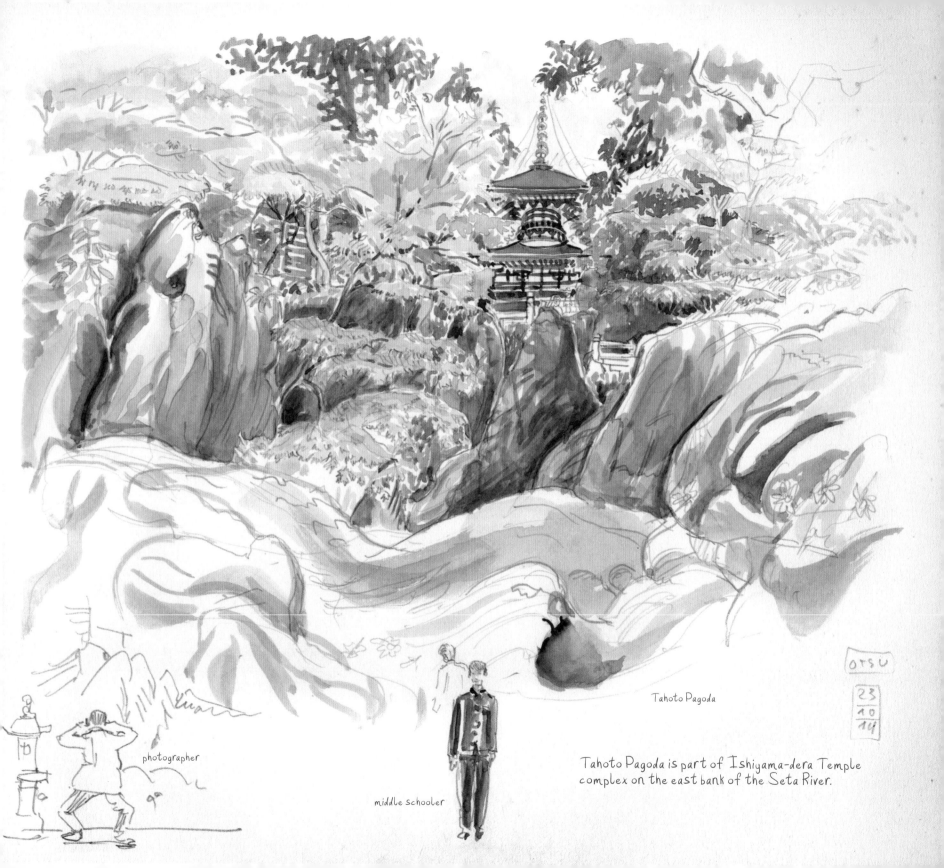

photographer

middle schooler

Tahoto Pagoda

OTSU

23
10
14

Tahoto Pagoda is part of Ishiyama-dera Temple
complex on the east bank of the Seta River.

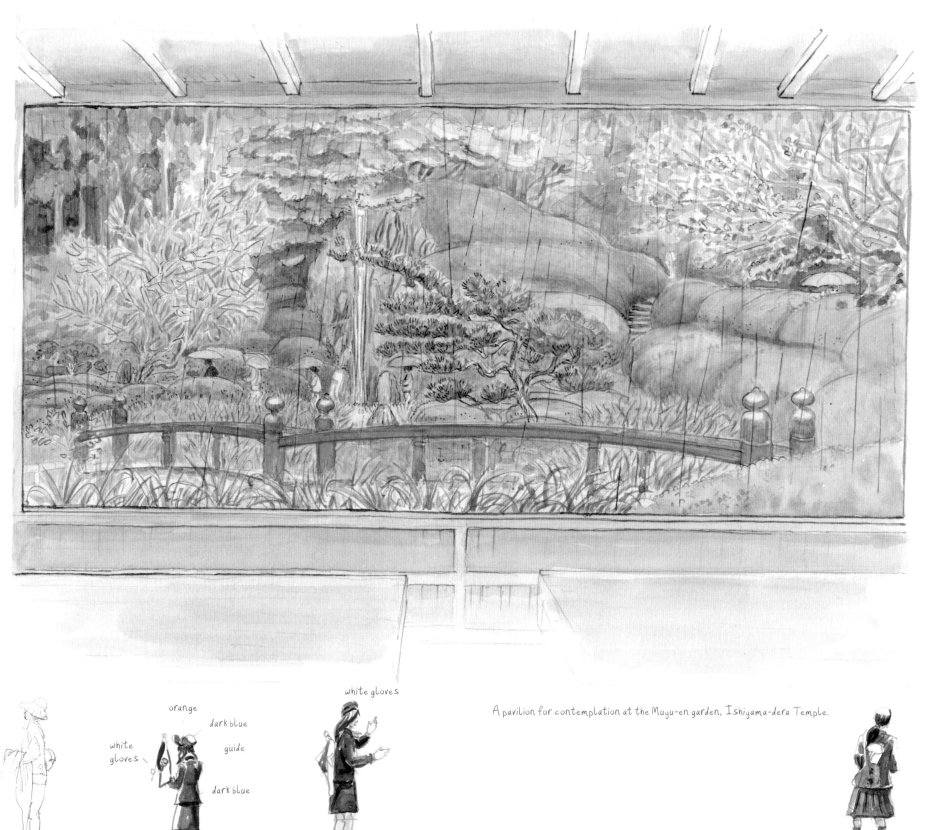

white gloves

orange

dark blue

guide

dark blue

white gloves

white gloves

A pavilion for contemplation at the Muyu-en garden, Ishiyama-dera Temple.

Kyoto

Entering the Imperial City

VIEW OF KYOTO FROM KEAGE POWER STATION

Water from Lake Biwa is channeled to Kyoto by a canal that travels through the mountains towards Higashiyama. Next to the old brick building that houses Keage Power Station the water runs through enormous pipes. The throbbing and grating squeaks of the water-plant machinery produce a surprising noise, reminiscent of the flutes in the *gagaku* music traditionally played at the imperial court. From here, there's a magnificent view of the imperial city.

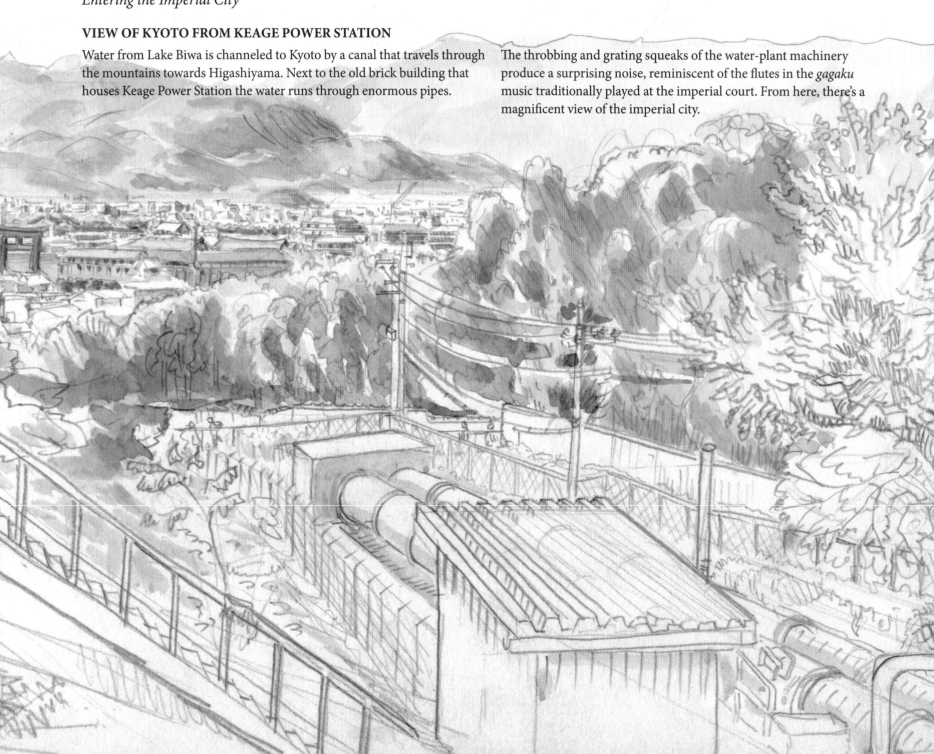

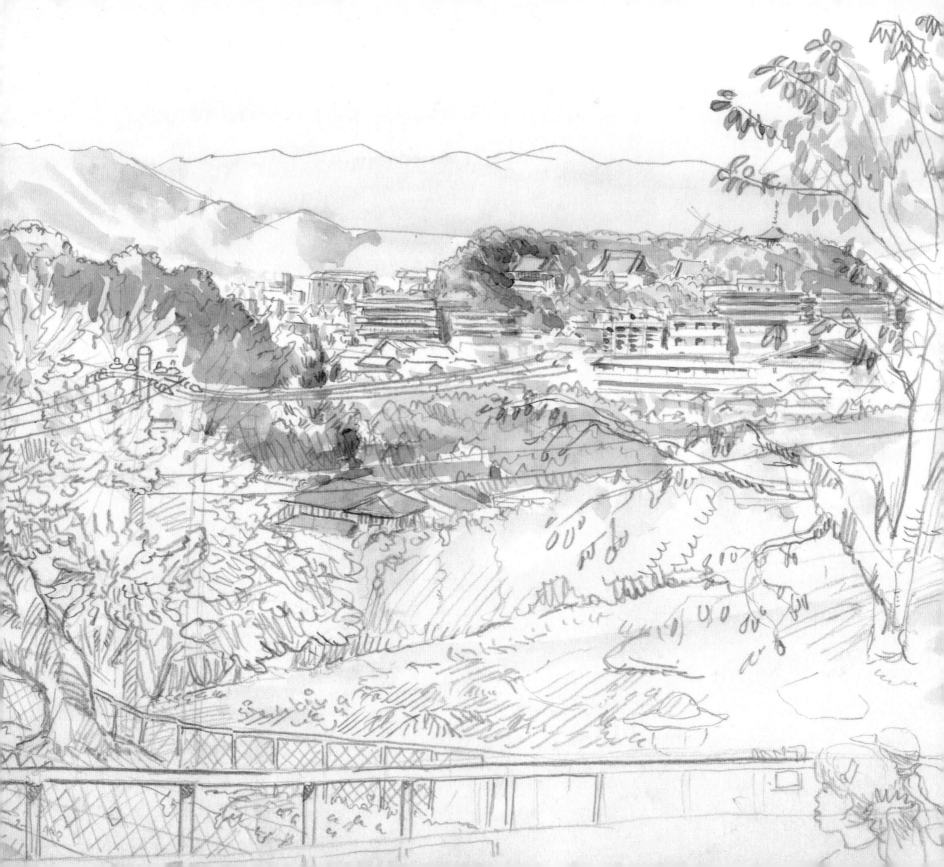

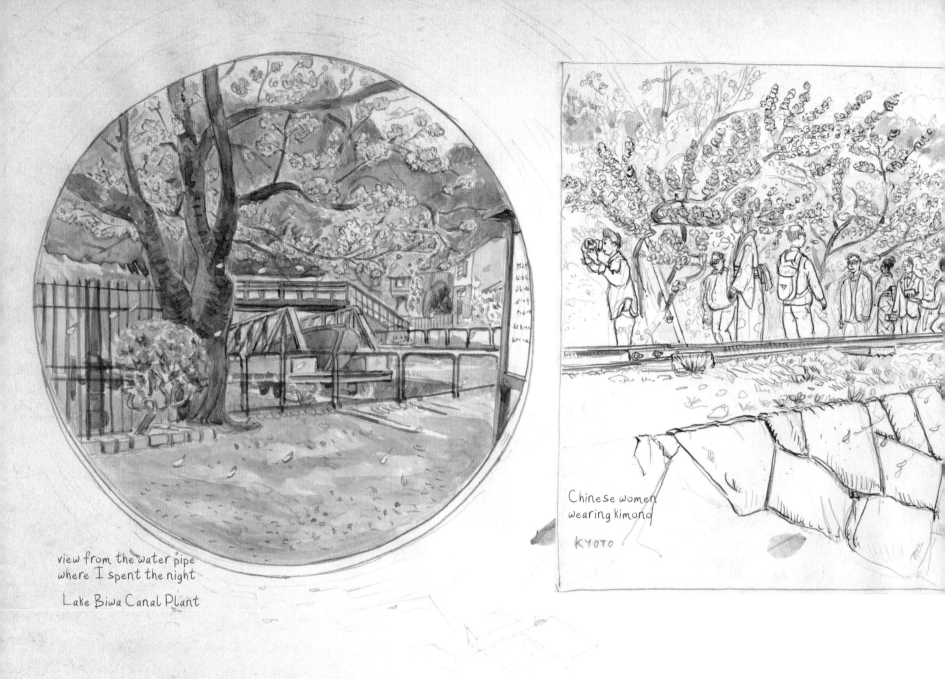

view from the water pipe
where I spent the night
Lake Biwa Canal Plant

Chinese women
wearing kimono

KYOTO

SLEEPING INSIDE A WATER PIPE

Since all the hotels in Kyoto are full, my only option is to sleep under the stars. Earlier, in Higashiyama, I had noticed an outdoor open water pipe that I could use for shelter. Once I'm in it, it reminds me of a capsule-hotel room and from the inside, the round "window" opening frames a view that includes a cherry tree in bloom above a boat in the middle of the railway tracks. In the background of this vista, a stone bridge crosses over Lake Biwa Canal and disappears into a tunnel.

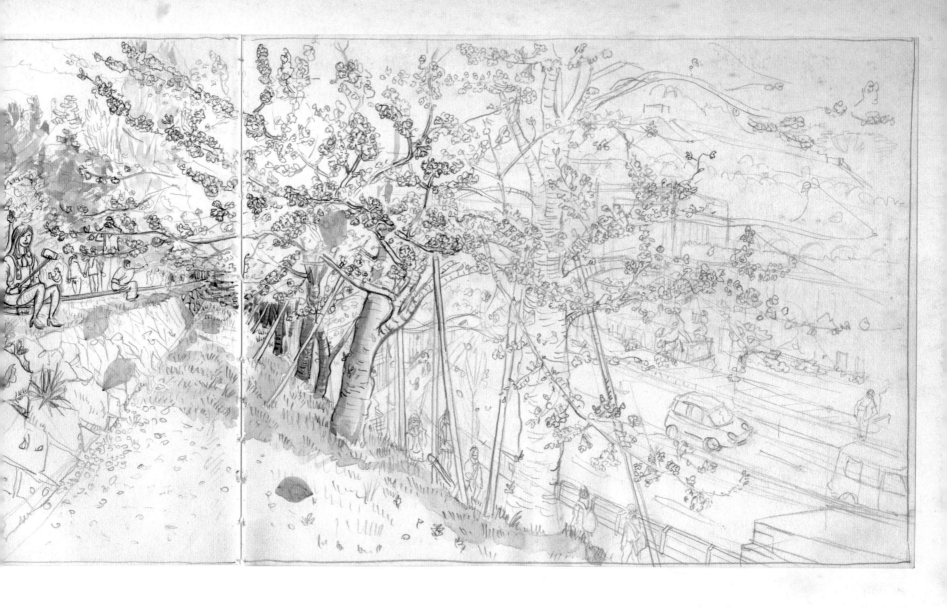

UNDER THE CHERRY BLOSSOMS

From the canal to downtown, there's a railway line flanked with blossoming cherry trees. In the *sakura* cherry-blossom season, the Japanese tradition is to take part in *hanami* flower viewing. Cultural paradox of the twenty-first century: it's mostly tourists clad in garish rented kimonos who are wandering around, speaking all languages except Japanese. A newly married couple pose in front of a blooming backdrop and there's a sudden flurry of selfies. Nobody, at this instant, is meditating on the ephemeral beauty of life.

The Sanjo Ohashi Bridge

One Hundred and Twenty-Five Leagues On

Just like Hiroshige's print, traffic on the Sanjo Ohashi Bridge doesn't let up. An employee from a nearby Starbucks sees me drawing and brings me a coffee. Sipping my drink, I watch the crowds and look for faces that would remind me of Kitahachi or Yajirobei.

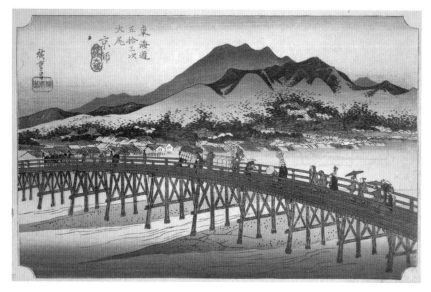

The final step, Sanjo Ohashi

三条大橋 / 広重画

The Tokaido ends in Kyoto after a trek of some one hundred and twenty-five leagues, about three hundred miles (five hundred kilometers). Travelers finally enter the imperial city by the Sanjo Ohashi Bridge across the Kamo River.

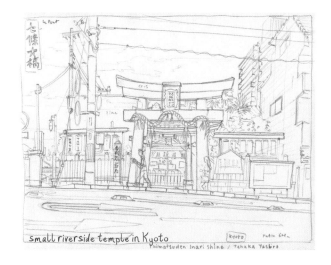

small riverside temple in Kyoto

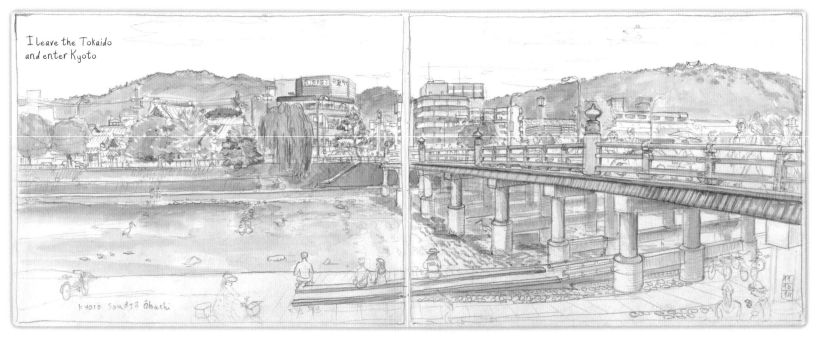

I leave the Tokaido and enter Kyoto

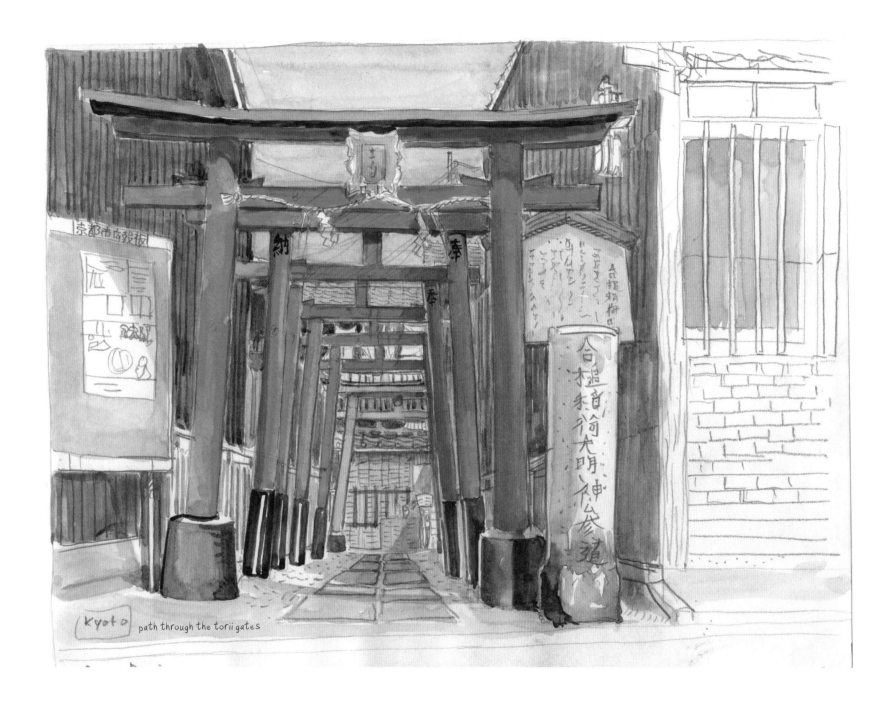

京都市広教板

奉

納

奉

合掲朗様日
こわようくん
ニわようくん
りいかん〇〇
みったい〇〇
こちらへ

合掲前
捏東伯荷大明神社参道

kyoto path through the torii gates

Kyoto

At the Gates of the Imperial Palace

It's not impossible to visit the inside of the Imperial Palace but it requires many formalities. At regular intervals, a police car makes slow rounds, blue pebbles scrunching on the road. Sometimes a daring photographer, coming too close to the outside walls, inadvertently triggers the siren of the laser alarm.

The gardens around the palace offer visitors calm and serenity. Nature photographers patiently monitor the movements of a marten in a pine tree. A woman bends down to collect seeds from a majestic camphor tree. A group of women wearing brightly colored tights wander along the paths with short steps. The cyclists all use the same route that the continuous traffic of bicycles has marked on the gravel.

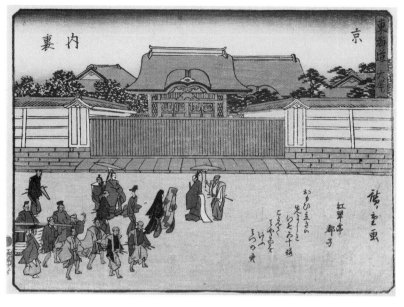

The Imperial Palace in Kyoto 京内裏 / 広重画

In the Tokaido series published by Sanoki, Hiroshige adds another stage to the journey, a view of the tightly closed gates of the Imperial Palace. A group of aristocrats, followed by samurai and servants, stroll along the surrounding park pathways in the leisurely manner of the privileged. Sheltered by parasols, the noblemen wear gauze caps and the women wear brightly colored silks.

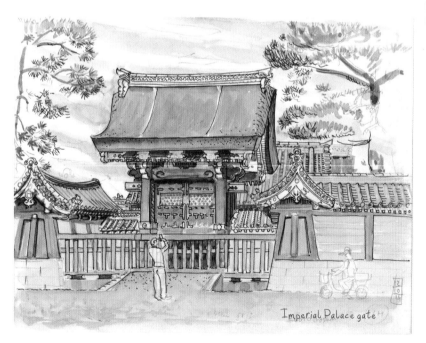

Imperial Palace gate

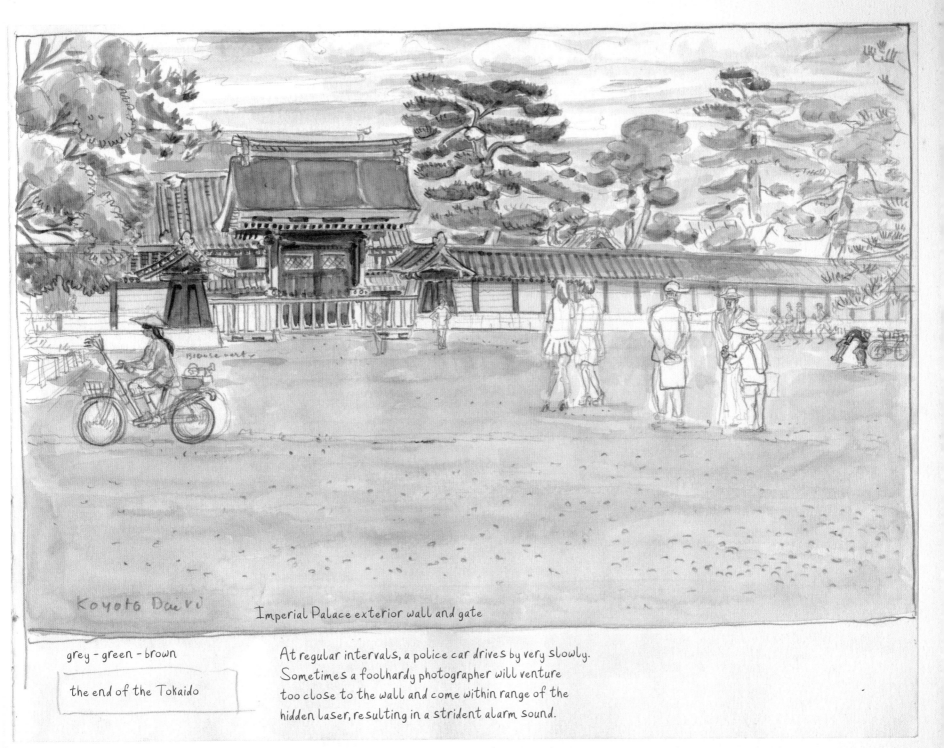

Koyoto Dairi

Imperial Palace exterior wall and gate

grey - green - brown

the end of the Tokaido

At regular intervals, a police car drives by very slowly.
Sometimes a foolhardy photographer will venture
too close to the wall and come within range of the
hidden laser, resulting in a strident alarm sound.

"Books to Span the East and West"

Tuttle Publishing was founded in 1832 in the small New England town of Rutland, Vermont (USA). Our core values remain as strong today as they were then—to publish best-in-class books which bring people together one page at a time. In 1948, we established a publishing office in Japan—and Tuttle is now a leader in publishing English-language books about the arts, languages and cultures of Asia. The world has become a much smaller place today and Asia's economic and cultural influence has grown. Yet the need for meaningful dialogue and information about this diverse region has never been greater. Over the past seven decades, Tuttle has published thousands of books on subjects ranging from martial arts and paper crafts to language learning and literature—and our talented authors, illustrators, designers and photographers have won many prestigious awards. We welcome you to explore the wealth of information available on Asia at **www.tuttlepublishing.com**.

Published as *Tokaido 53* by Elytis, Bordeaux, France. 2017.
TOKAIDO 53 – Philippe DELORD
© 2017 ELYTIS
13, rue de Domrémy 33000 Bordeaux - France

Translation copyright © 2021 by Periplus Editions (HK) Ltd.
Translated from the French by Marie S. Velde

Published by Tuttle Publishing, an imprint of
Periplus Editions (HK) Ltd.

www.tuttlepublishing.com

ISBN 978-4-8053-1629-0

Distributed by

North America, Latin America and Europe
Tuttle Publishing
364 Innovation Drive, North Clarendon
VT 05759-9436 U.S.A.
Tel: 1 (802) 773-8930 Fax: 1 (802) 773-6993
info@tuttlepublishing.com
www.tuttlepublishing.com

Japan
Tuttle Publishing
Yaekari Building 3rd Floor
5-4-12 Osaki Shinagawa-ku, Tokyo 141 0032
Tel: (81) 3 5437-0171 Fax: (81) 3 5437-0755
sales@tuttle.co.jp
www.tuttle.co.jp

Asia Pacific
Berkeley Books Pte. Ltd.
3 Kallang Sector, #04-01, Singapore 349278
Tel: (65) 67412178 Fax: (65) 67412179
inquiries@periplus.com.sg
www.tuttlepublishing.com

Printed in Malaysia 2107TO
24 23 22 21 10 9 8 7 6 5 4 3 2 1

TUTTLE PUBLISHING® is a registered trademark of Tuttle Publishing, a division of Periplus Editions (HK) Ltd.